THE SARTORIALIST
Scott Schuman

PENGUIN BOOKS

Published by the Penguin Group
Penguin Books Ltd, 80 Strand, London WC2R 0RL, England
Penguin Group (USA) Inc., 375 Hudson Street, New York, New York 10014, USA
Penguin Group (Canada), 90 Eglinton Avenue East, Suite 700, Toronto, Ontario,
Canada M4P 2Y3 (a division of Pearson Canada Inc.)
Penguin Ireland, 25 St Stephen's Green, Dublin 2, Ireland (a division of Penguin Books Ltd)
Penguin Group (Australia), 250 Camberwell Road, Camberwell, Victoria 3124,
Australia (a division of Pearson Australia Group Pty Ltd)
Penguin Books India Pvt Ltd, 11 Community Centre,
Panchsheel Park, New Delhi – 110 017, India
Penguin Group (NZ), 67 Apollo Drive, North Shore 0632, New Zealand
(a division of Pearson New Zealand Ltd)
Penguin Books (South Africa) (Pty) Ltd, 24 Sturdee Avenue,
Rosebank 2196, South Africa

Penguin Books Ltd, Registered Offices: 80 Strand, London WC2R 0RL, England

www.penguin.com

First published 2009
8

Designed by Stefanie Posavec
Printed and bound in Italy by Graphicom srl

ISBN: 978–1–846–14250–5

To my Father, Earl Schuman –
simply the most influential
man in my life.

The Sartorialist, at its core, is about fashion, but I don't often think of 'fashion' when I look at my photos.

I have been sharing photos with my audience on a daily basis for the past four years, and over the course of that time I have begun to see my images more as a social document celebrating self-expression than as a catalogue for skirt lengths or heel heights.

The comments on The Sartorialist website make the blog a living fabric. The audience interaction made me realize the variety of interpretations the same look can provoke. I might be totally entranced by a young lady's hairstyle, while someone else won't be able to stop looking at her flipflops.

It's all about self-expression. I rarely shoot a look where I love all the elements. I don't need to love the whole look: I just need to identify the one or two elements that mean something to me, and then capture it in the romantic way I see it. In that way I think I am 'visually greedy'. Like most of the designers I know, they can hone in on the trim-detail of a vintage dress and simply disregard the rest. Let's just say it's a positive and less judgemental way to look at the world.

I hope that, as you look at the images in this book, rather than giving a look a 'thumbs up' or a 'thumbs down', you will focus on the elements that could inspire you. Maybe you'll find inspiration in a colour combination, or maybe in a play on textures or a mix of genres, for example 'punk meets eskimo'.

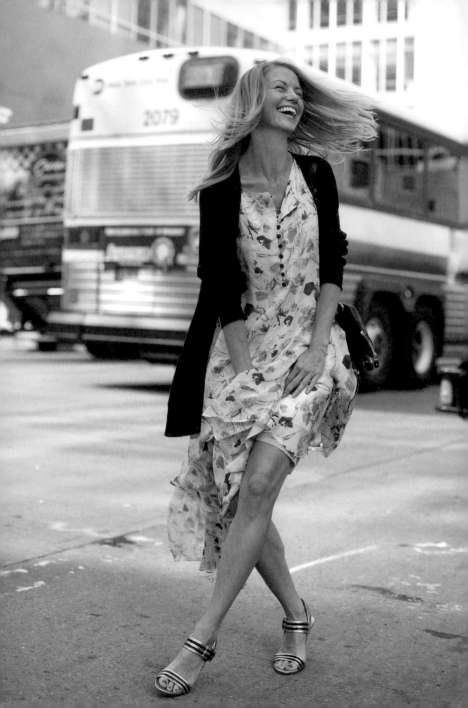

I like people to draw their own conclusions, to find their own inspiration without the influence of a guiding hand. That's why you won't find a lot of text in this book. My inspiration comes from contrast and variety. I'm proud that this book celebrates style through a wide range of ages, income levels, and nationalities. On the surface these individuals are very different, but they somehow share a common bond in the execution of their sartorial expression.

What constitutes great personal style? This is one of the questions I get asked the most. We tend to think that to achieve great personal style someone must have perfect clarity about who they are and what they stand for. I politely disagree. I think conflict about who you are often leads to even greater expression. That is why young people, or the young at heart, are those that inspire or move fashion forward. They are still struggling to find themselves: 'Am I a rocker? A footballer? Or a little bit of both?'. These contradictions produce the most interesting looks.

I hope that, while looking at the images in this book, you will begin to see fashion and style in a different light: that you make it yours, let yourself get inspired and experience a deeper enjoyment of your own sartorial expression.

Scott Schuman

Ignorance is bliss

Lino is a charming raconteur, spinning tales of world travel
and youthful misadventure. At least I think he is. He doesn't
speak English and I don't speak Italian. We communicate
on a very basic level, but I find this simple language barrier
quite useful when I'm shooting people. I mean, I want to
capture something about the people I shoot but at the same
time I am totally open to creating my own version of who I
think this person is. Let's be honest, the reality rarely lives
up to the romance, and I am OK with that – I think we all
could benefit from letting ourselves get lost in the romance
of an idea or perception instead of having to know every
excruciating detail of reality.

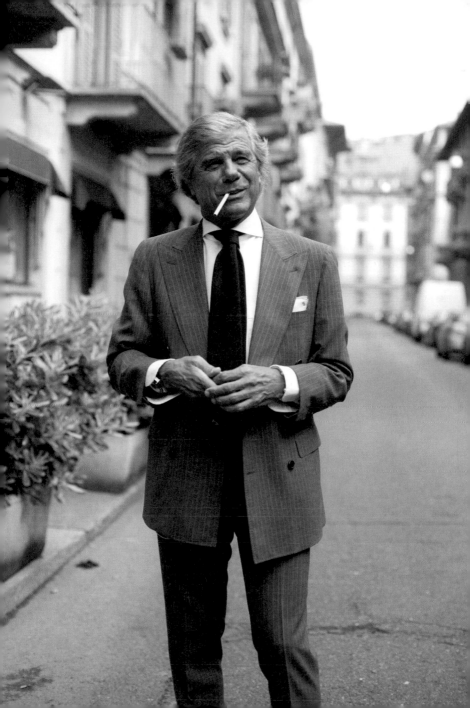

Bryant Park,
New York

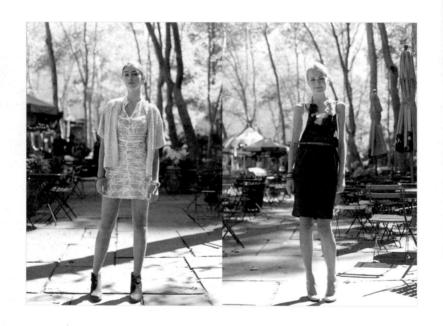

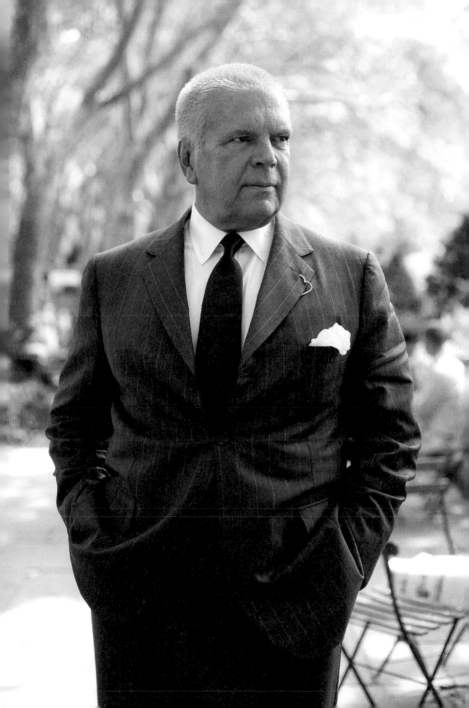

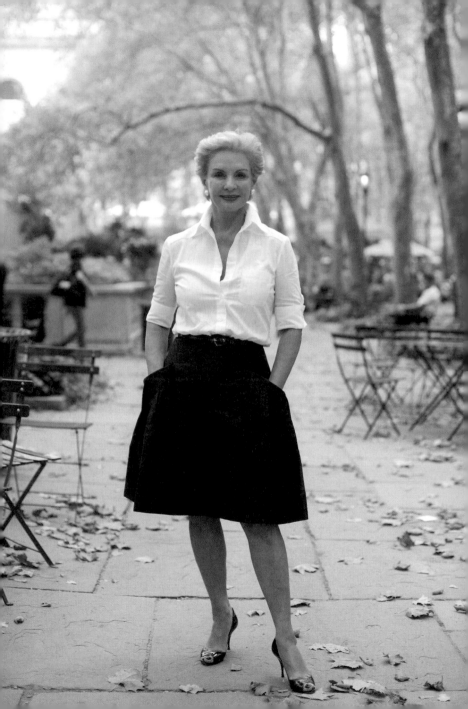

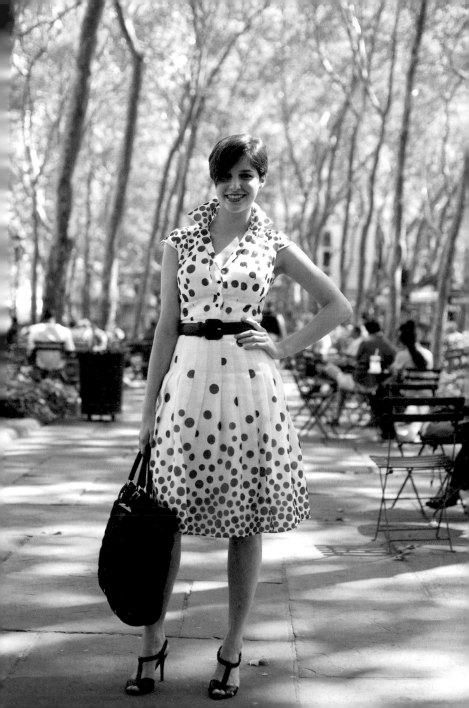

Unexpected style, New York

When I saw this girl, I wanted to shoot her because I liked the unexpectedness of her style: those rolled-up jeans with a dress, her stillness, and those shoes – how many fashion girls would pick those shoes? But when I posted the picture on the blog, most of the conversation about the shot focused on her weight. It was fascinating to read how different the reactions were between the American/European comments and the Asian comments. For me, the image will always be about her stillness, not her weight.

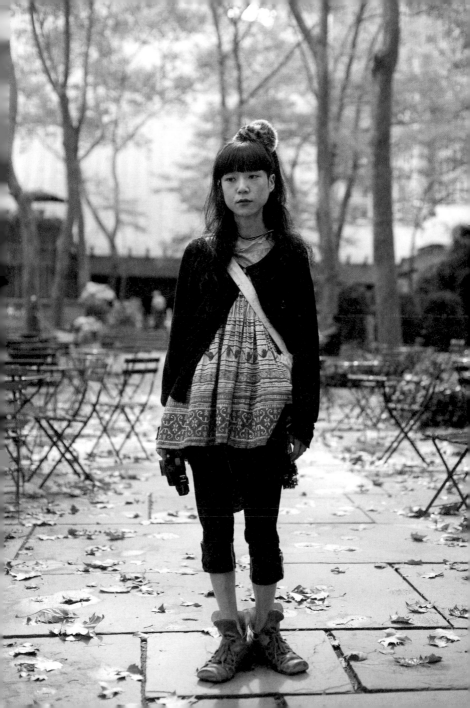

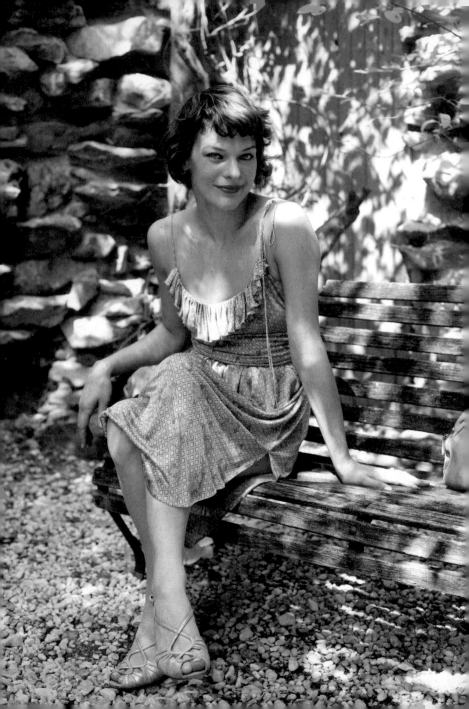

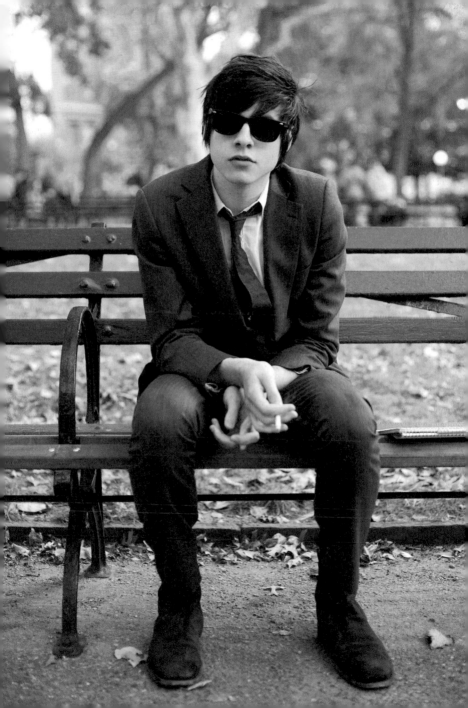

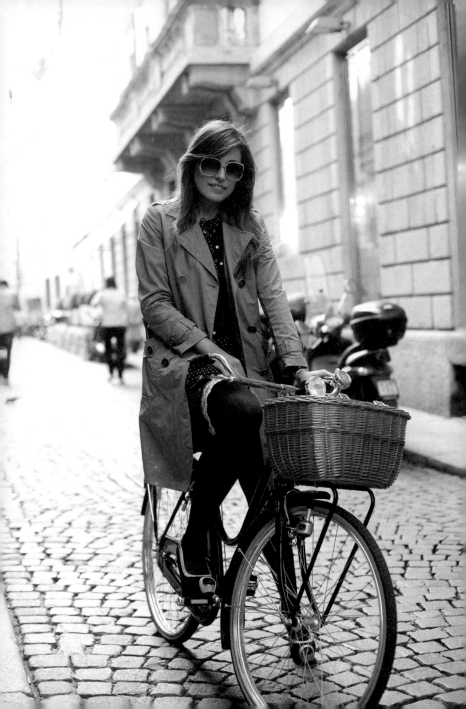

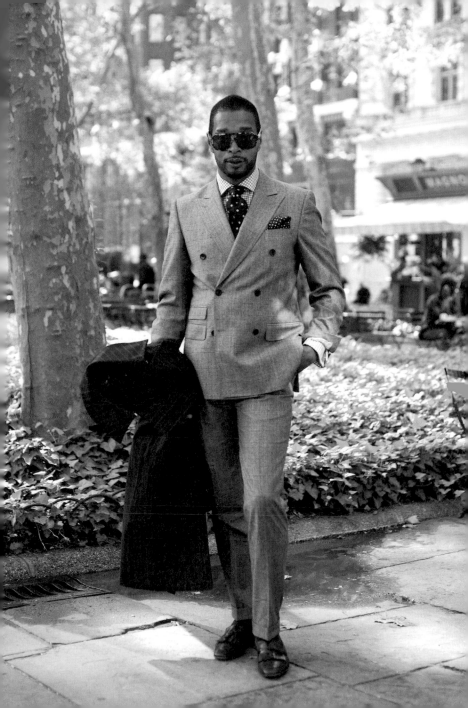

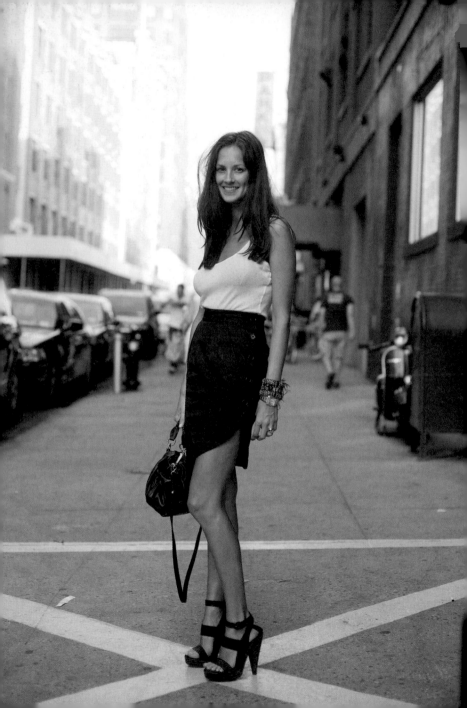

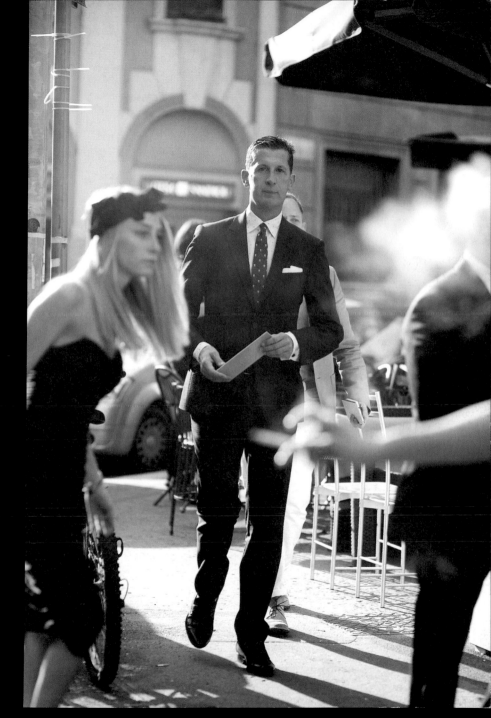

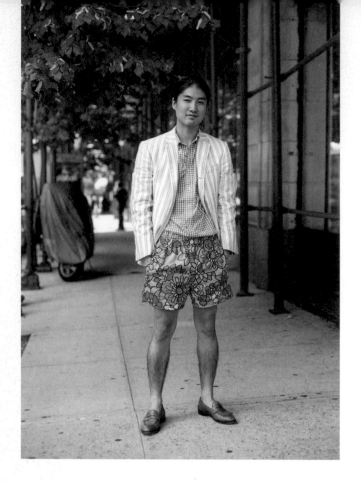

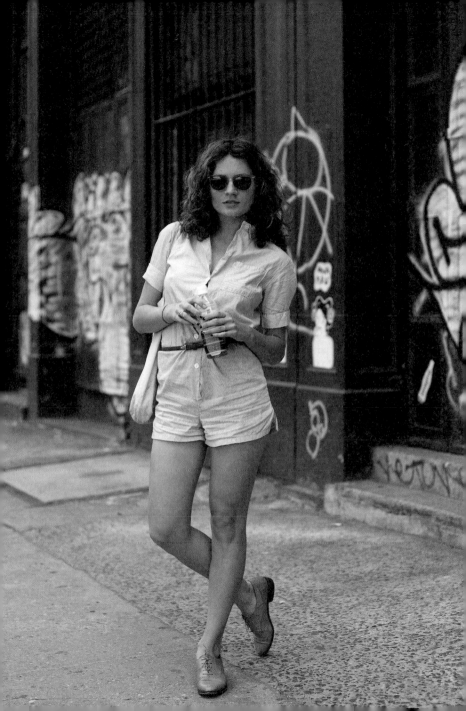

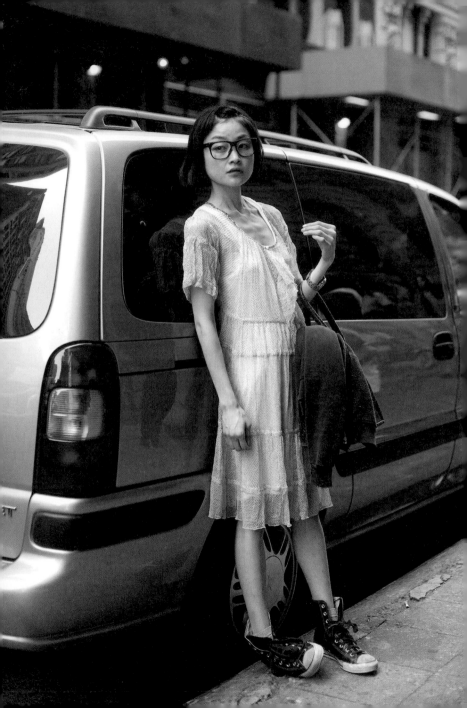

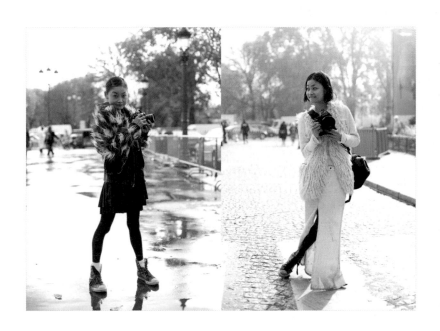

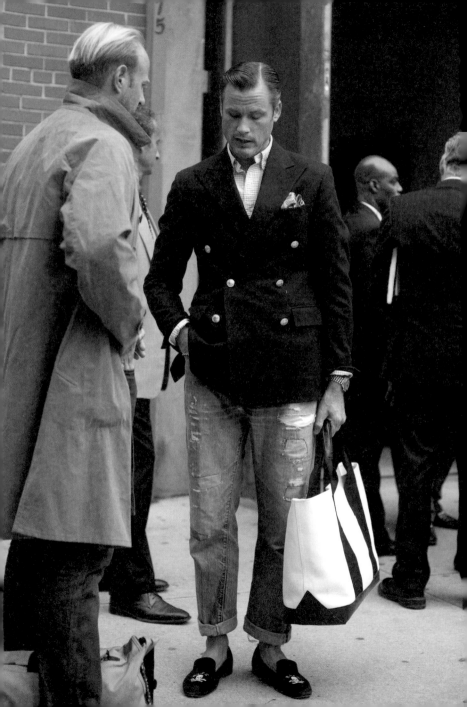

Visually greedy

I think most of us are like stylish hermit crabs: we change our outershell to camouflage our way into certain social positions. We 'dress the part'. When you accept this idea, fashion/people watching becomes less judge-mental and more about being 'visually greedy'. It becomes less about what that person is wearing and more about what the elements of the look can mean to your own personal style. 'Visual greed' is one of the reasons I don't usually put the name of the person or labels that they are wearing on my blog – they simply don't matter to me. For instance, this gentleman was shot outside a recent Ralph Lauren fashion show. I know he works for Ralph and I know that Ralph 'encourages' employees to dress in a certain 'Ralph Lauren-ish' manner. So is his look *real* personal style? I don't know and I won't judge him on that, but I will allow myself to be inspired by the concept of a Navy blazer with totally distressed jeans or crisp side-parted hair that always seems to look modern. In a way, being 'visually greedy' allows you to separate the personality from the 'look' and puts the pressure on you to figure out how to harness that stimulus instead of just grading others as 'pass' or 'fail'.

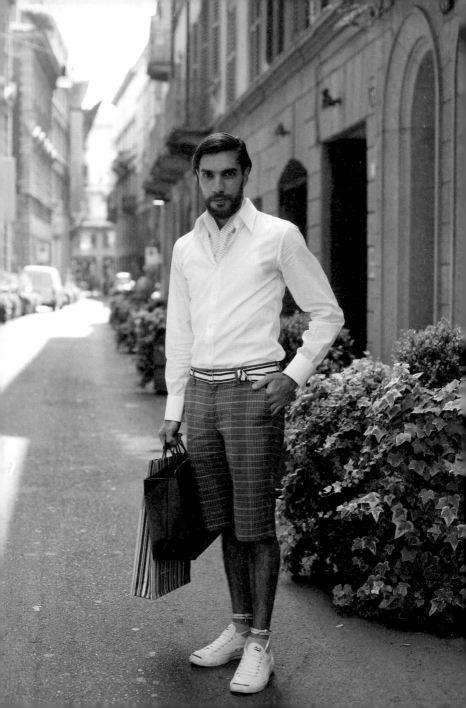

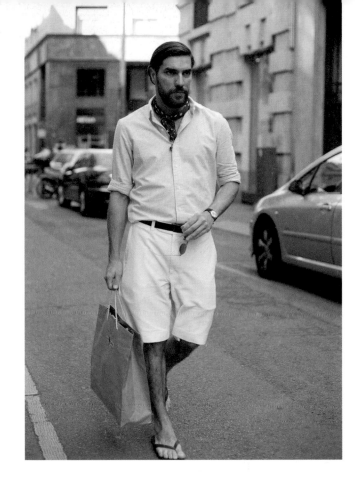

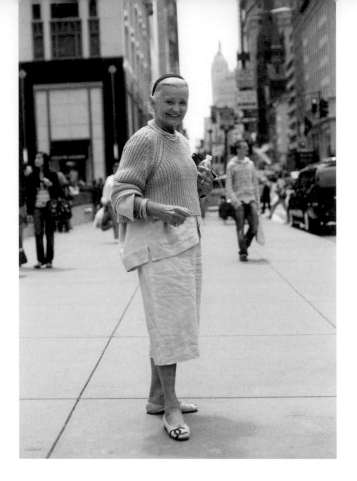

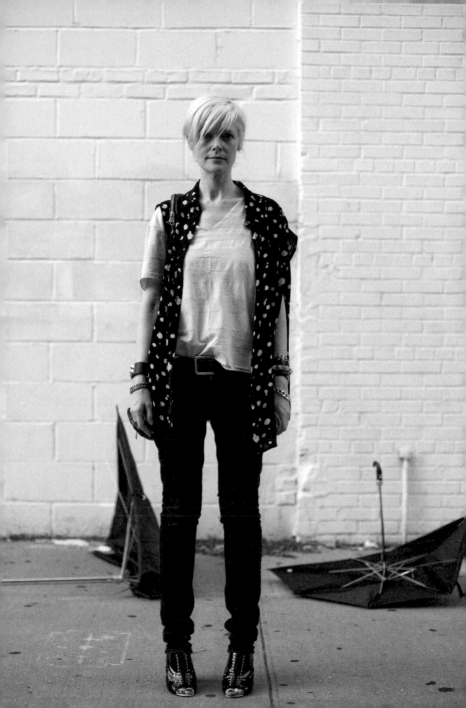

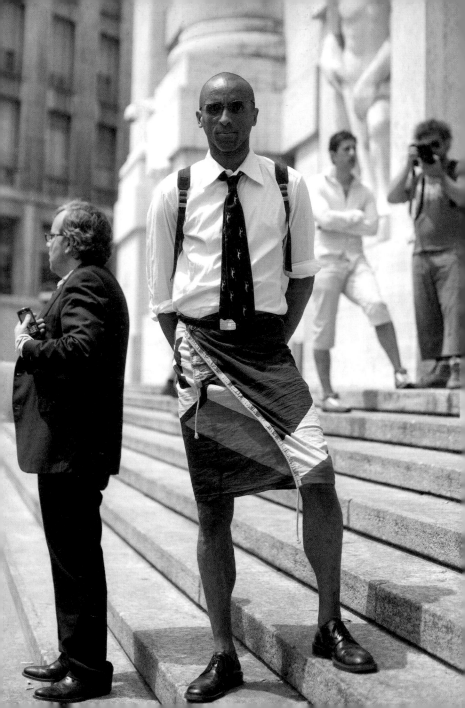

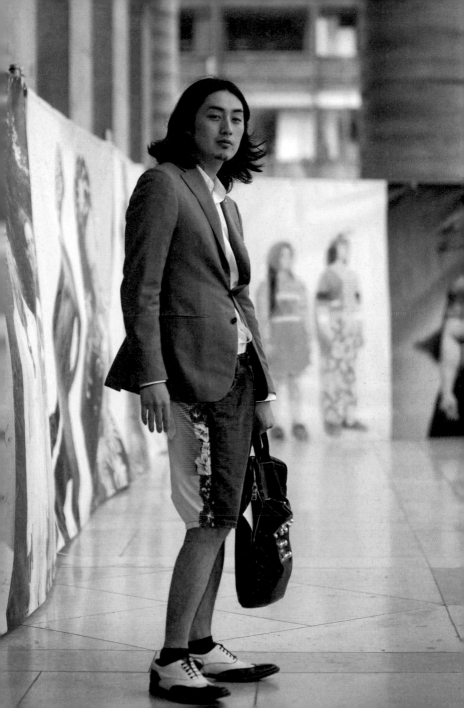

The Seed of Style, Paris

For me, this photo is all about a person whose mind and style has matured more quickly than his physical body has grown. I think he said he was thirteen years old, but he has the style of a nineteen-year-old and the face of an eight-year-old. My only regret is that, just off to the right-hand side of the shot, his mom is holding the ice cream cone she'd just bought for him. Unfortunately, when I posted this shot on the blog the majority of comments were about the $1,200 sneakers he was wearing.

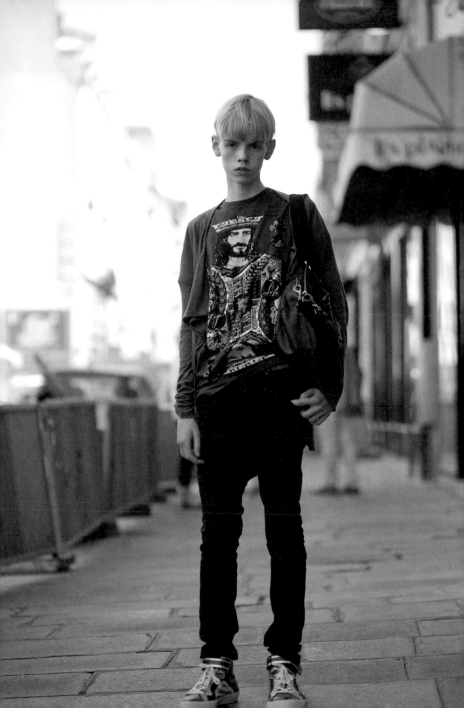

Carine Roitfeld

Carine is the Editor-in-Chief of French *Vogue*, and one of the most influential people in the fashion world. She does a great job of reflecting her personality on the pages of her magazine. I really respect how, in a business that can make women feel insecure, she surrounds herself with a team of women of equal beauty and style.

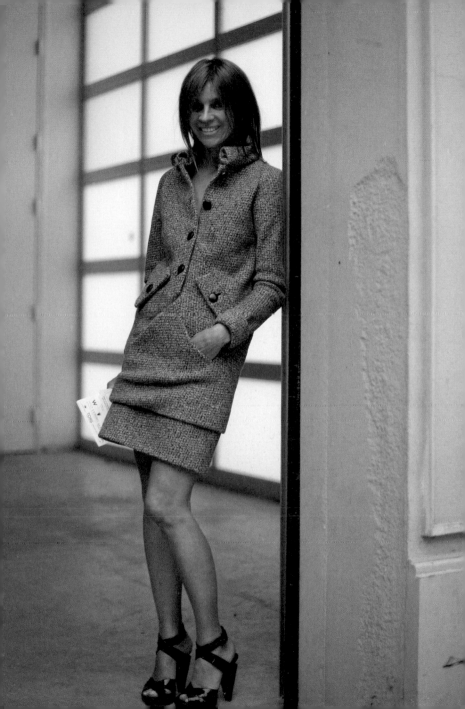

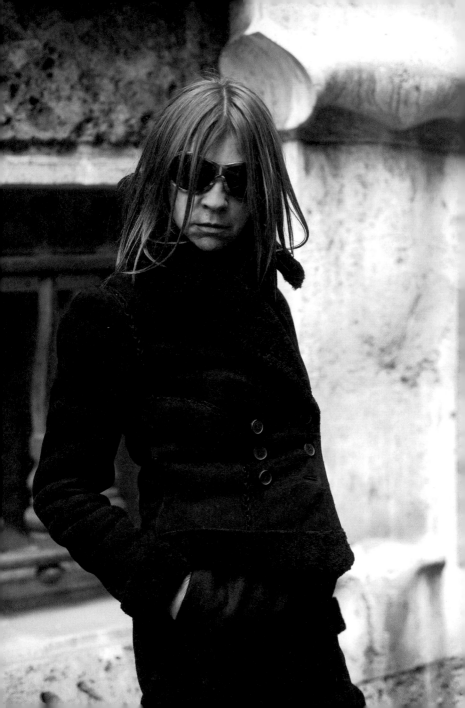

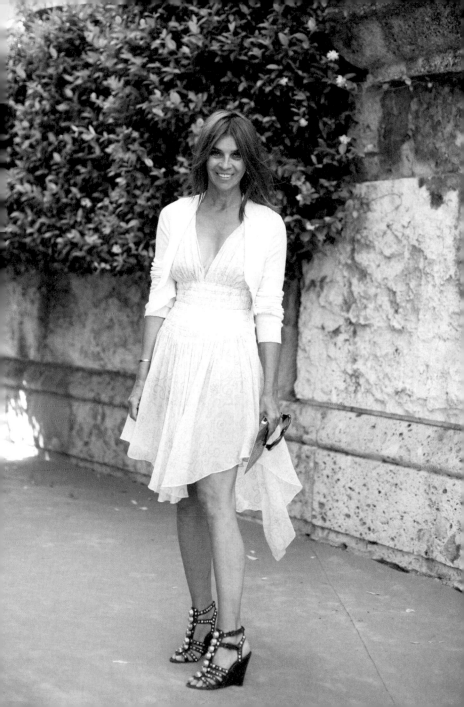

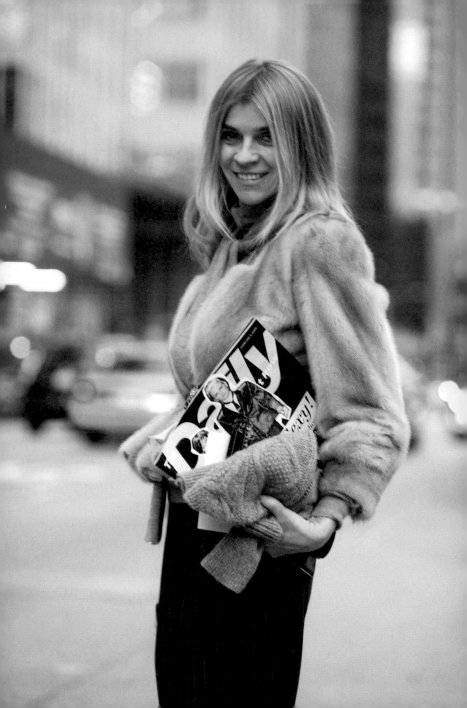

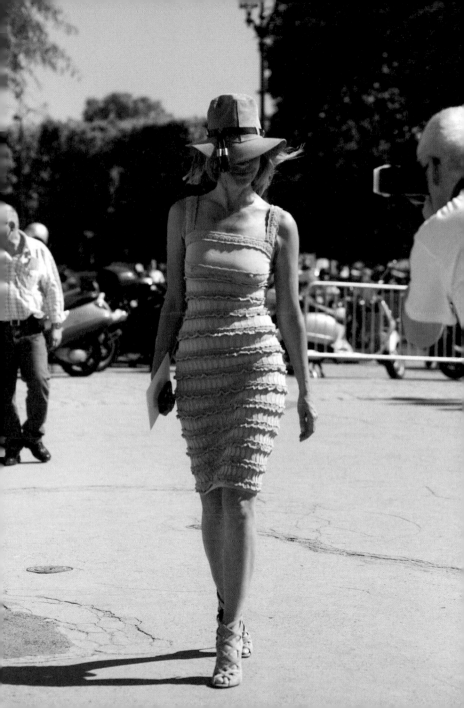

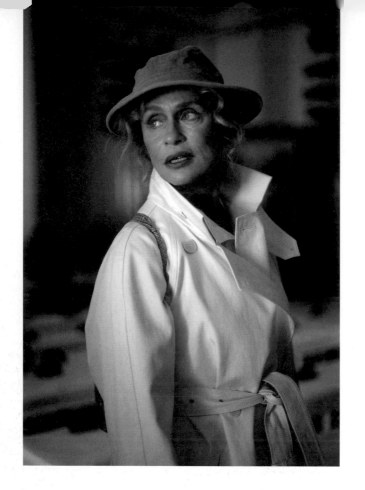

Lauren Hutton at Calvin
Klein, New York

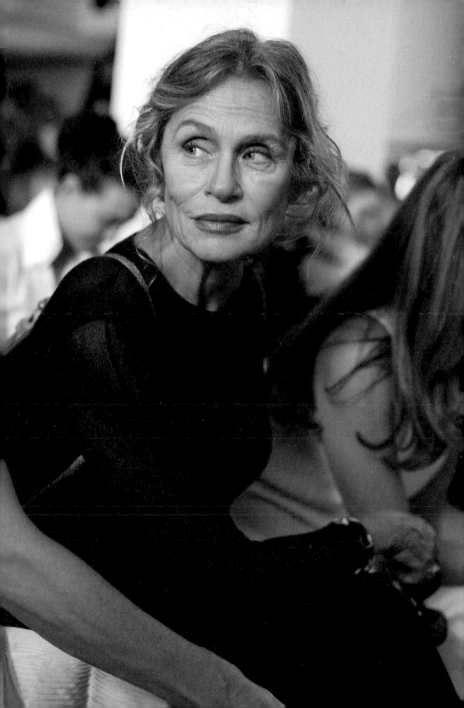

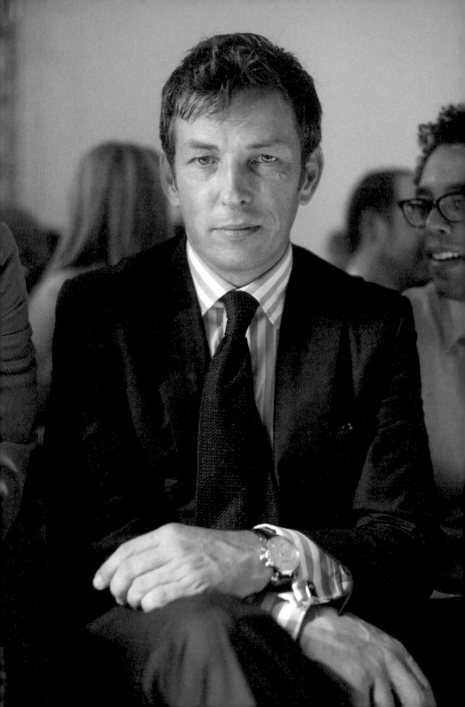

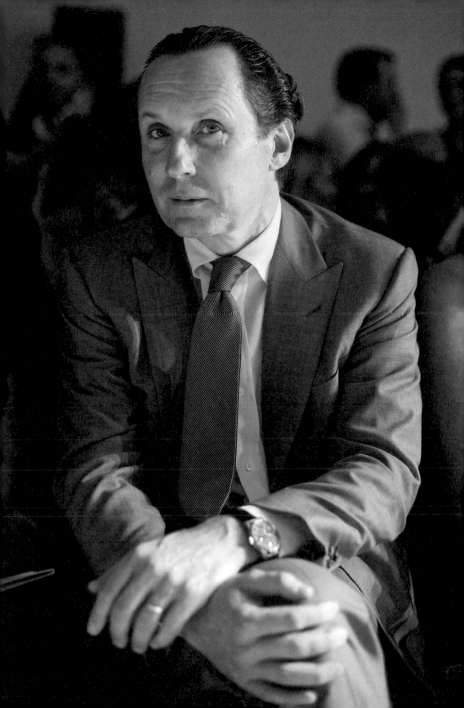

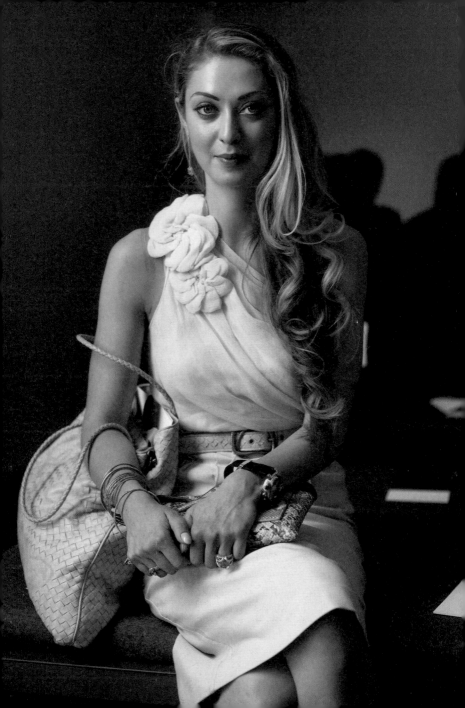

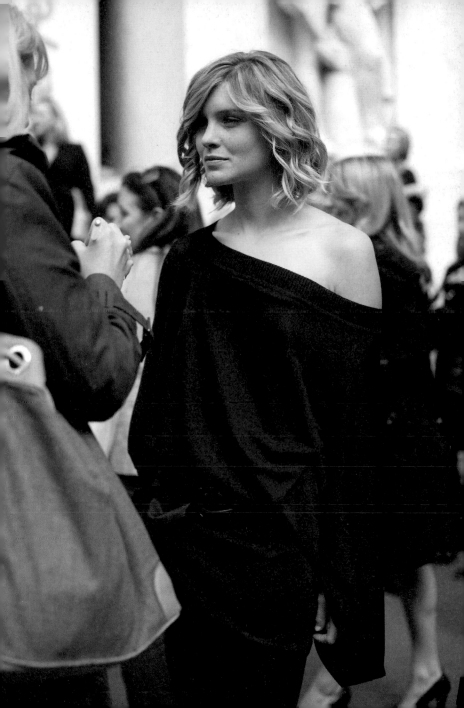

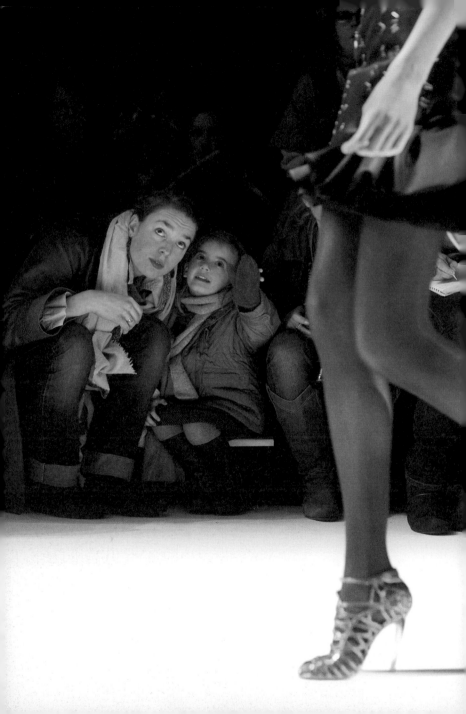

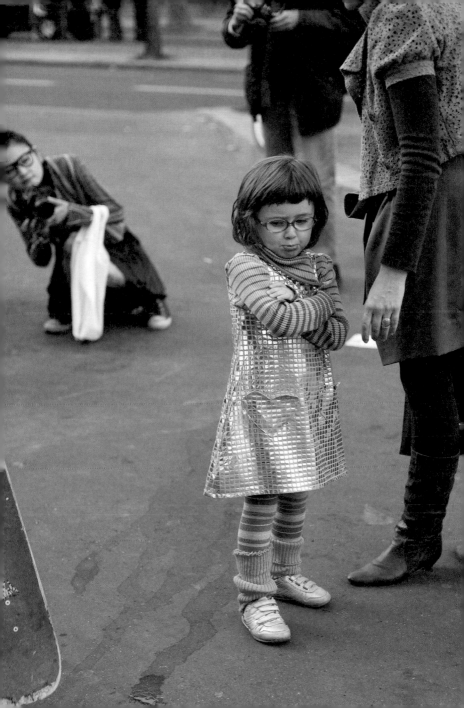

Just after the show,
Paris

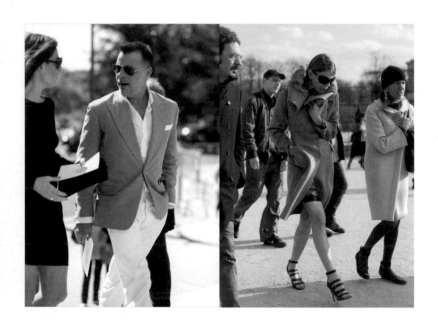

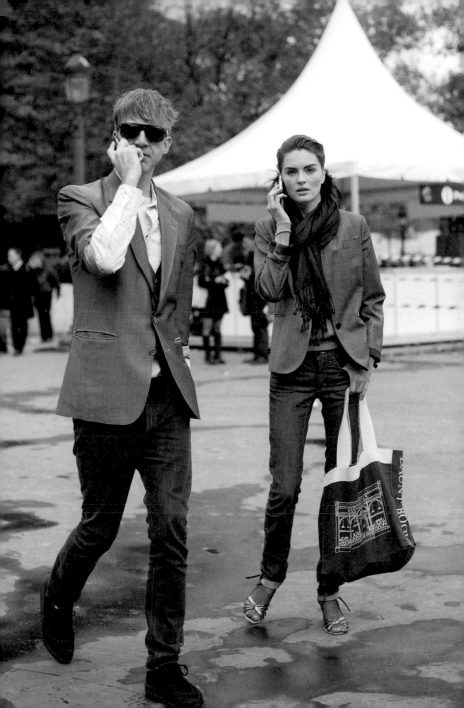

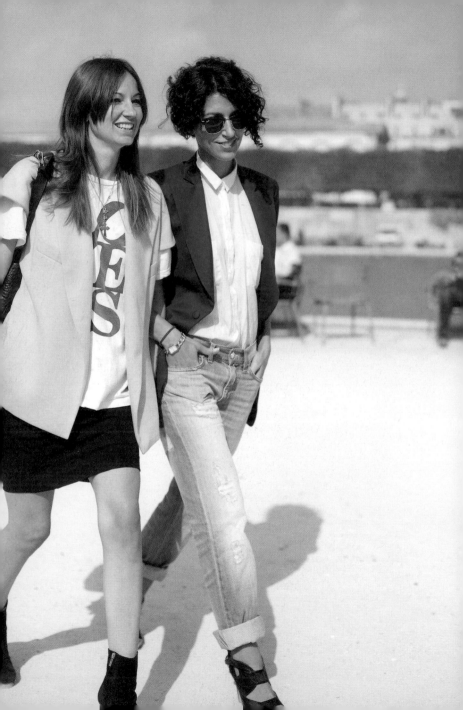

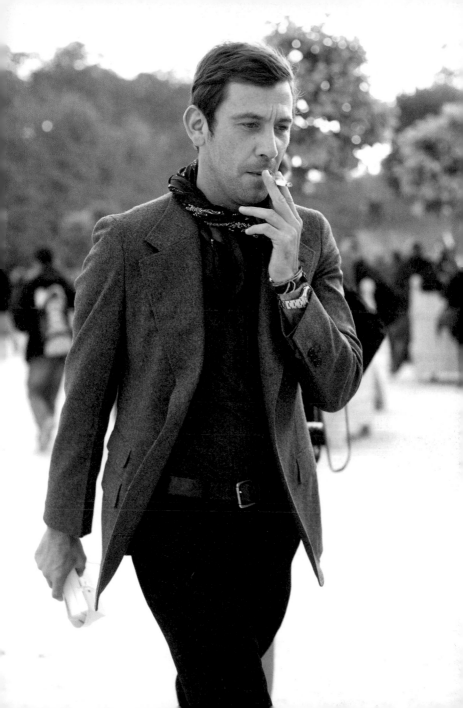

Beppe Modenese,
Milano

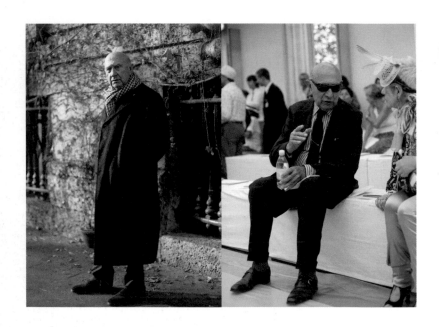

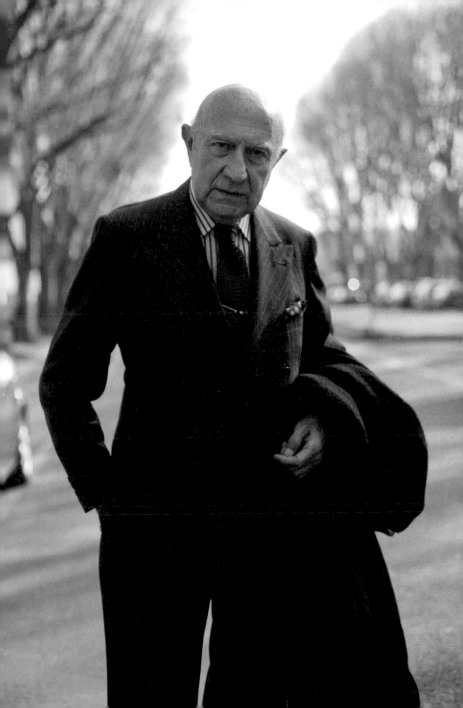

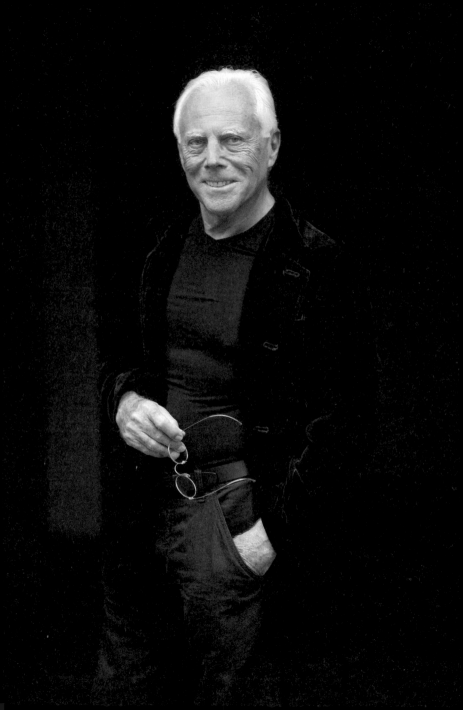

Giorgio Armani, Milan

My biggest fashion influence growing up in the 1980s was Giorgio Armani. I have always been fascinated not only by his designs but equally by his ability to project and protect his personal image and style.

The first time I went backstage at his fashion show in Milan, I saw this ability in action. Mr Armani (as he is called) was surrounded by photographers waiting to take a few candid snaps after the show. Mr Armani, however, would not look up at the cameras until he had adjusted his tee shirt, his pants and his hair and made sure he was backed by his preferred black background (better for his beautiful white hair). No one was taking his photo until he was ready for them to take his photo.

About a year later I saw Giorgio walking down the street in Milan (actually, I saw his giant bodyguard first) and tried to persuade him (and the bodyguard) to let me take his photo. I told him I could do it very quickly and threw out references to Style.com and *GQ* but still he was not convinced ... until I said/motioned that we should do it 'over there' in front of a dark alcove so that his hair would really standout against the dark background. That got him.

George

Everyone I know agrees that George has great style. Masculine, refined, classically advanced. Yet the actual items are surprisingly simple and consistent. Using a deceptively uncomplicated colour palette, George sets himself apart from the trad/khaki/prep set by playing with the proportions of classic items and focusing on the 'how' of wearing clothes – extra high roll on a shirt sleeve, a deep cuff on khakis, or never wearing socks, but always, always with the sunglasses.

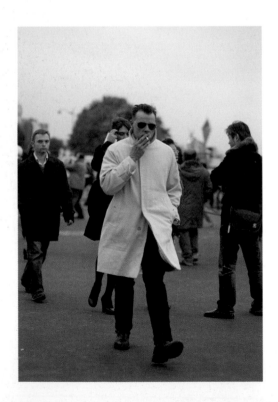

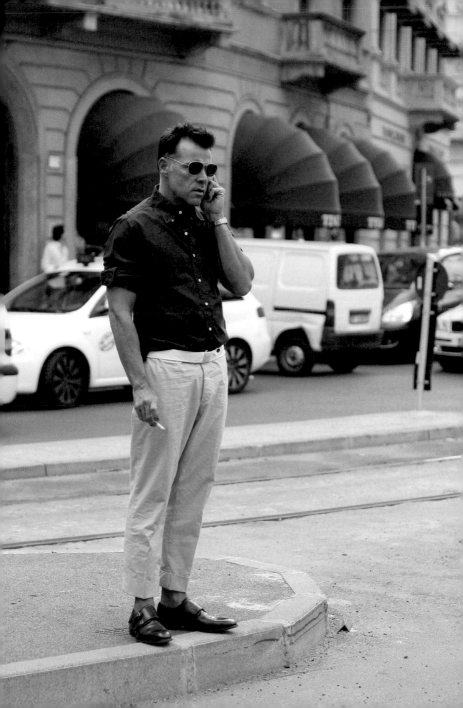

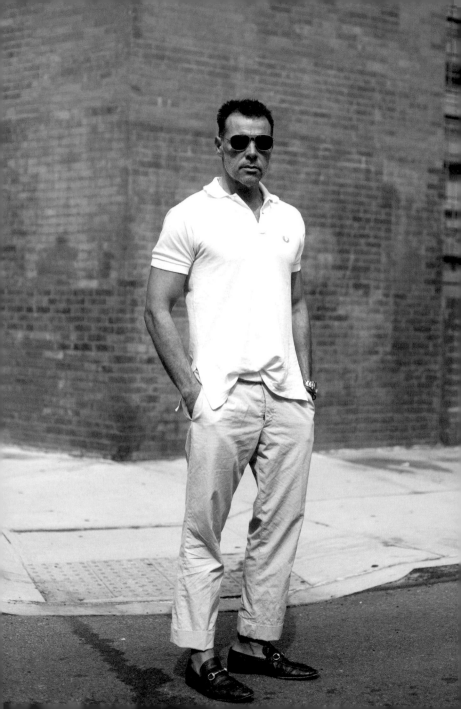

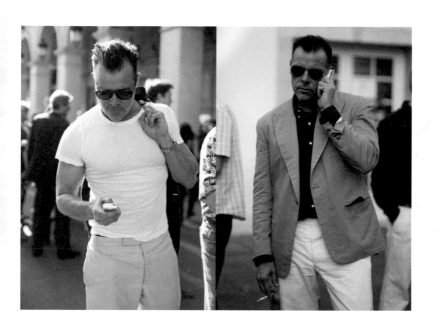

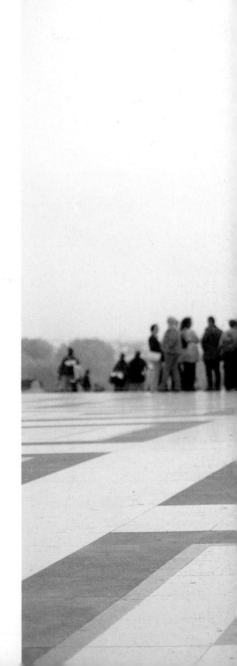

Girls on a
school trip,
Paris

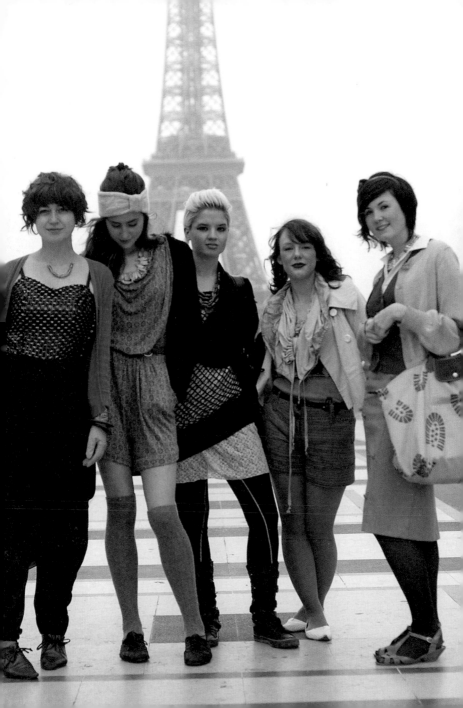

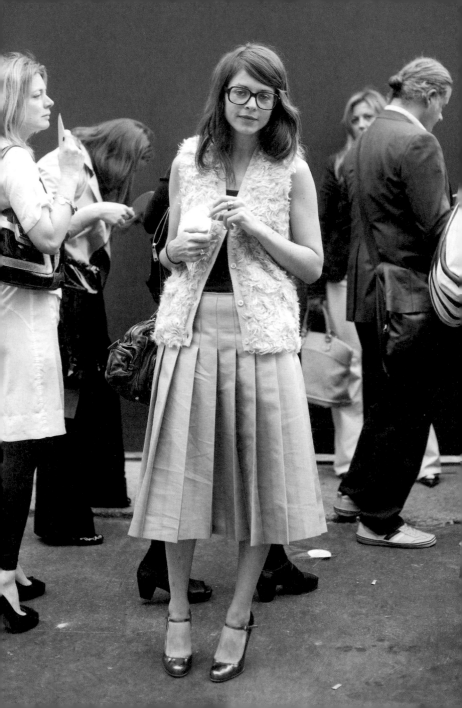

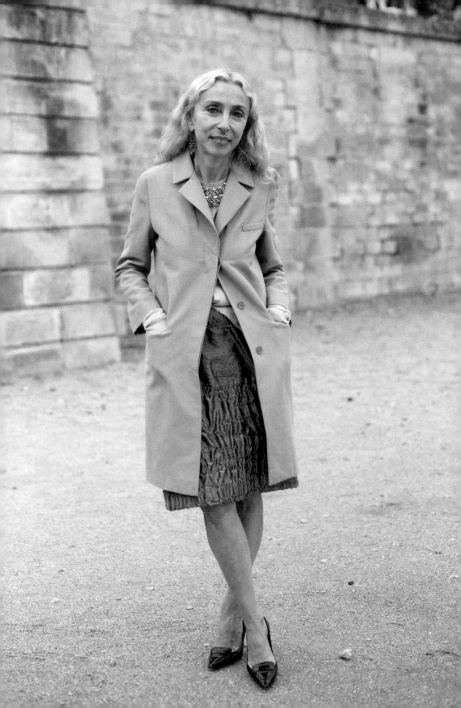

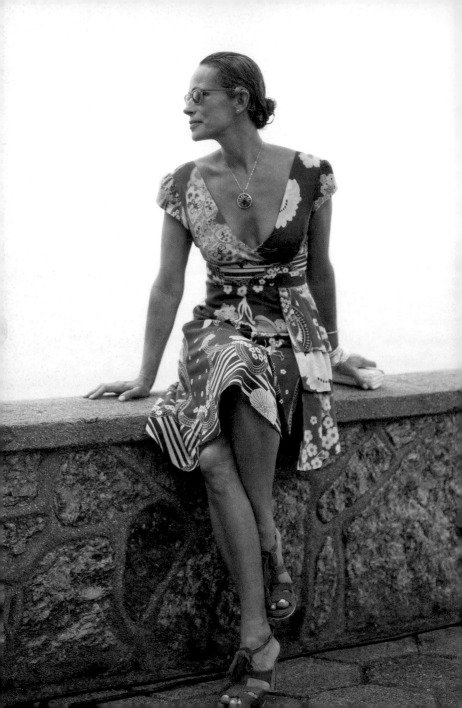

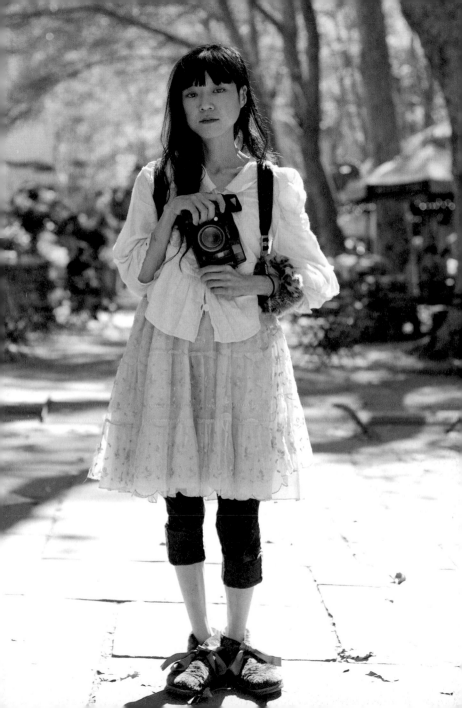

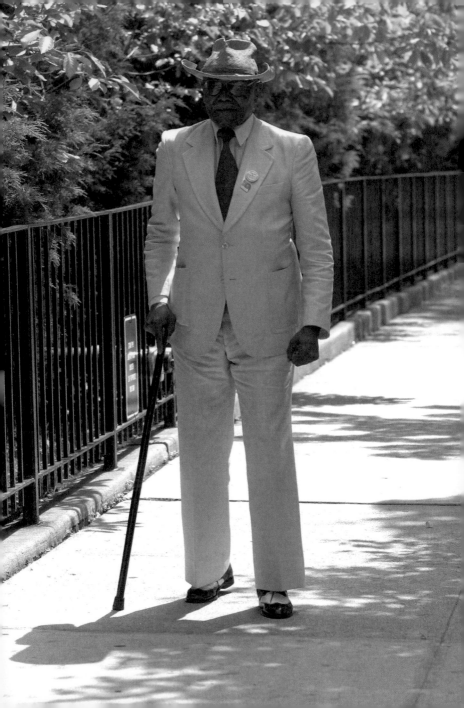

Sunday Morning, Harlem

While I was preparing to take this gentleman's picture I asked him about his fine summer suit, expecting to hear he'd had it for ever. Instead, he told me that ten years ago he was a drug dealer. When one of his customers couldn't pay for her drugs, she threw this suit at him in payment.

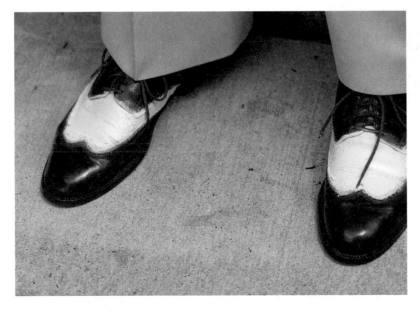

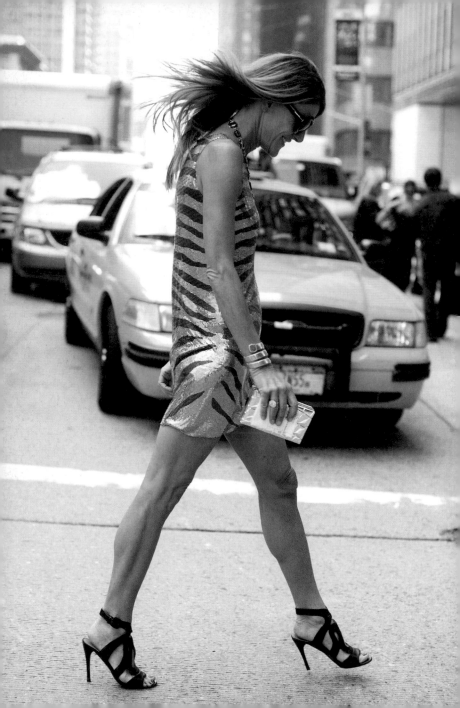

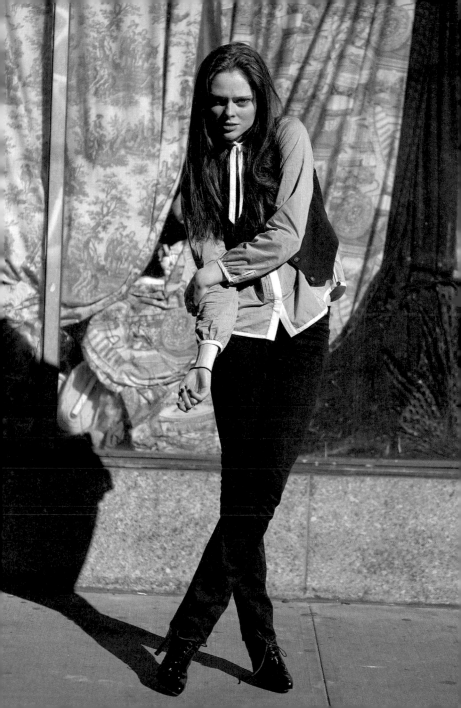

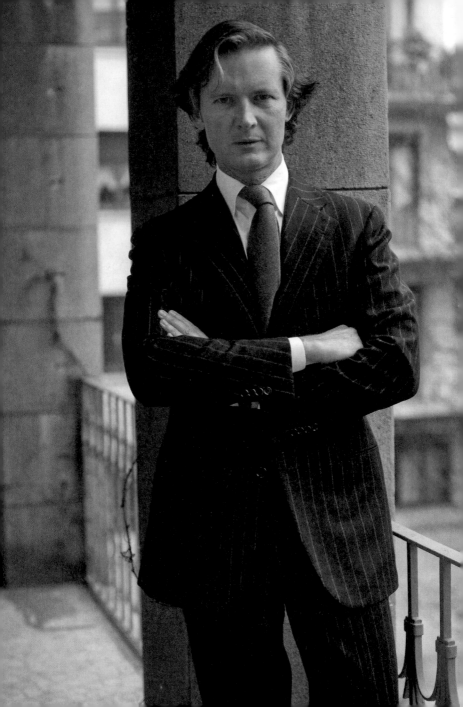

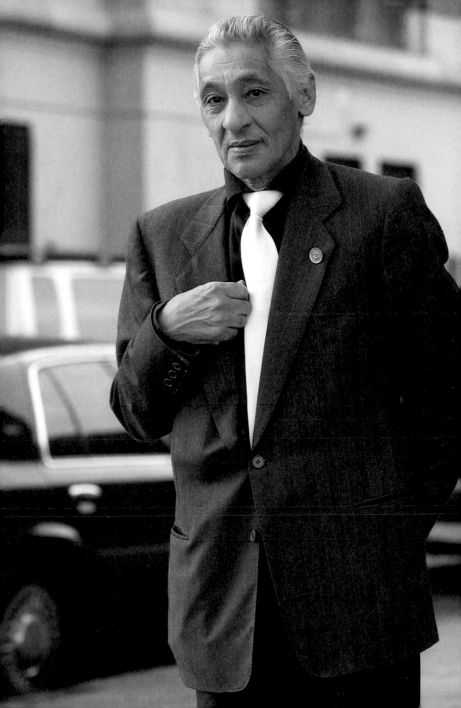

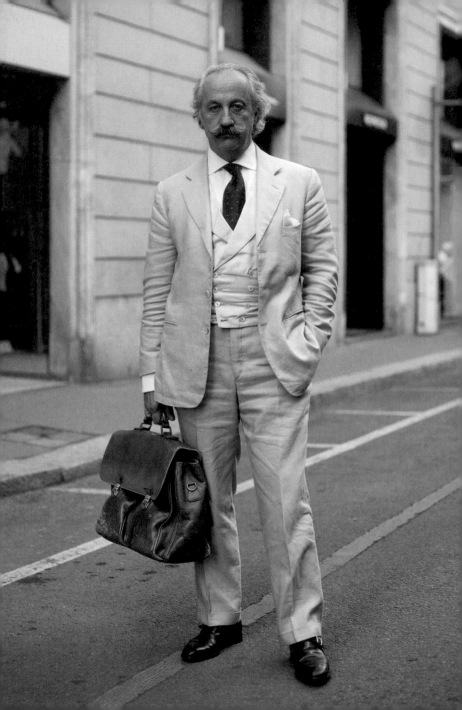

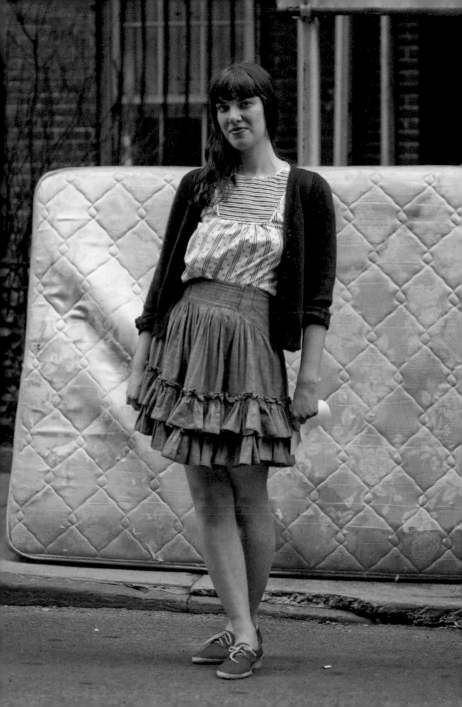

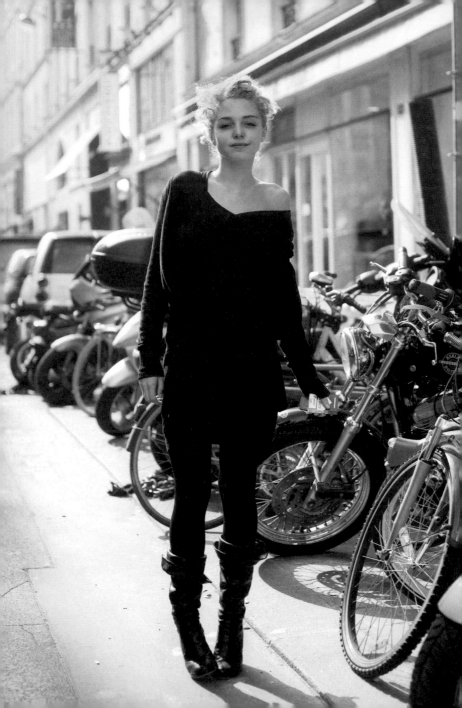

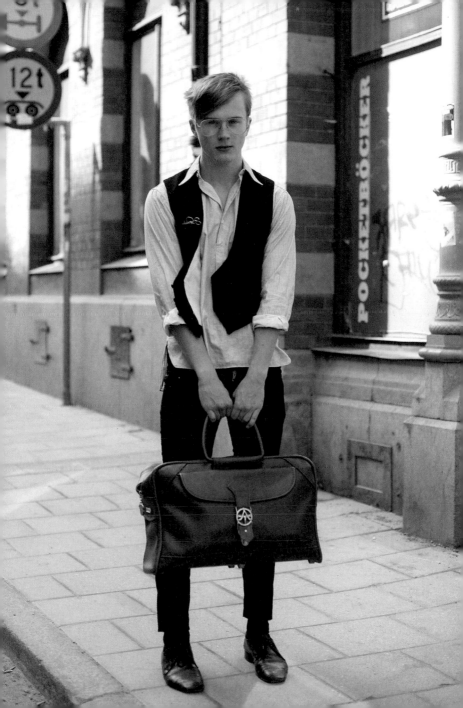

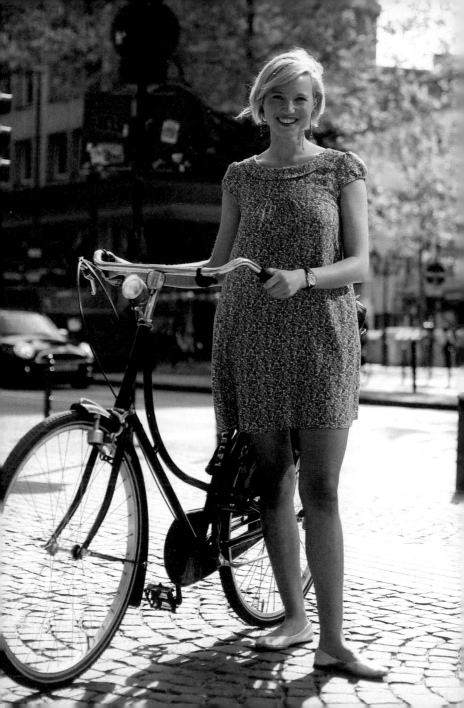

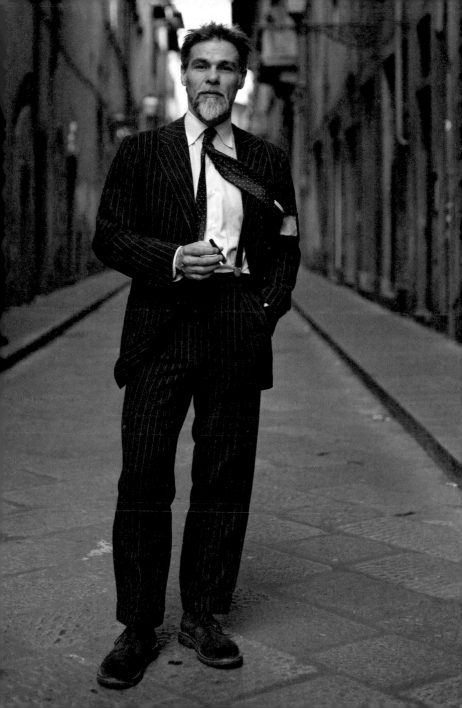

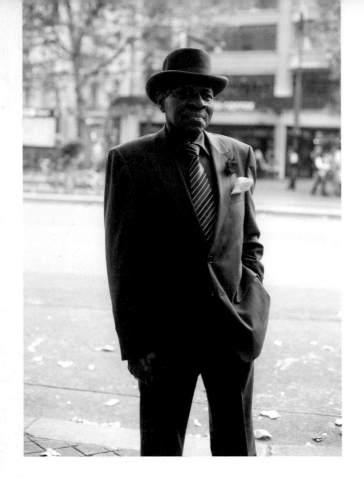

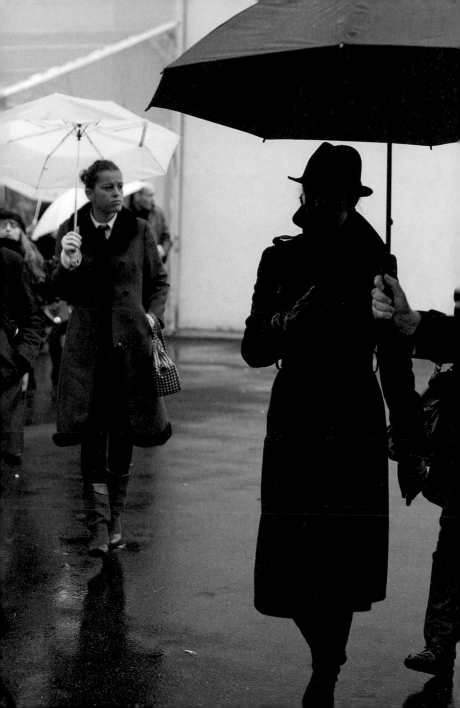

Evolution or Revolution?

I shot this young man on one of my first trips to Milan. He speaks very little English, so our communication is usually very brief and takes place only once or twice every six months, during the men's fashions. I remember really loving his kinda cowboy/hippie-via-Kyoto vibe, but after I took this shot I lost track of him and hadn't seen him around the shows for a while. At least I didn't think I had seen him. Apparently at some point between seasons he changed his look to such a sharply tailored Master of the Universe vibe that I completely failed to realize it was the same person. I would see this guy at the shows and we would share one of those professional courtesy head nods, but I still didn't get the transformation until I was reviewing some old images while one of his recent photos was on my computer screen. It is a weird feeling when you put 2 and 2 together and get 4 ½.

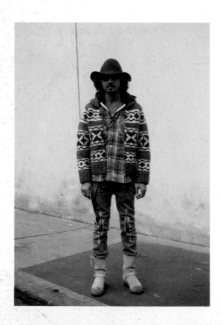

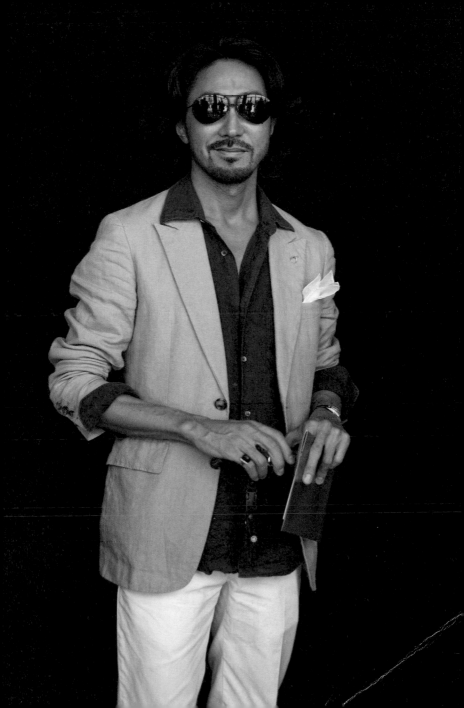

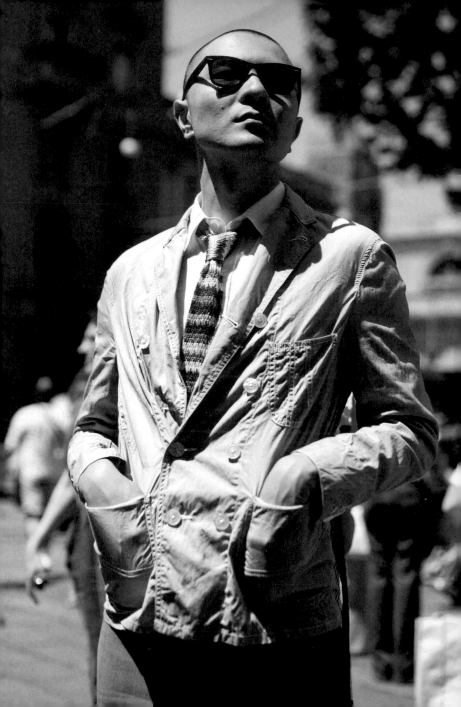

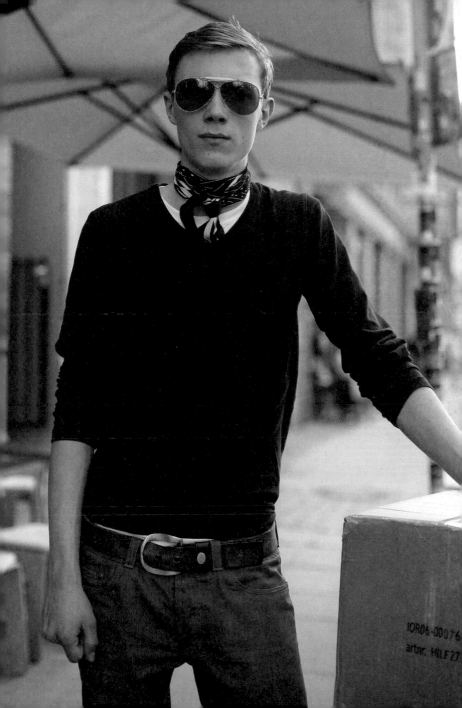

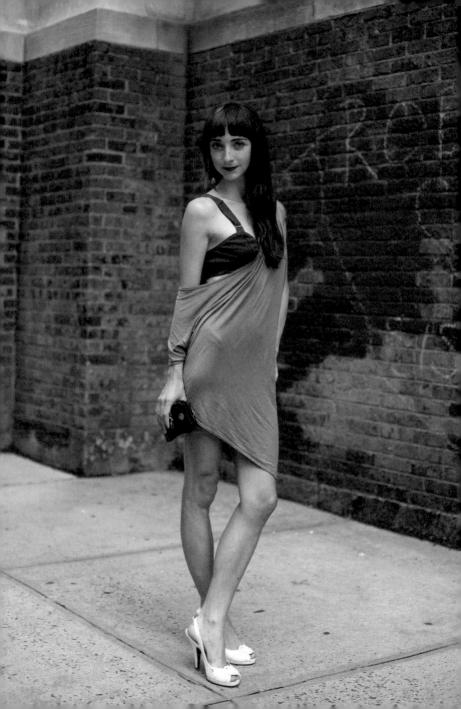

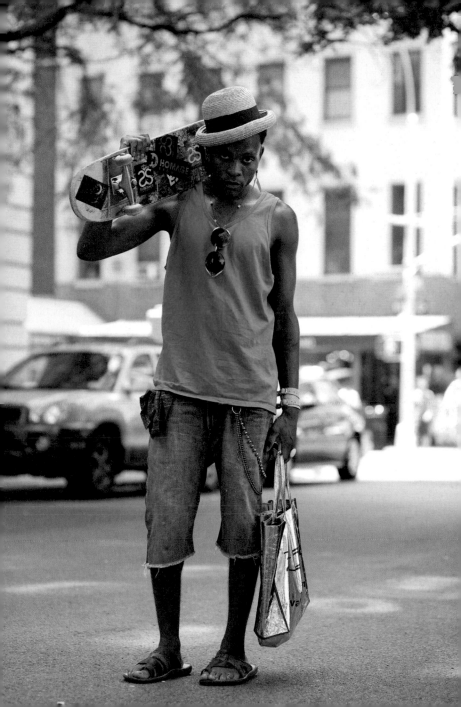

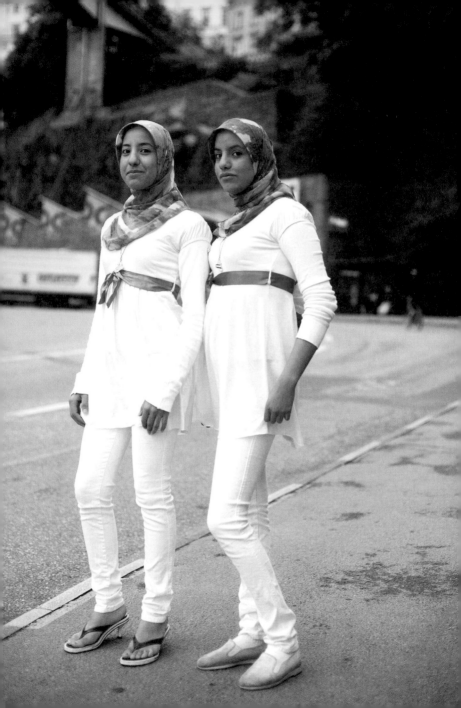

Typical Teens, Stockholm

I saw these two exiting a subway station in Stockholm's Södermalm neighbourhood. I really was unsure whether I should take their photo, but finally I decided it was just too perfect to pass up. They looked so exotic to me and yet somehow familiar. They spoke mainly Swedish with just a touch of English, however their predominant language was the language spoken only by a tiny, very special group – TEENAGER! It quickly became clear to me that what was exotic about them was not their traditional dress with just a subtle nod to modern girly fashion but actually the for ever unknowable world of teenage silliness and giggles. Regardless of how they looked on the outside, they would fit in at any 10th-grade class anywhere in America or Europe, or even on the moon.

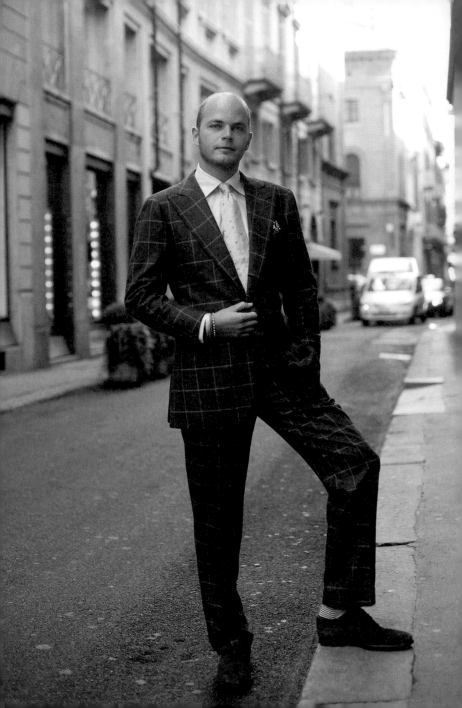

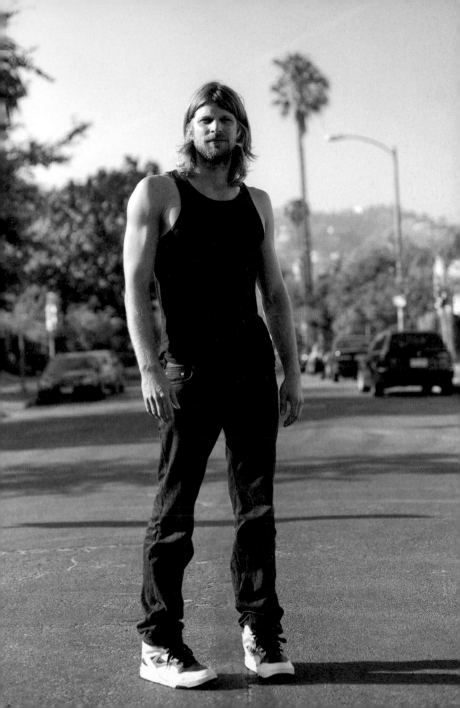

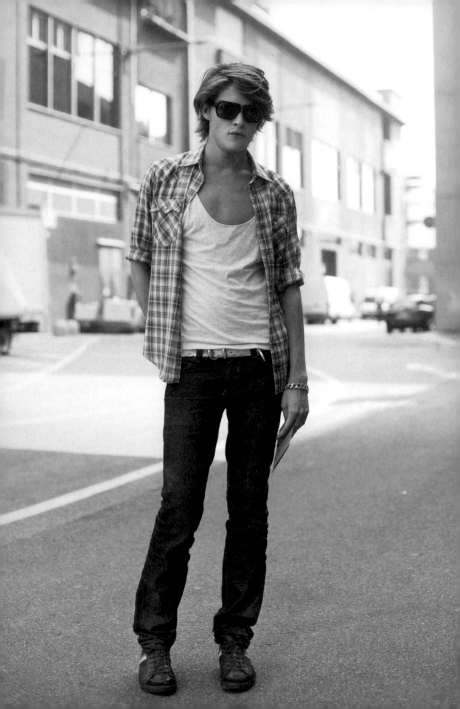

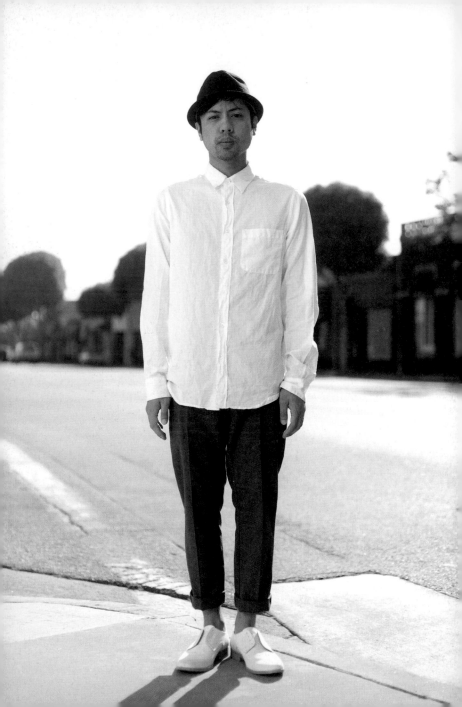

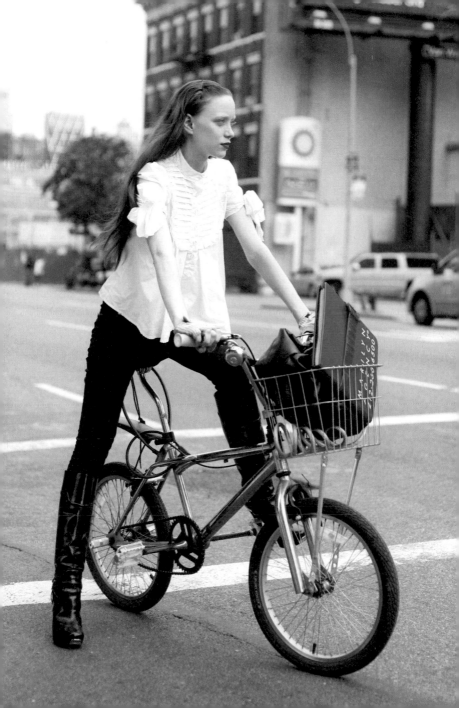

Williamsburg, Brooklyn

I ran two NYC marathons during the late 1990s. I remember that while I was running (slowly) I made a mental note that someday the crowds watching the marathon would make up a great visual tapestry of New York personalities for photography. A decade later, when I was first learning photography, I decided to follow the marathon route to try to capture some of the characters of the five boroughs. Somewhere close to Williamsburg, Brooklyn I spotted this Hasidic gentleman watching the passing runners. I didn't speak to him but indicated that I wanted to take his photo. Whatever religious differences separated us, these were easily bridged by the dude-ish head nod that is instantly understandable to any New Yorker regardless of cultural affiliation. To my utter surprise, when I raised the camera, instead of taking a pious stance of serious religious strength he pushed his hat forward on his head and took a Hollywood Rake-worthy lean against the phone box. His posture said more about his personality than any item of clothing ever could.

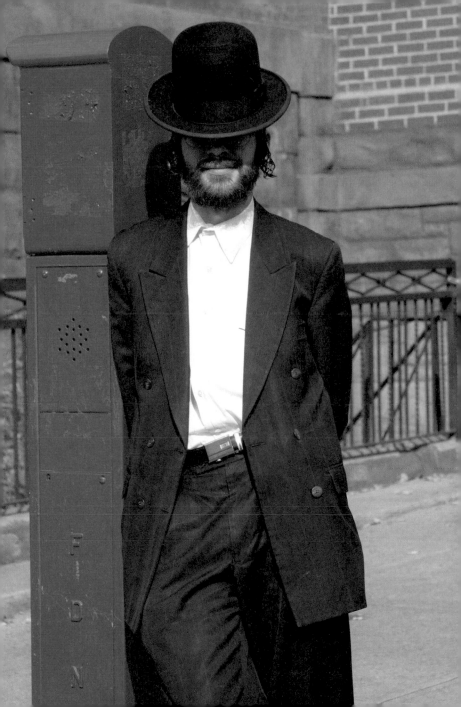

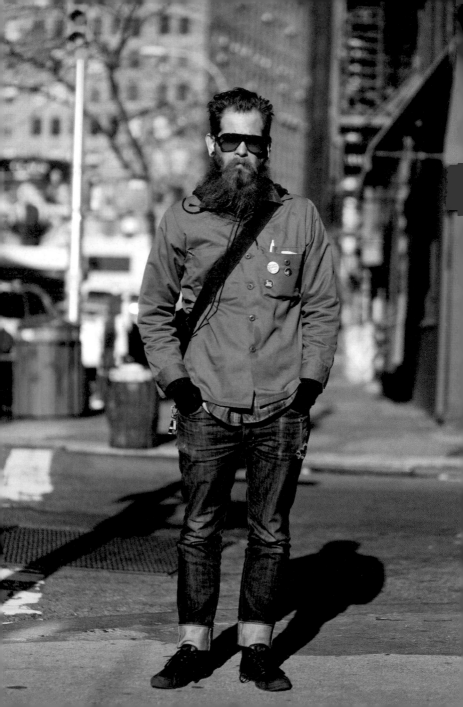

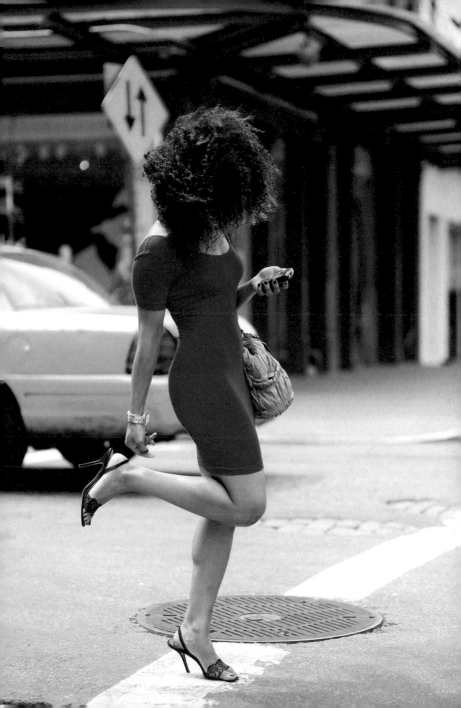

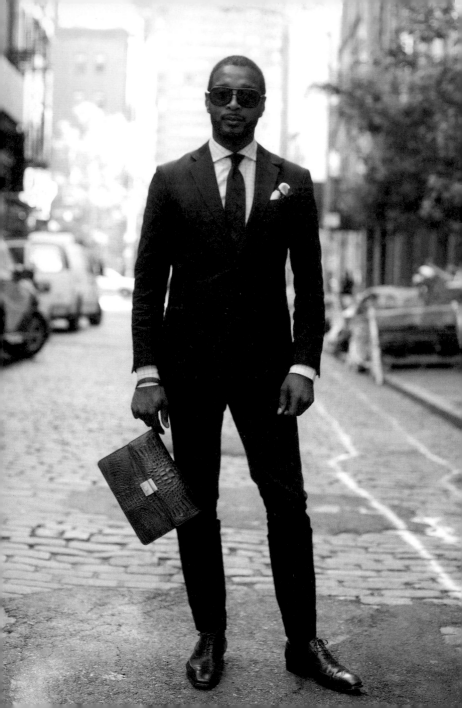

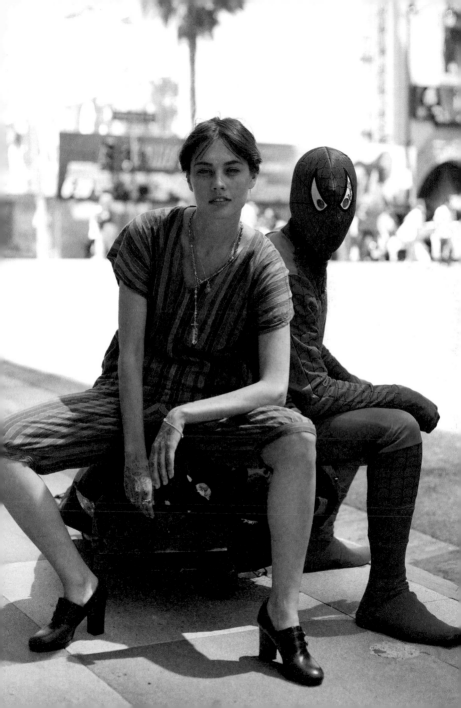

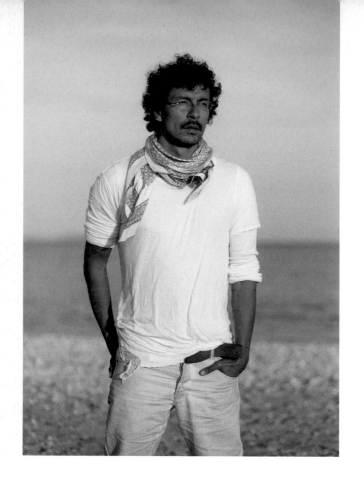

Hyères, France

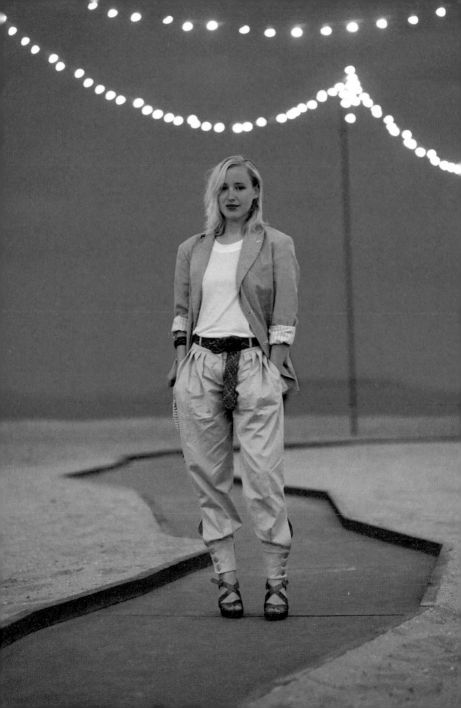

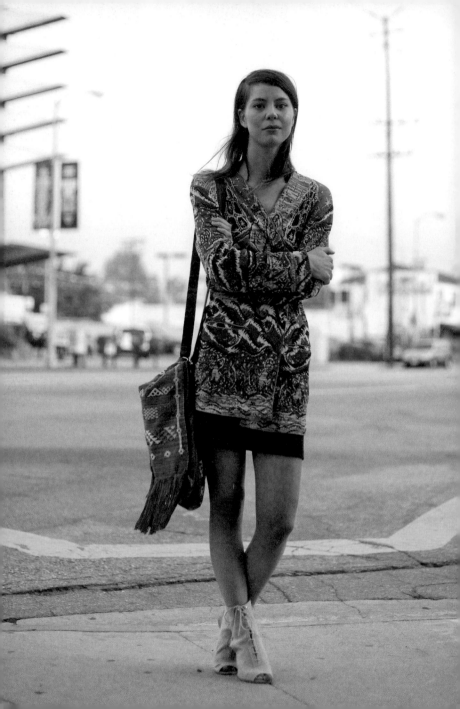

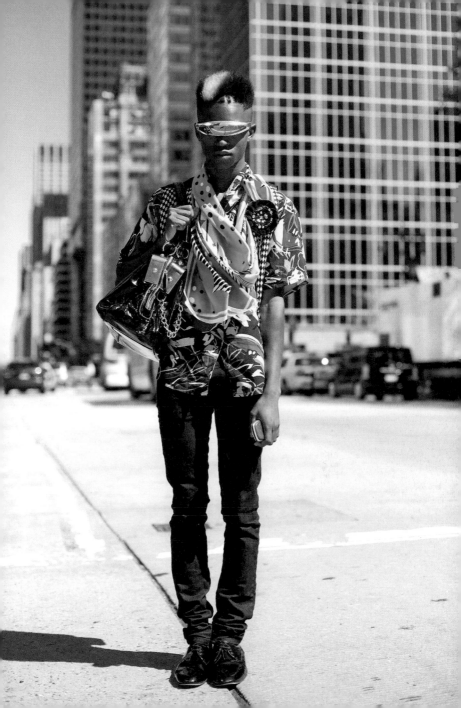

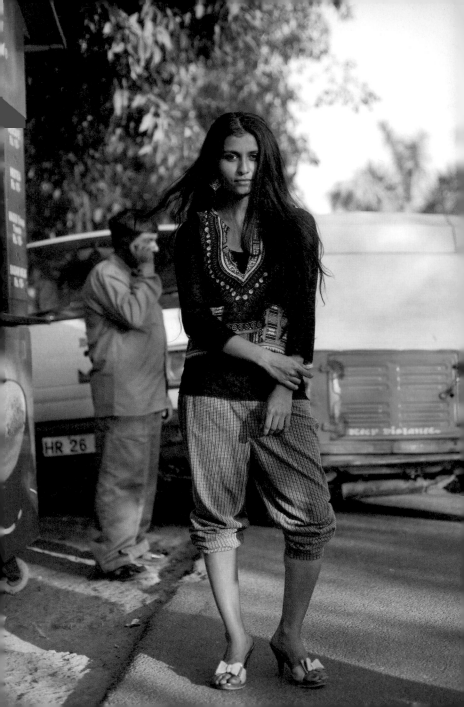

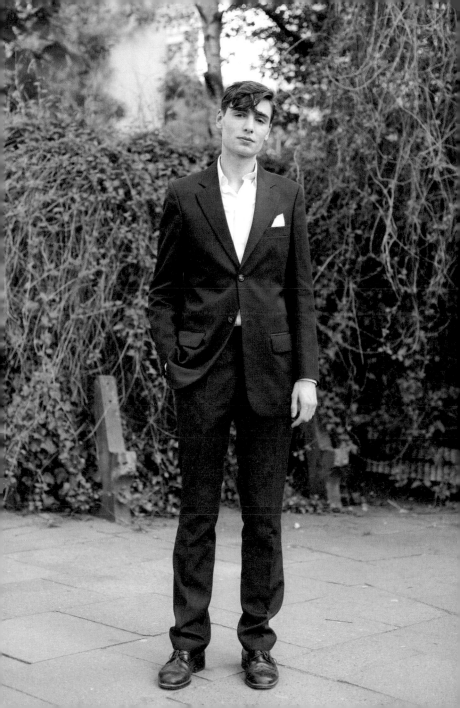

Near the Duomo, Milan

I shot this on my first trip to Milan for The Sartorialist. It was one of those moments when I used to think, 'If I only had a camera,' but this time I did! I only got one shot off, which is a little soft in focus but, to me, still perfectly captures that idea of *la dolce vita* – cycling while smoking at the end of a beautiful day, dressed in a perfectly cut suit. *Grazie Milano!*

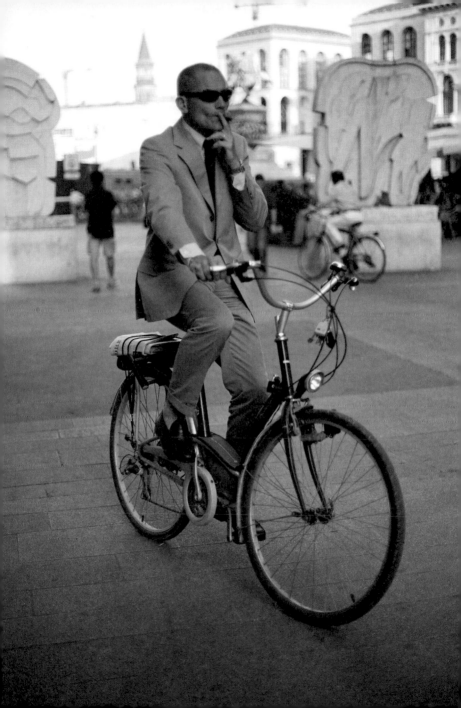

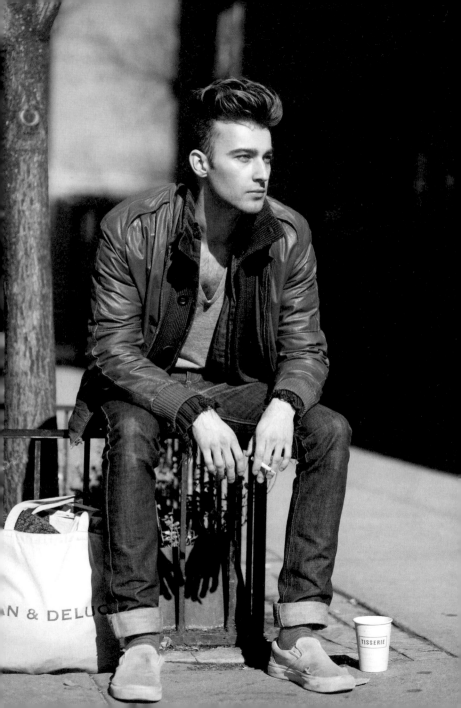

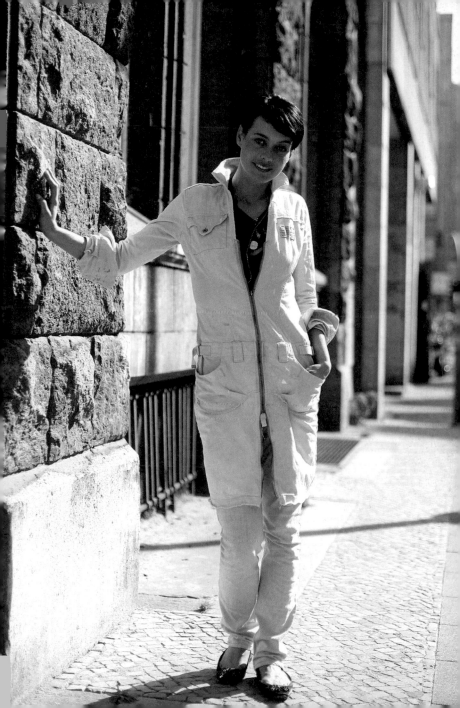

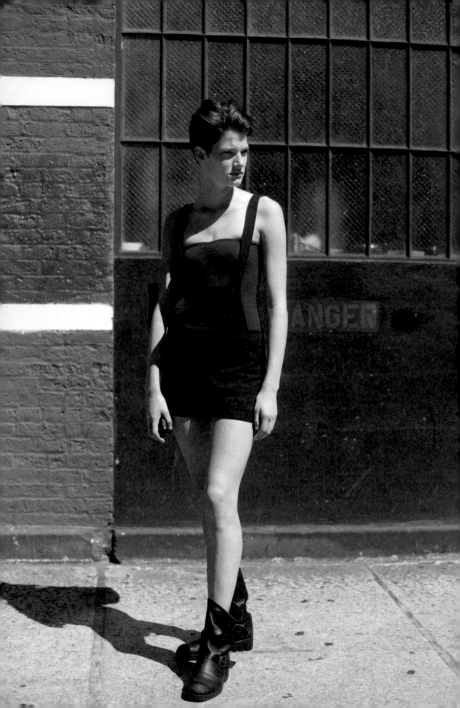

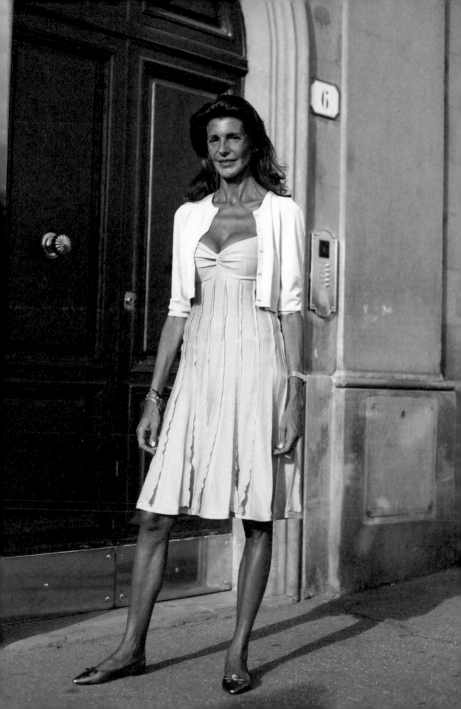

Of all the 'vintage style' shots
I've taken I like this one most.
Some people just live a vintage
life, and this gentleman is one
of them. He talks with a slight
vintage staccato, and he sings that
way too. I think it's romantic to
have that kind of commitment
to a way of life.

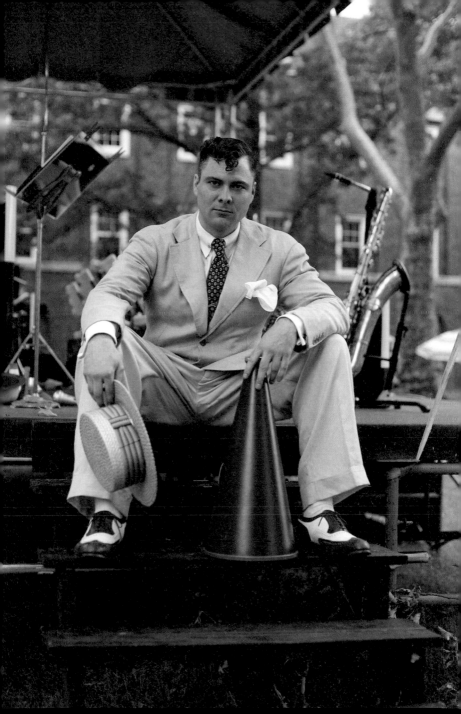

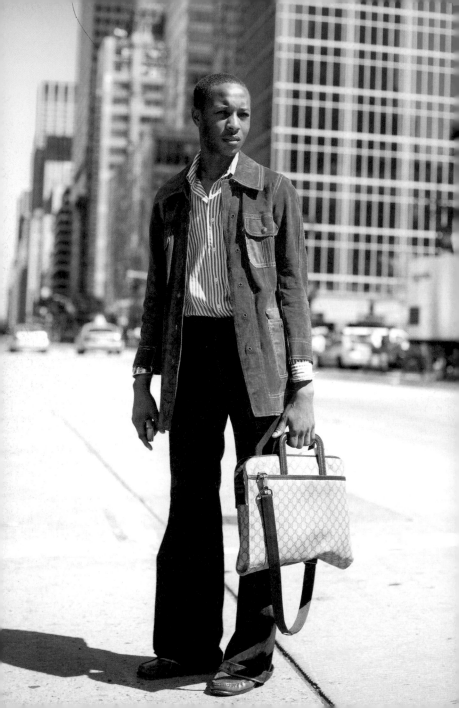

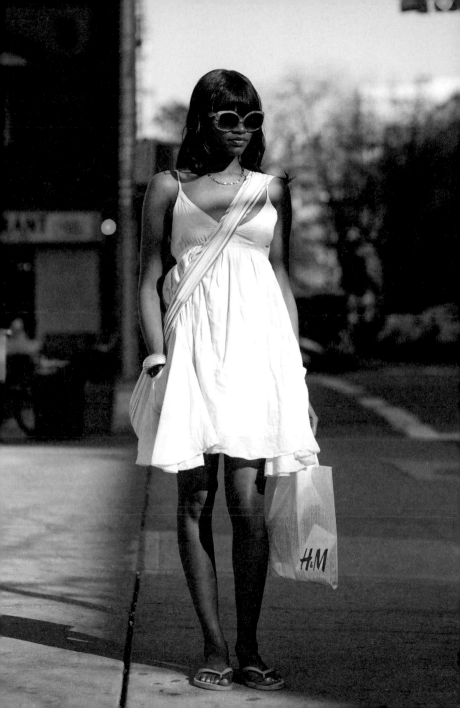

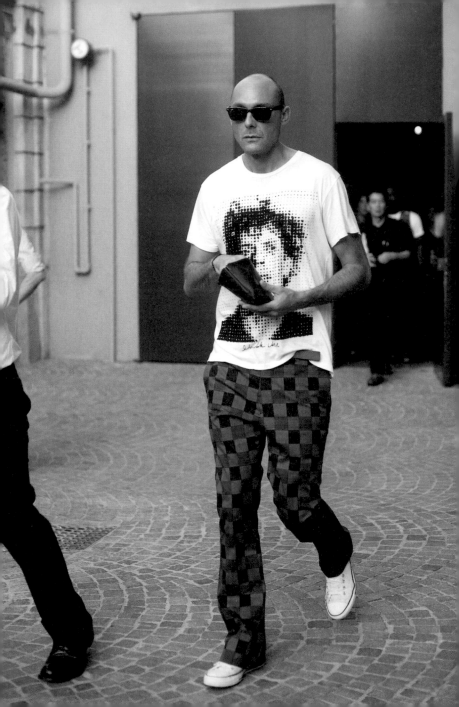

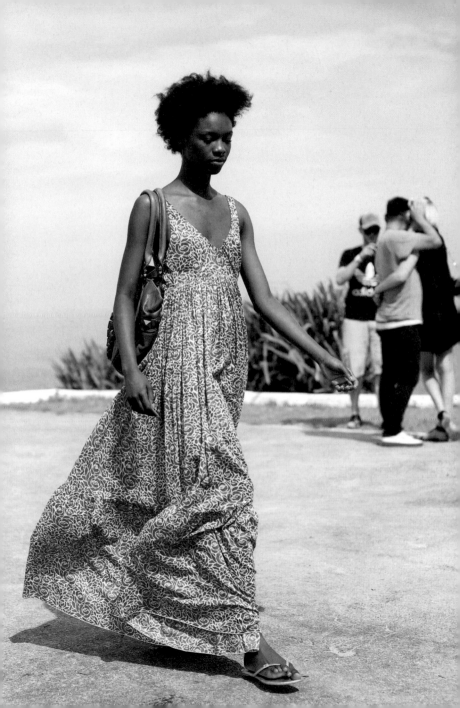

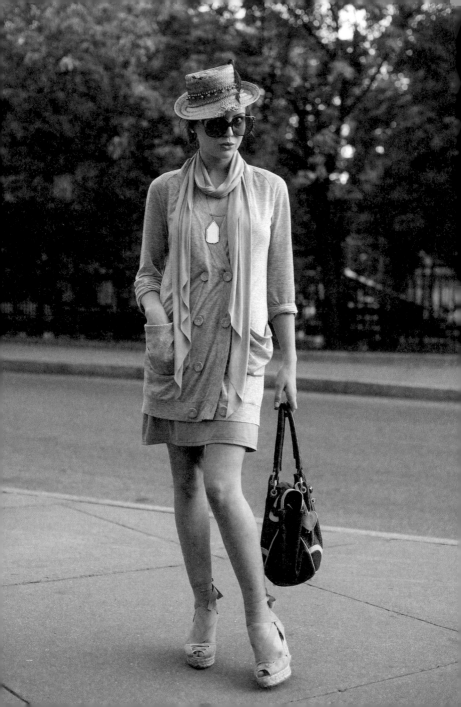

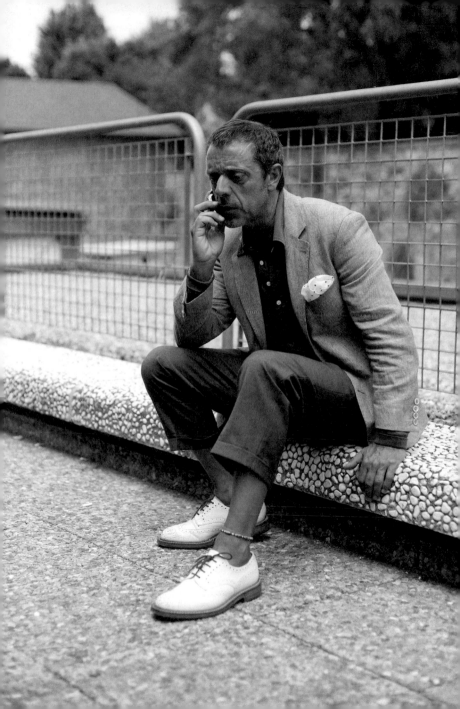

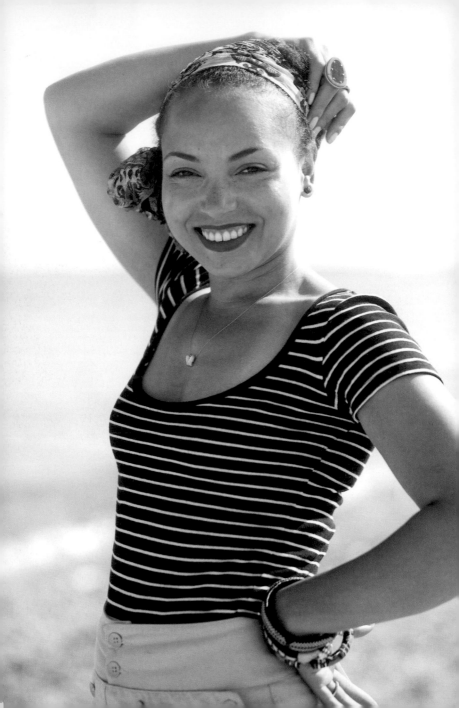

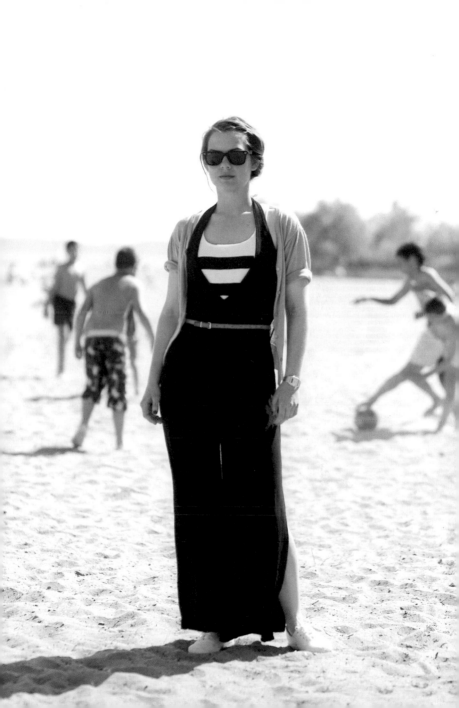

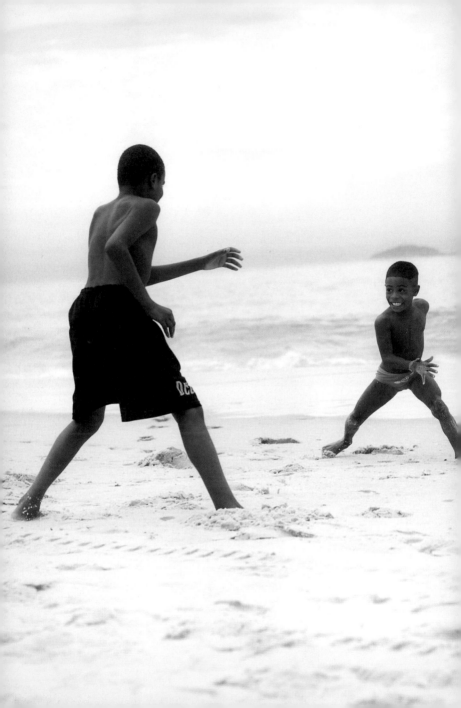

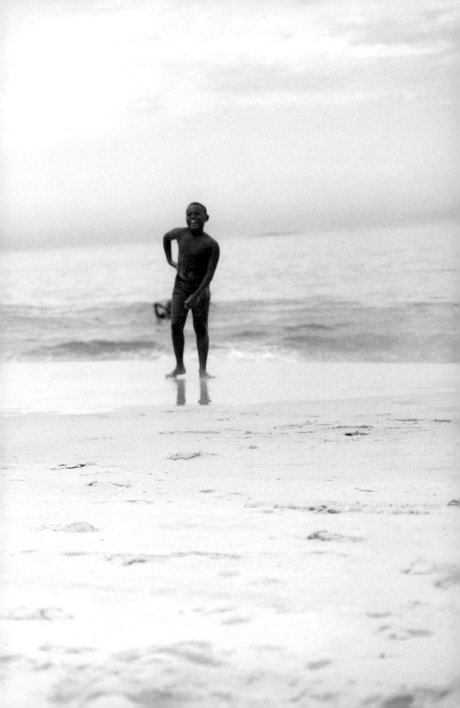

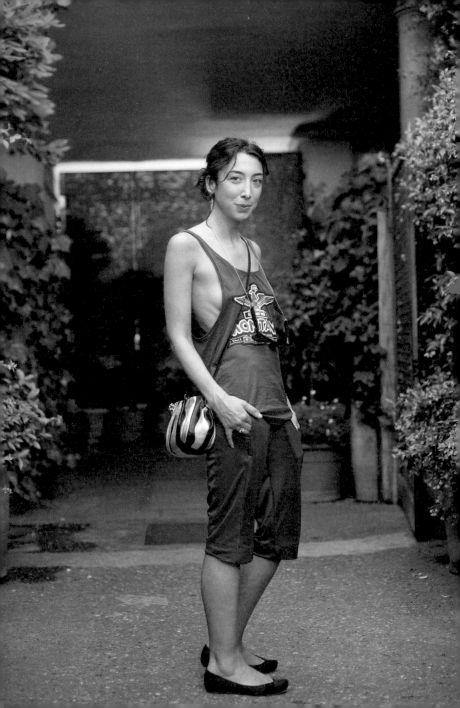

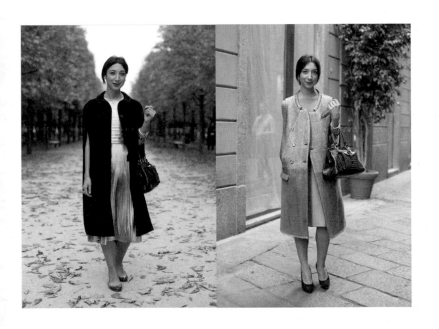

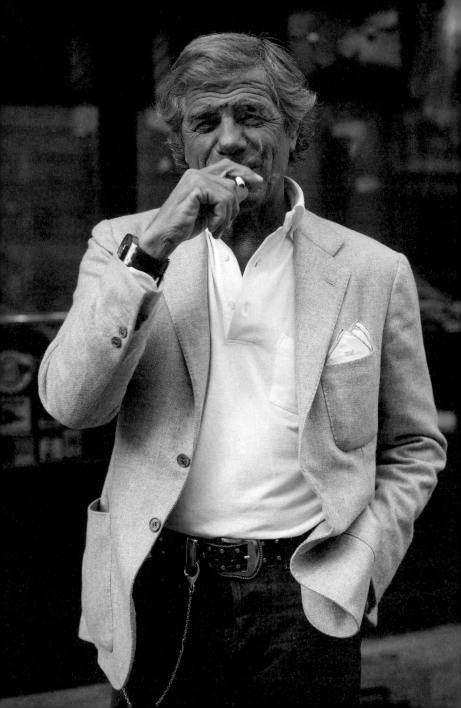

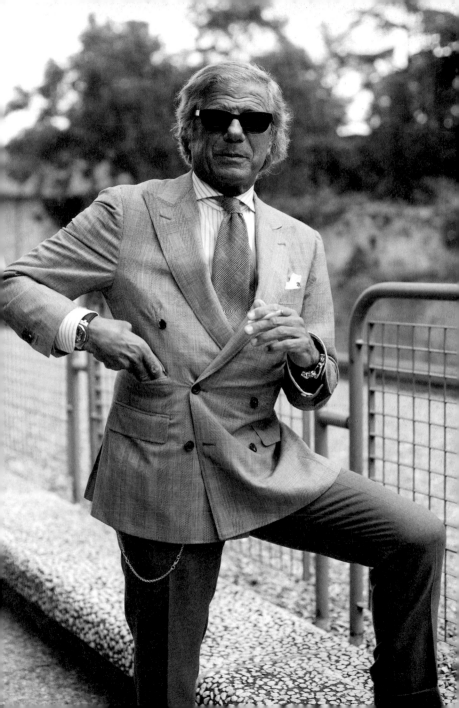

The Boutonnière, Florence

How many guys still wear a flower in their lapel buttonhole? This is one of those style elements that if executed overzealously would be too contrived and obvious, but this gentleman has perfected a certain nonchalance about it that allows it to go almost unnoticed.

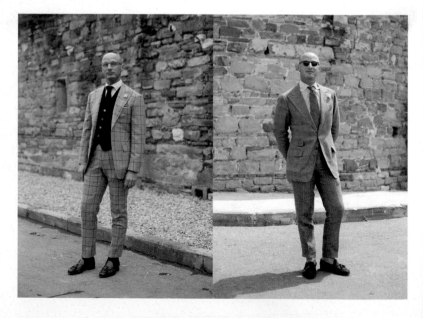

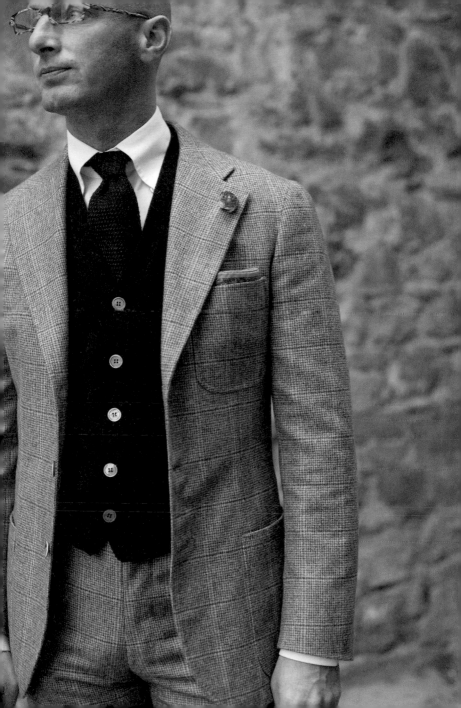

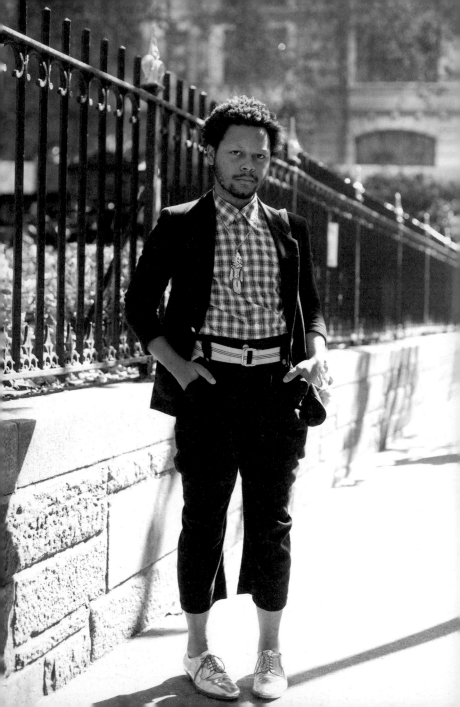

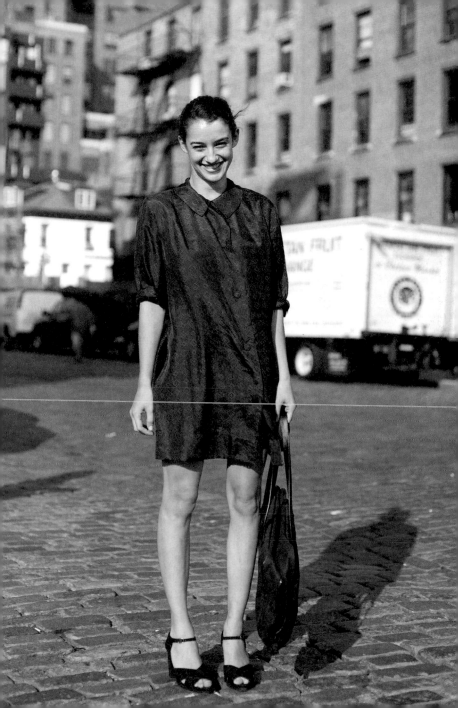

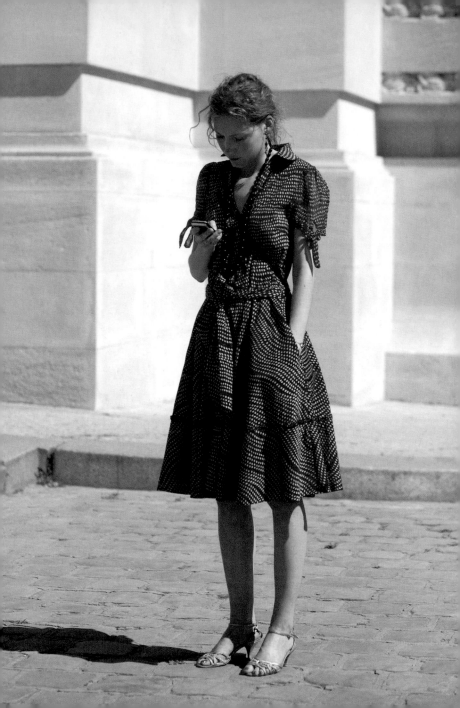

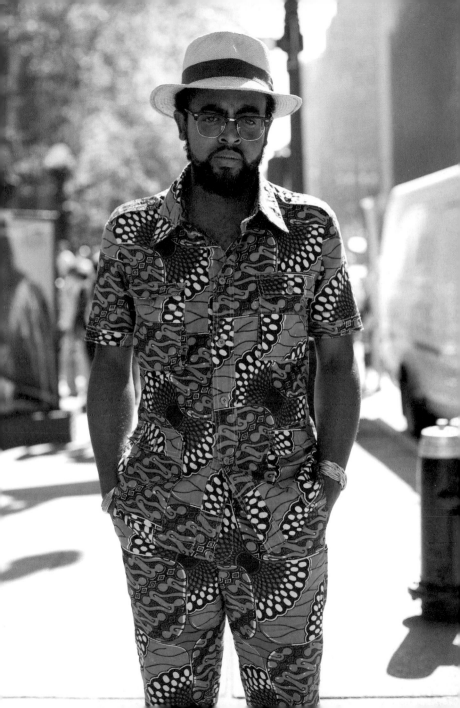

His Dad's suit, Milan

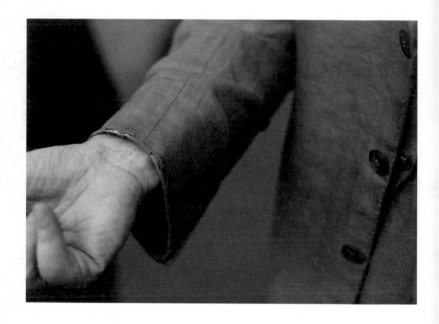

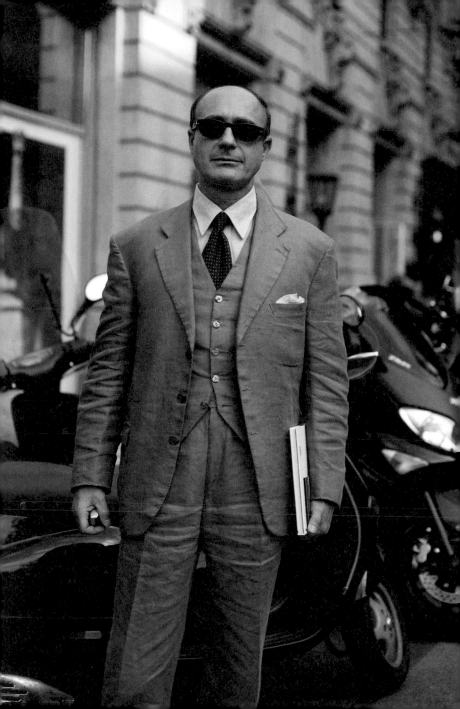

Giovanna

Below is the first shot I took of Giovanna, around 2006. Since then I've shot her many times. I love how she keeps evolving her style – hair up, hair down, hair straight, hair curly. She isn't afraid to take risks and try something new, and yet at the core she always looks like Giovanna.

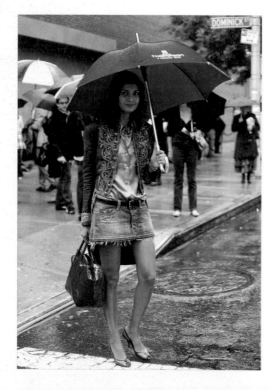

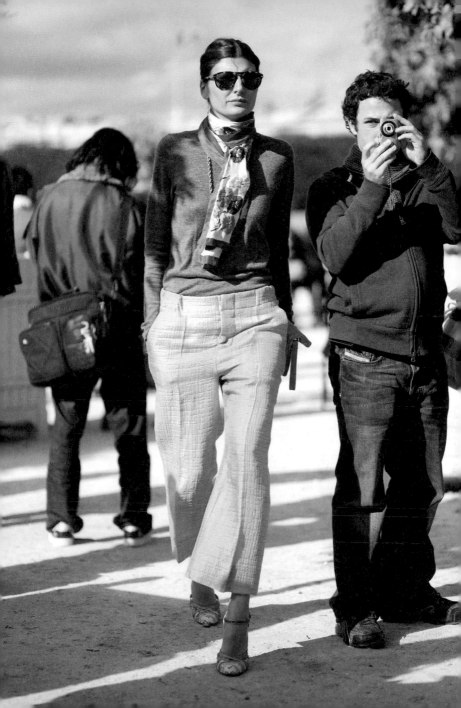

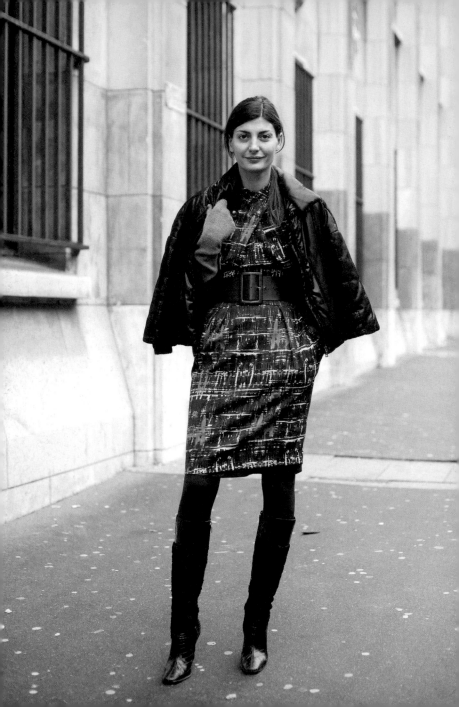

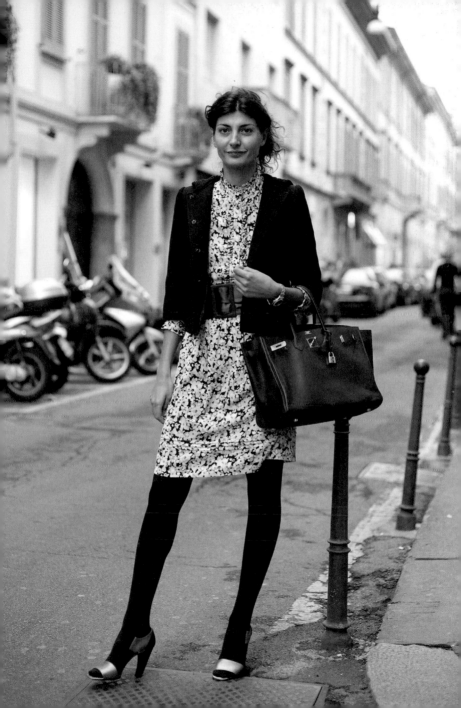

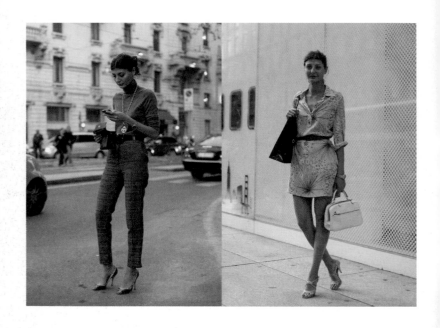

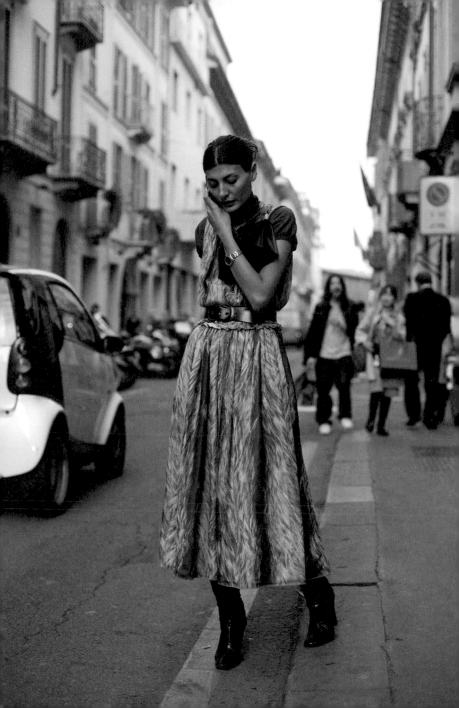

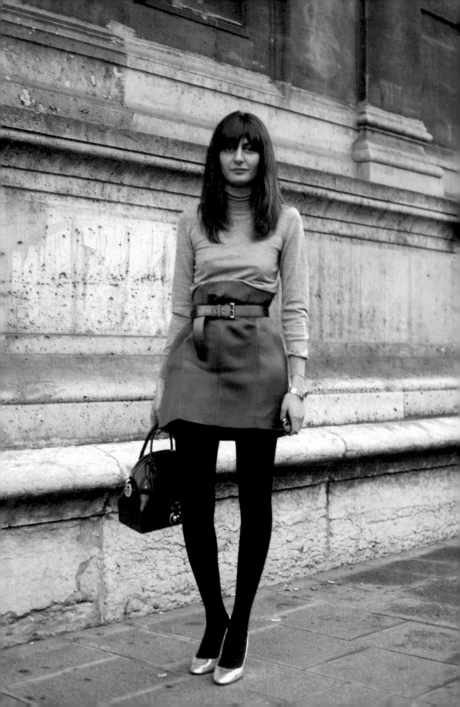

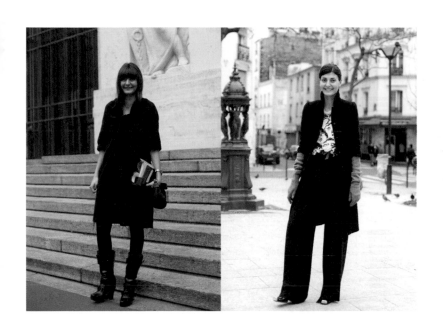

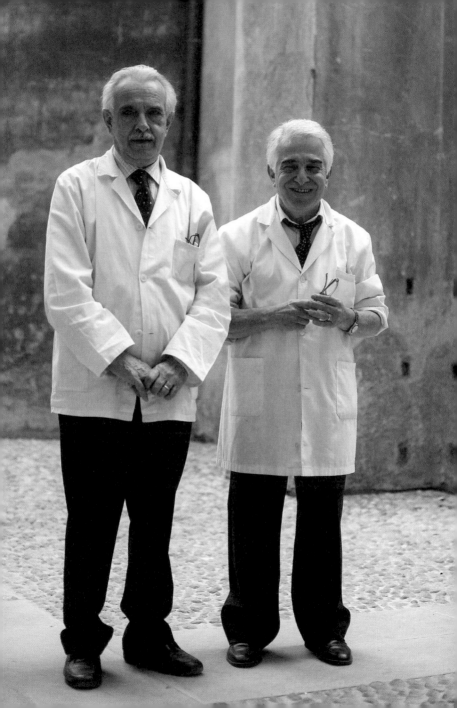

Barbieri, Milan

A few years ago I was in Milan and badly needed a haircut. Close to my hotel was a perfect little barbershop, which I had been wanting to try for years. Actually, I didn't need a haircut that badly, but every time I passed this place I would stop and watch these two gentlemen plying their craft in the same manner, and probably in the exact same spots, as they have done virtually every day for the past thirty years. There is something about the quiet, repetitive simplicity of barbers or tailors that I find very touching.

These young men don't speak English, so my haircut was pretty much in their hands – it was a challenge to give even simple direction. The most charming part of the whole process was when they covered me in three very clean, very crisply ironed towels – one across my legs, one front to back on my shoulders and one back to front on my shoulders. Like any true New Yorker all I could keep thinking in this process was, 'Wow, they must spend a ton on laundry service. Their margins must be paper thin!'

I am just glad that places like this still exist (even if I have to go all the way to Milan to enjoy them).

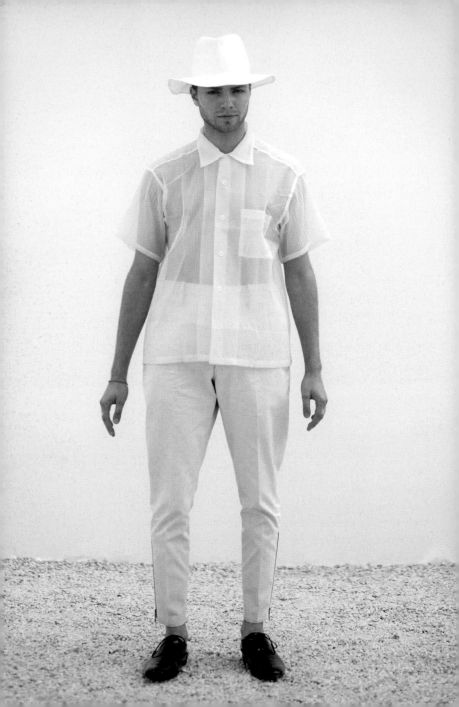

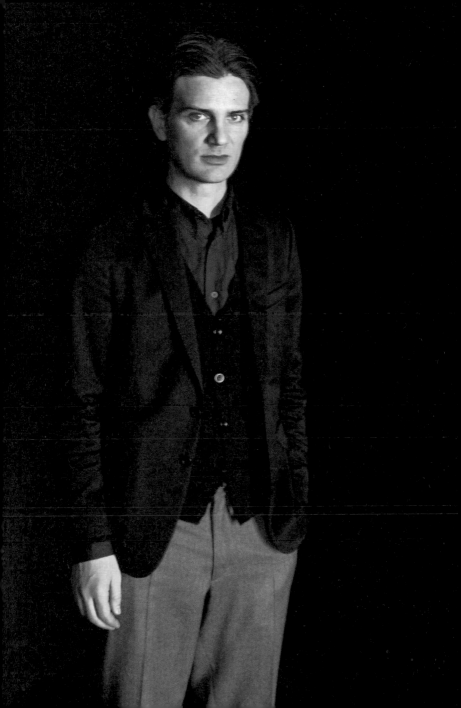

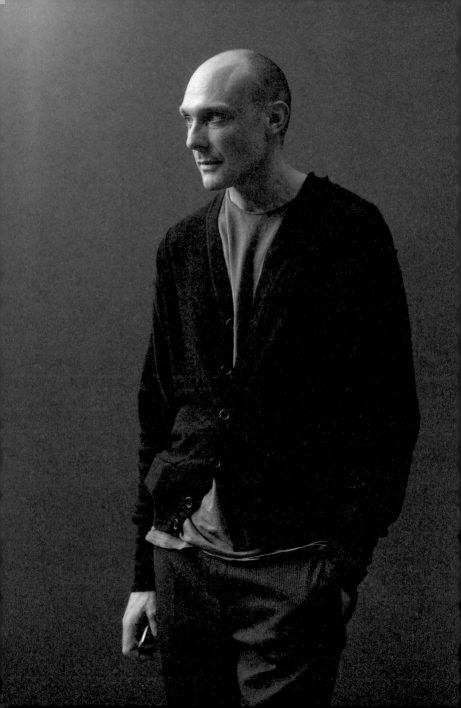

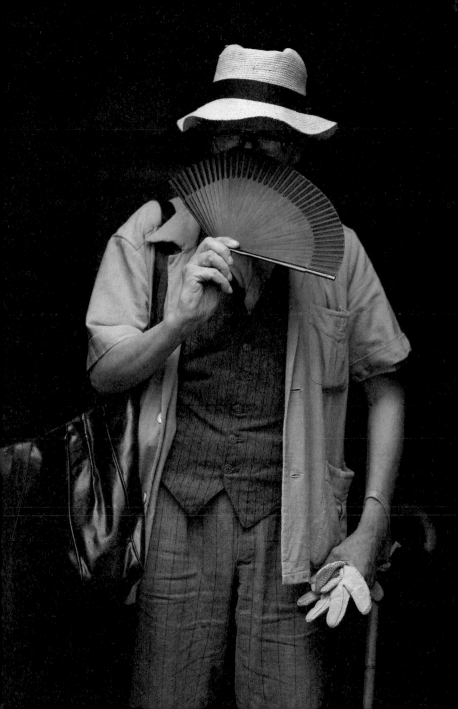

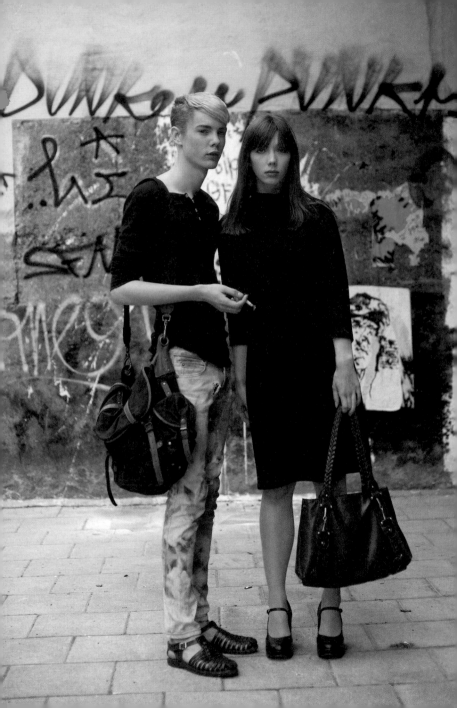

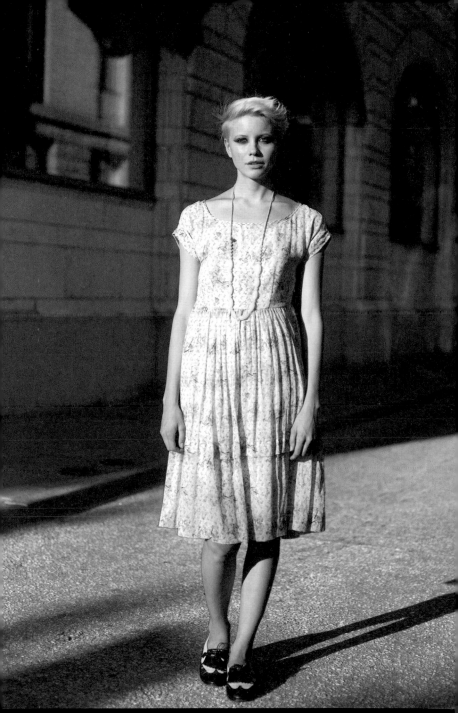

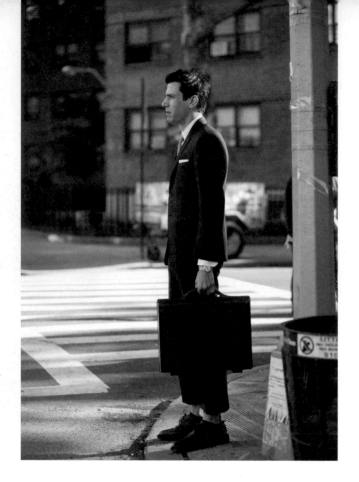

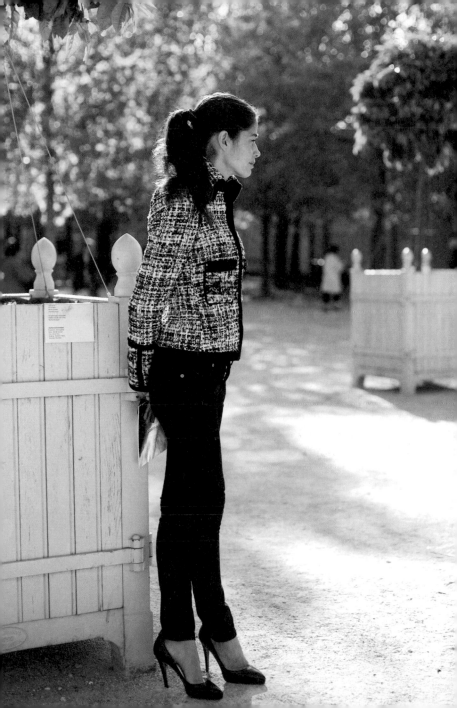

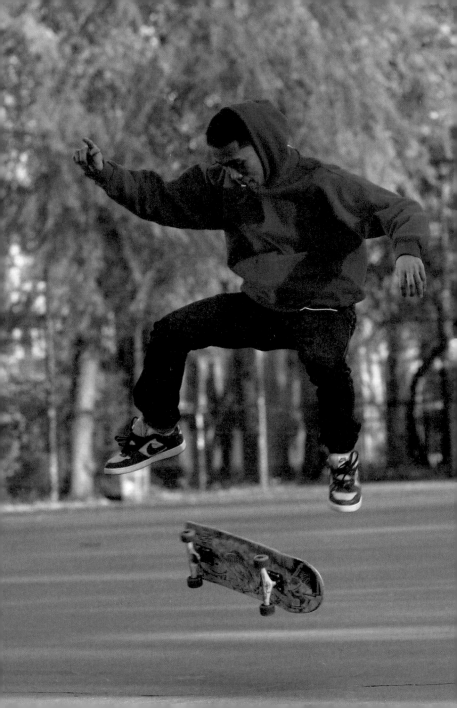

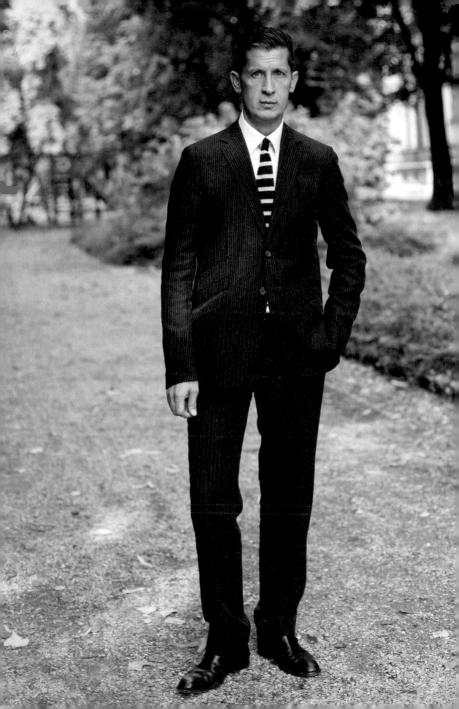

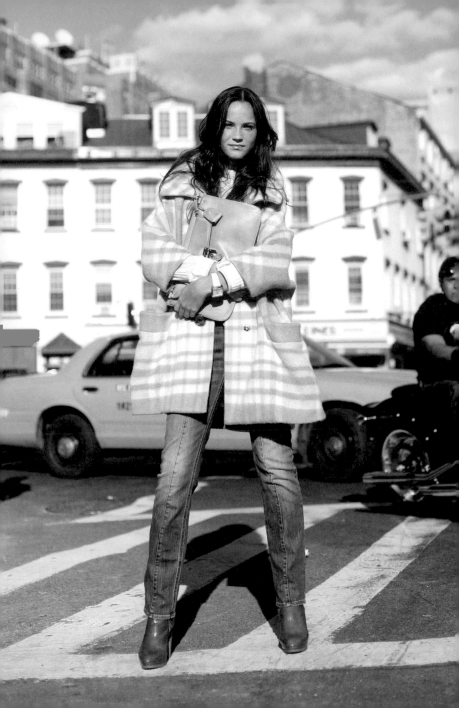

An early editorial, New York

This is an image for British *Elle*, October 2007, one of my first editorial shoots. Interviewers have often asked if 'street style' blogs have affected the photography of glossy fashion magazines. I have found that most of fashion editors are keyed into the minute social changes in visual images and have been very open to reflecting this new way of shooting in the pages of their magazines. One of the things I have been proud of is that if I am shooting for a glossy like *Vogue* or *GQ* I don't need to change my method of shooting. I often ask hair and make-up artists to stand down the street and around the corner so they are not popping in to touch up the subject between shots. Sometimes their perfection can lead to a perfectly boring shot.

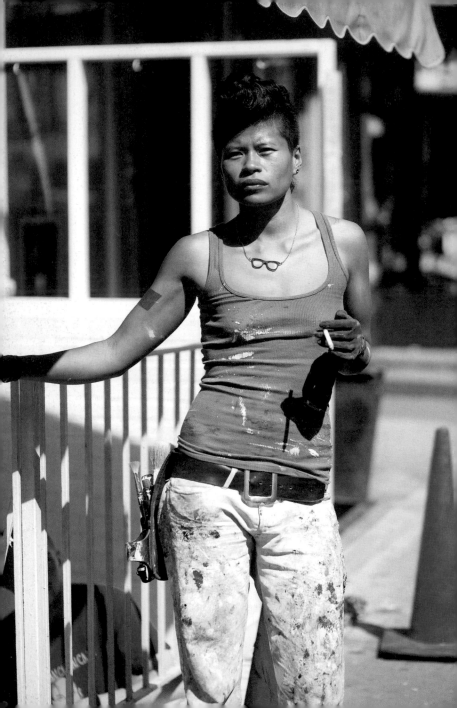

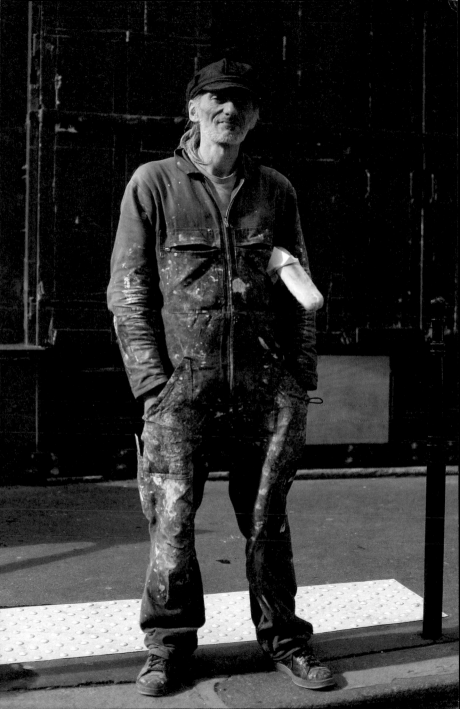

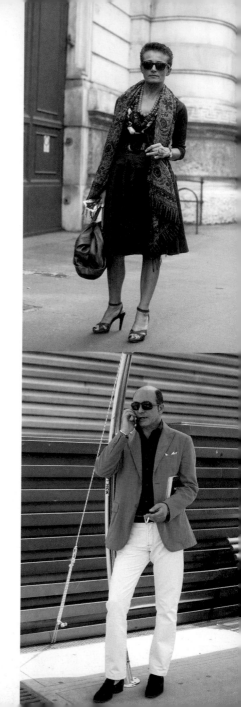

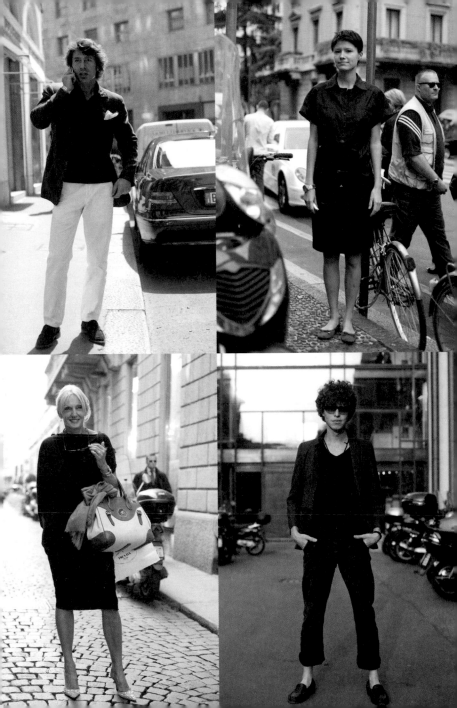

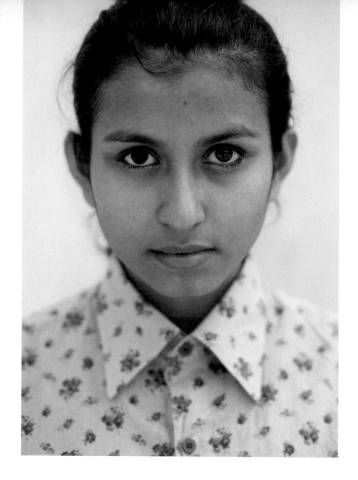

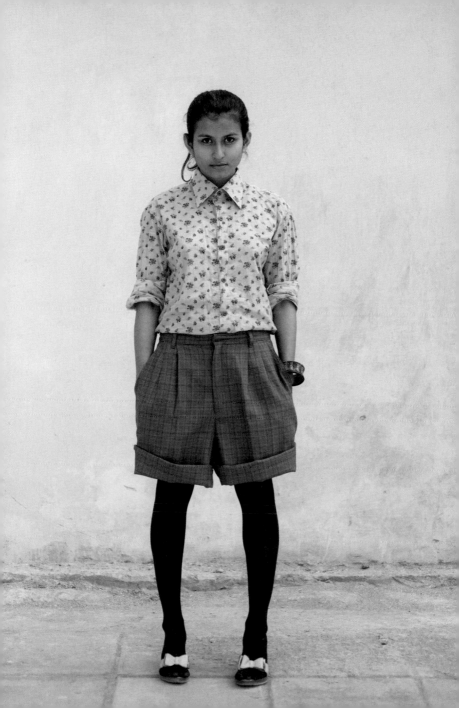

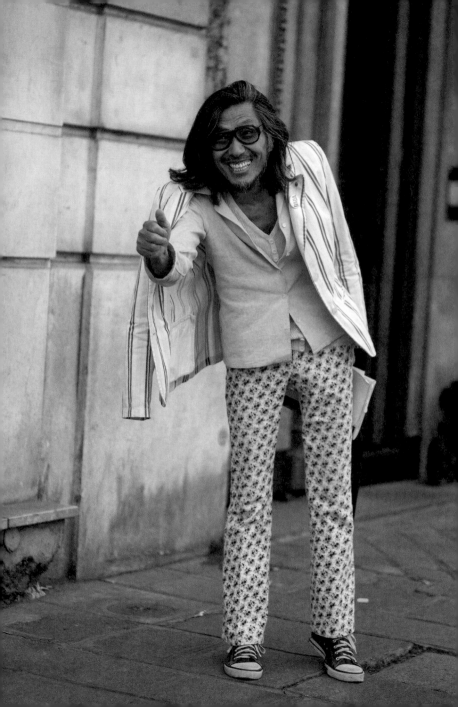

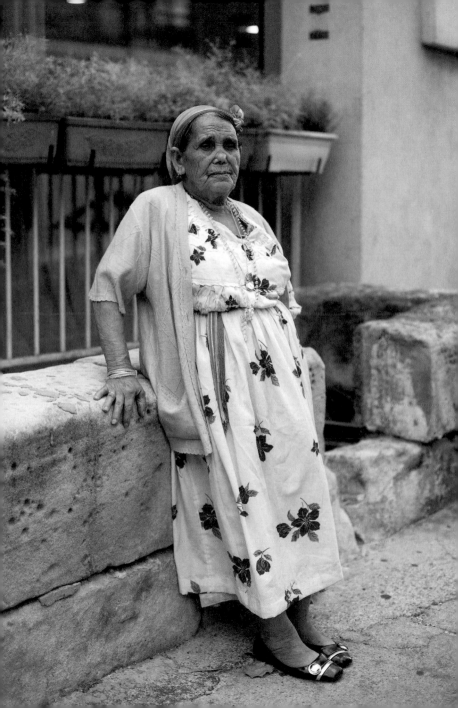

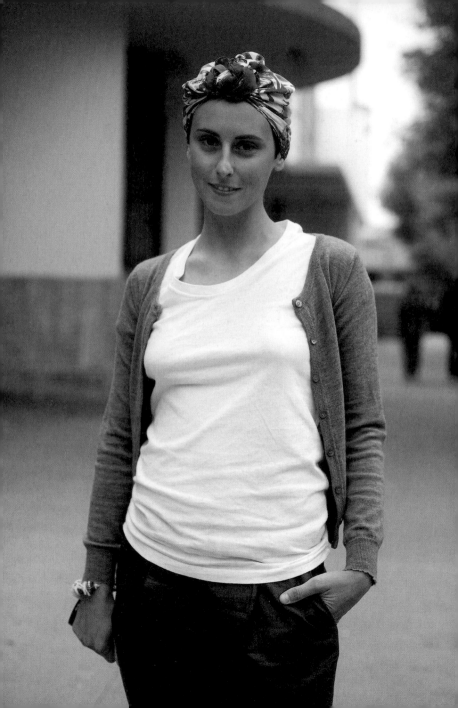

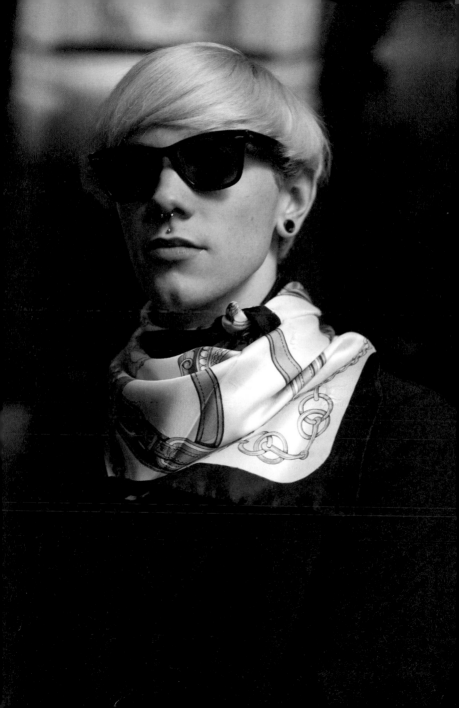

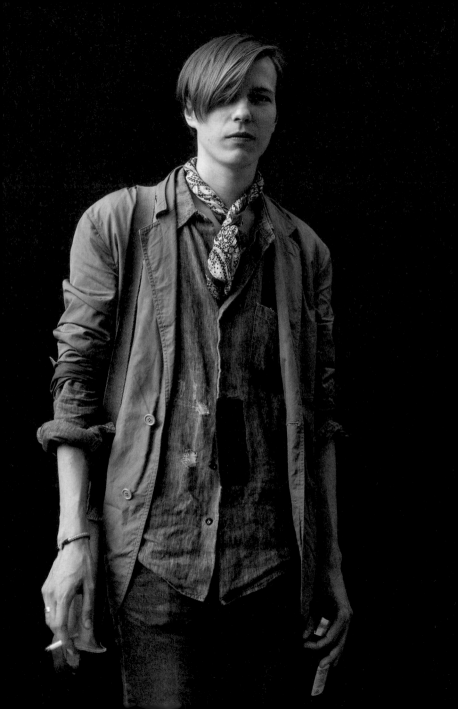

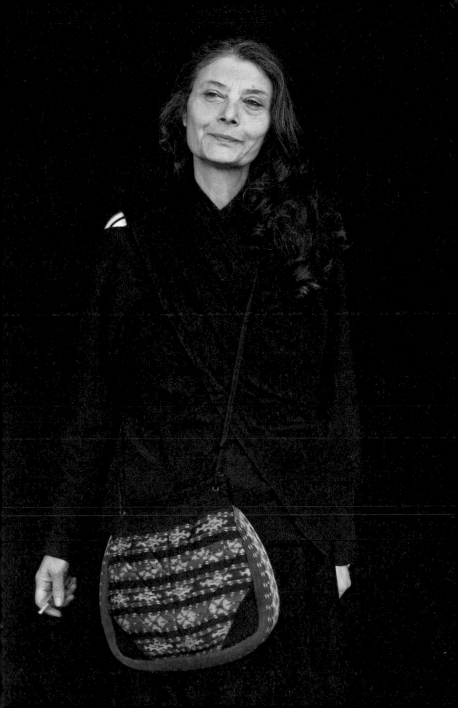

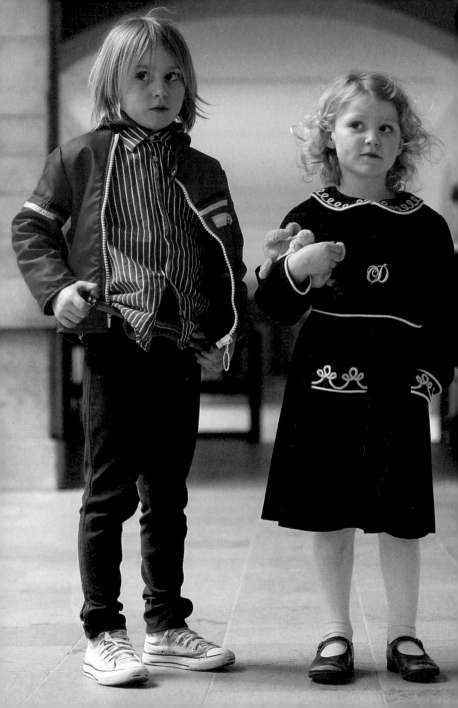

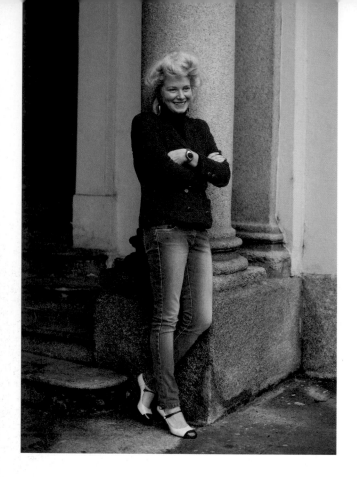

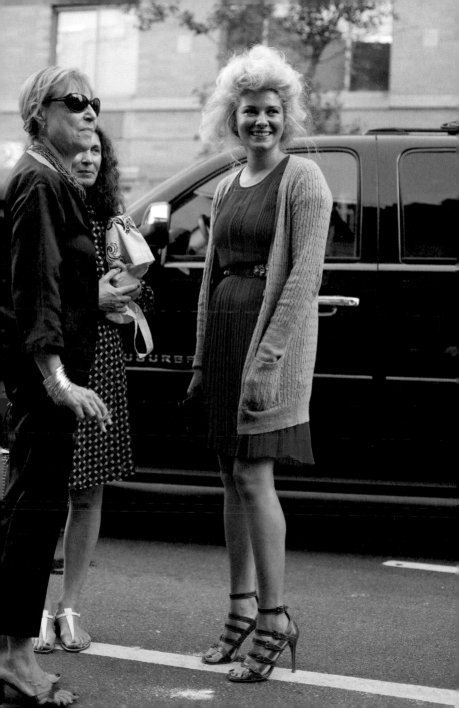

Julie, New York

This is Julie. She is one of my favourite subjects to shoot for the blog. Often when I post a picture of her she receives comments like, 'Oh, she is *sooo* perfect, so chic, a modern Audrey Hepburn.' Well, she is very chic, but she is far from perfect, physically at least. Julie has one leg slightly shorter than the other, has very slim arms, and walks with a very slight limp. However, she has never let her physical challenges alter her appearance or diminish her presence. This young lady stands tall. In a world of fashion that celebrates a certain kind of beauty, I have so much respect for the people who don't let their non-fashion-world physique stand in the way of expressing the beautiful person that they know themselves to be. I find that type of inner strength the most captivating of all, and it is a major reason why Julie is on the cover of this book.

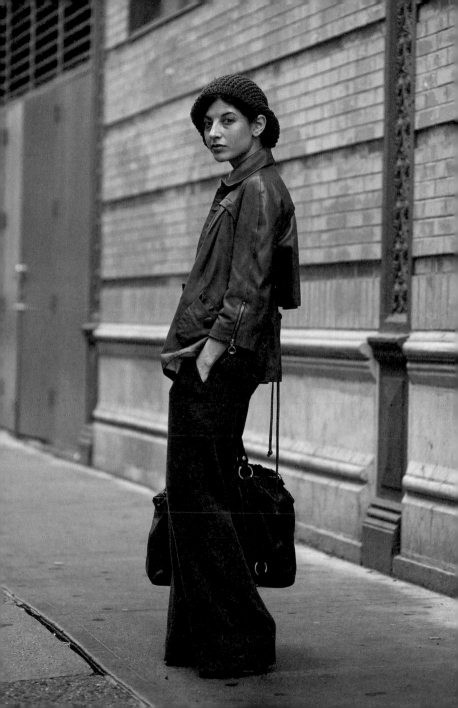

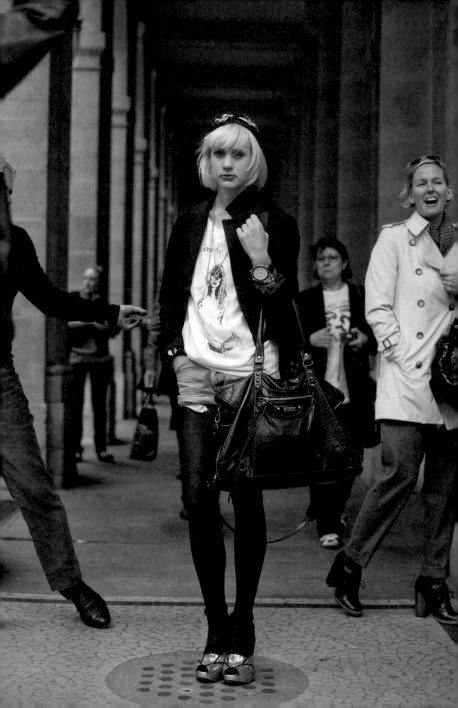

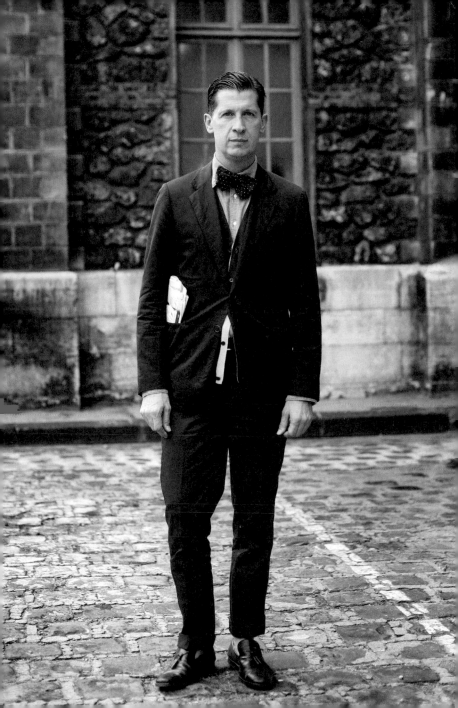

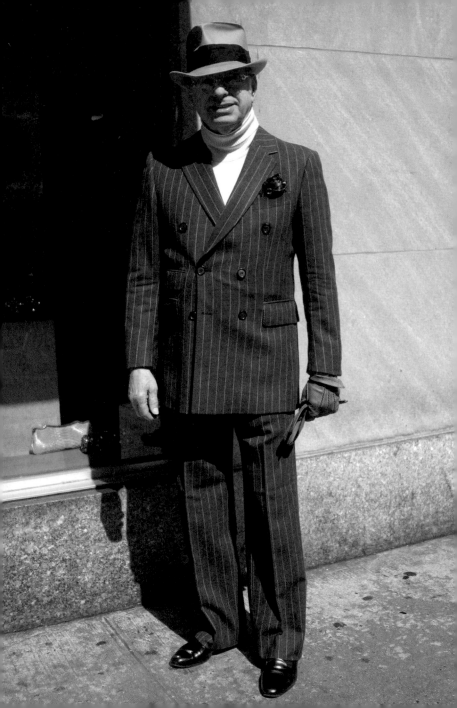

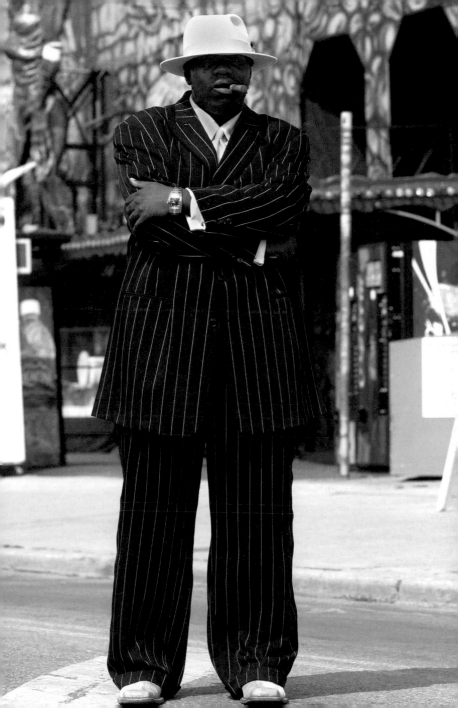

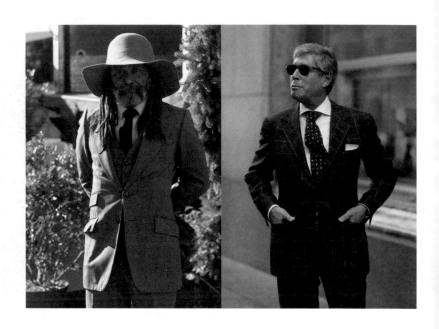

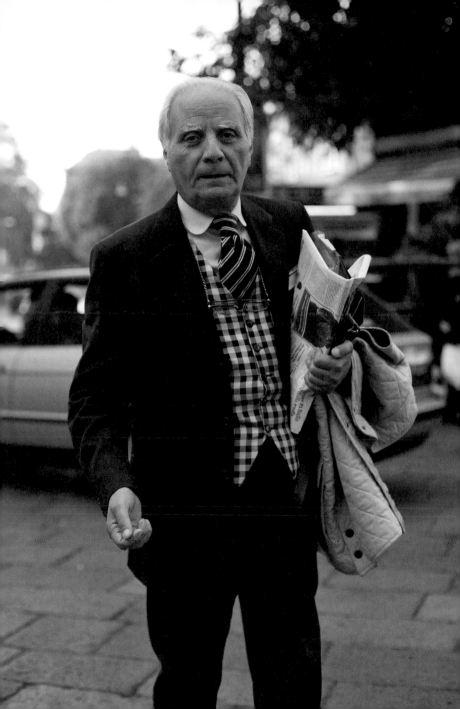

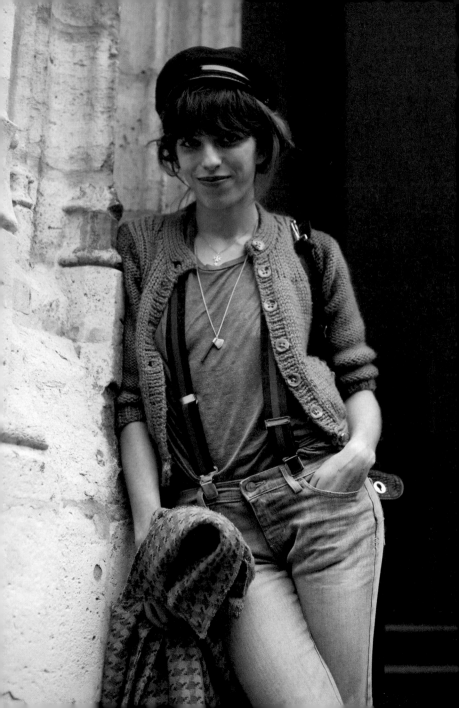

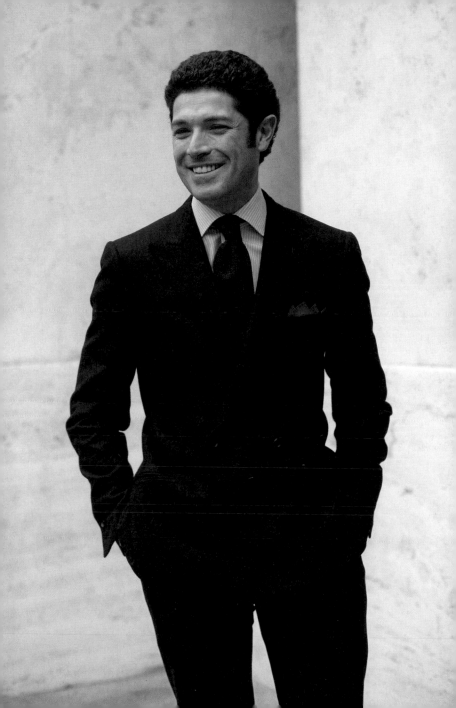

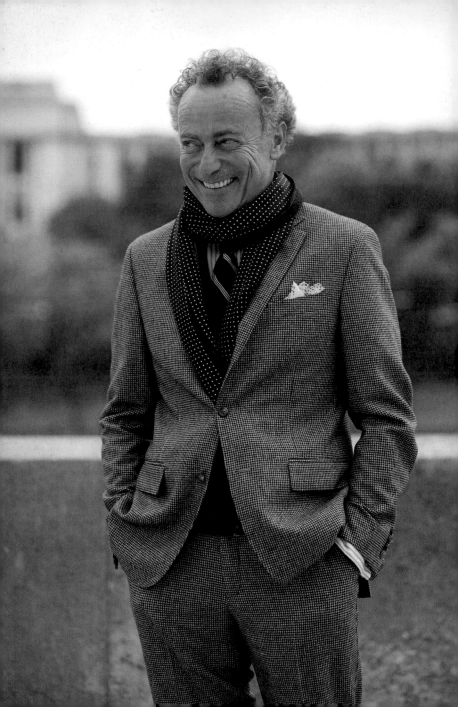

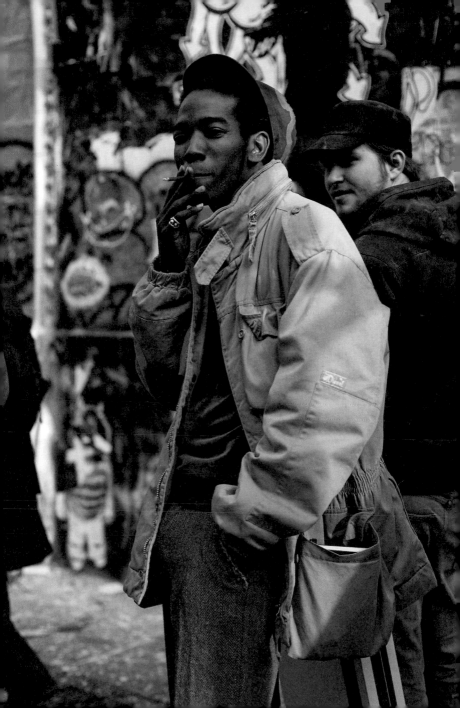

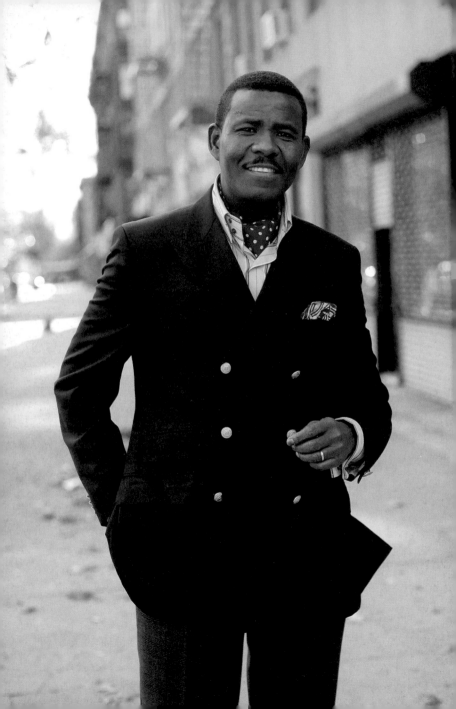

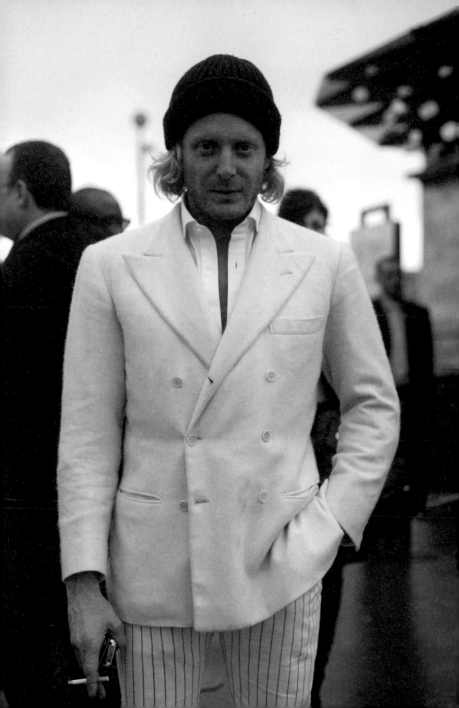

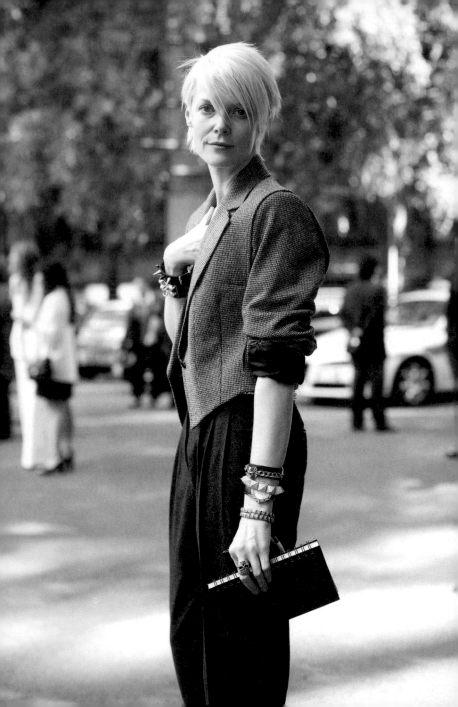

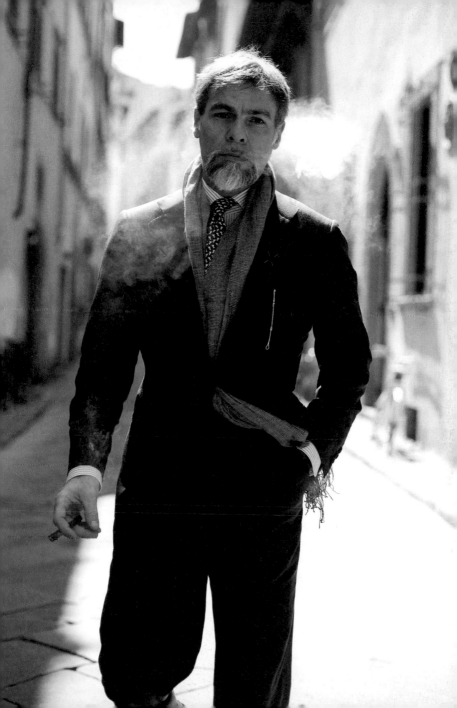

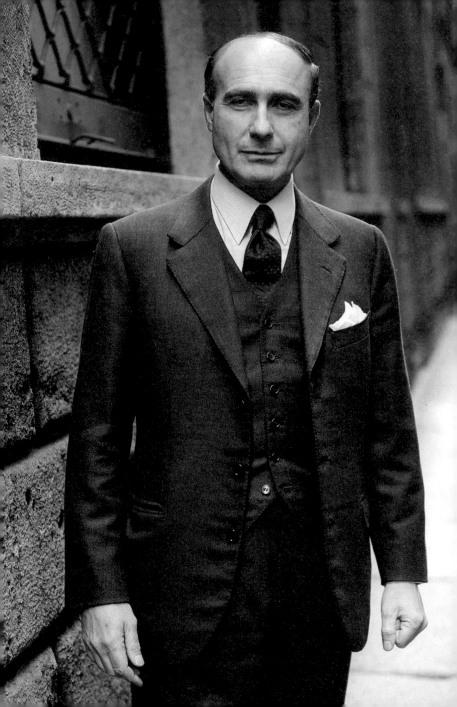

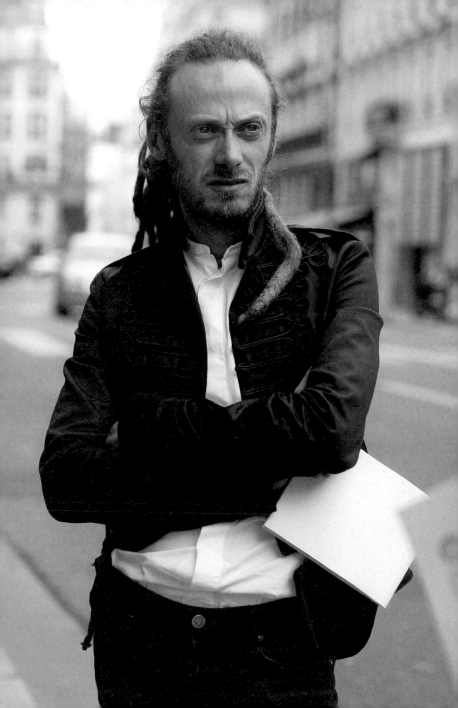

The last shot, Stockholm

People in Stockholm have a reputation for being quite shy and a little closed to outsiders. That is fine for me, because I think that lends an intimate gentleness to my Stockholm images. This young lady was very shy and self-conscious while I was taking her photo. I tried all my tricks to try to loosen her up, but none worked. I did notice that whenever I pulled the camera away from my face to look at the LCD monitor on the back she would finally relax a bit. I told her I needed just a few more frames and we were done. She agreed but continued to look very tense. After a few shots I said 'Got it!' and started to put the camera down. Just at that moment this smile spread across her face and I quickly grabbed the shot before she realized what was happening. That is a smile of pure relief – which is good enough for me.

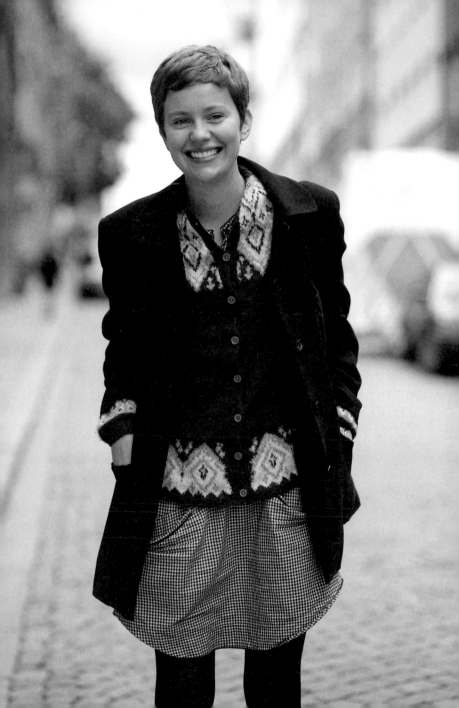

Creased jeans, Florence

In America the only people who crease their jeans are cowboys. I am not a big fan of 'cowboy style', so when I saw this very chic gentleman in Florence sporting creased jeans I was disconcerted. His execution of the creased jeans was different (Italian – dark denim; cowboys – faded denim) but am I that shallow to be so easily swayed? Yes, I am. A few days later I saw another Italian gentleman wearing creased jeans. I asked him if he always wore a crease in his jeans. His friend laughed and said, 'This guy even creases his underwear.'

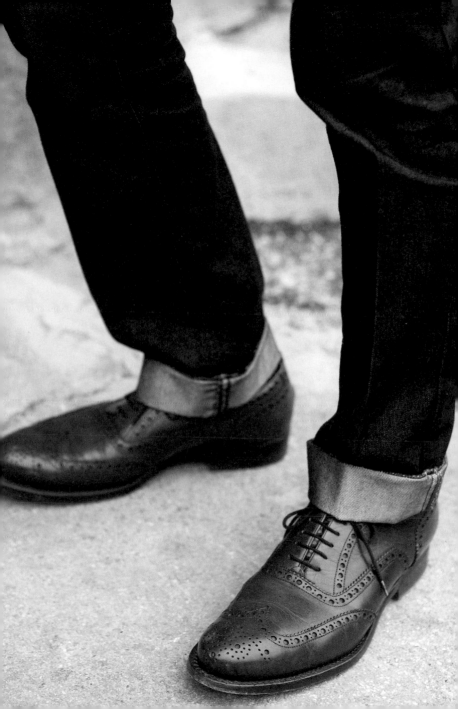

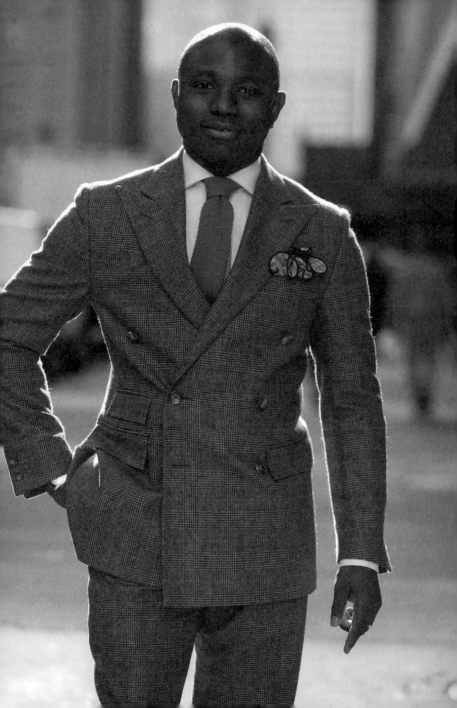

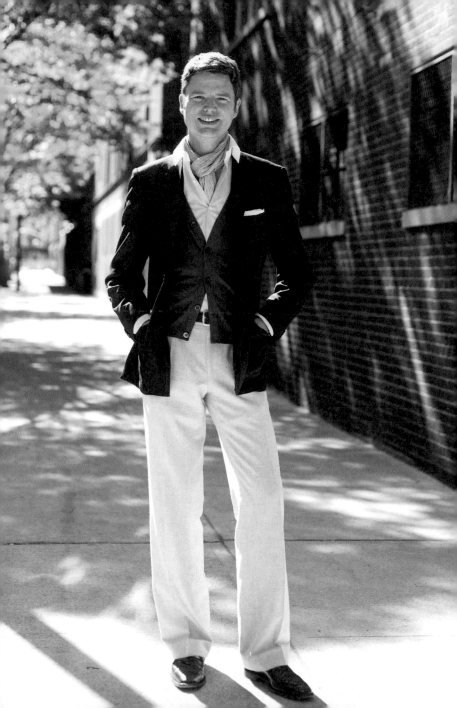

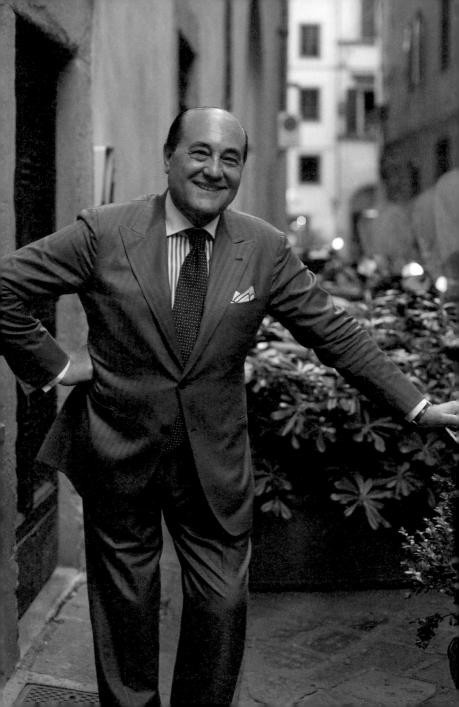

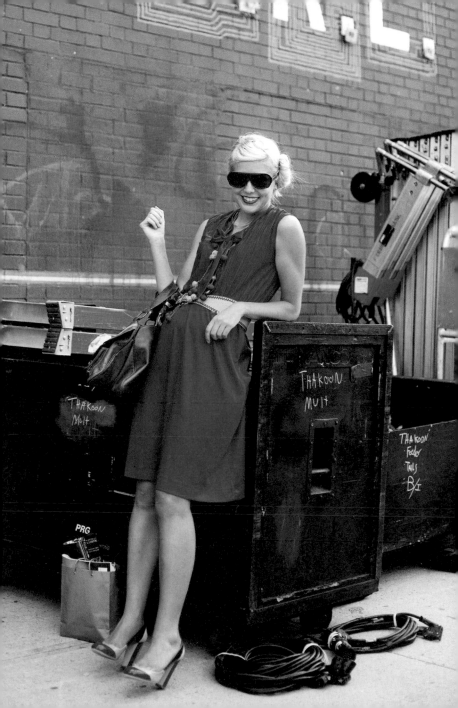

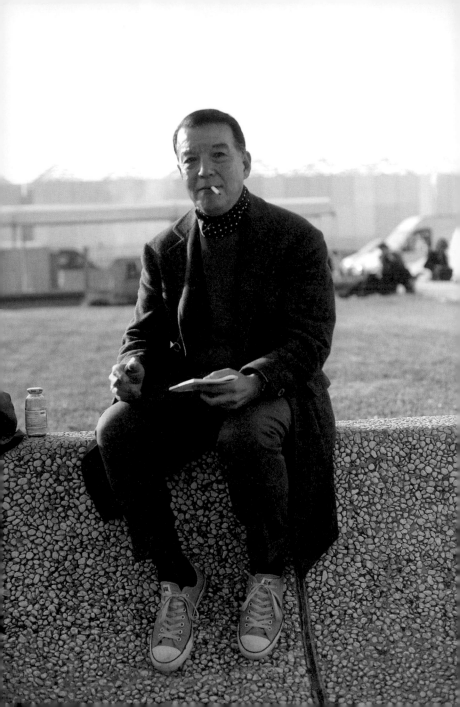

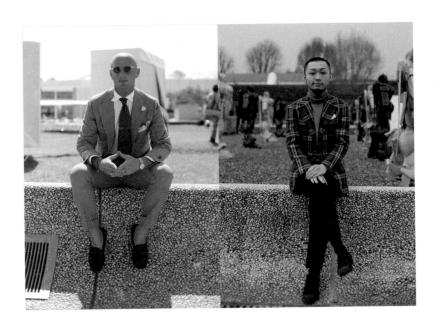

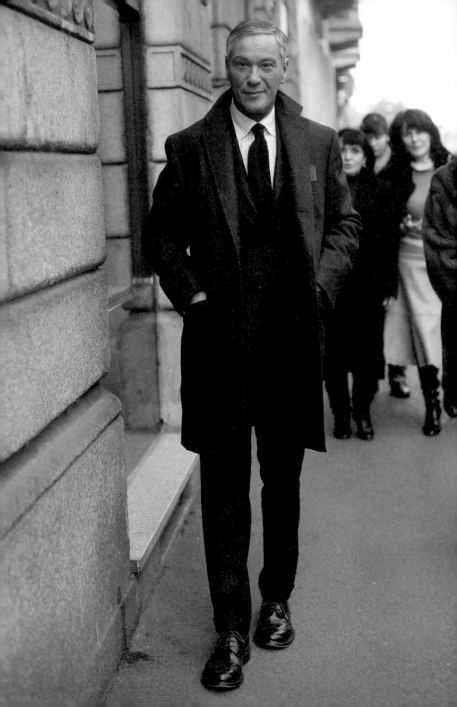

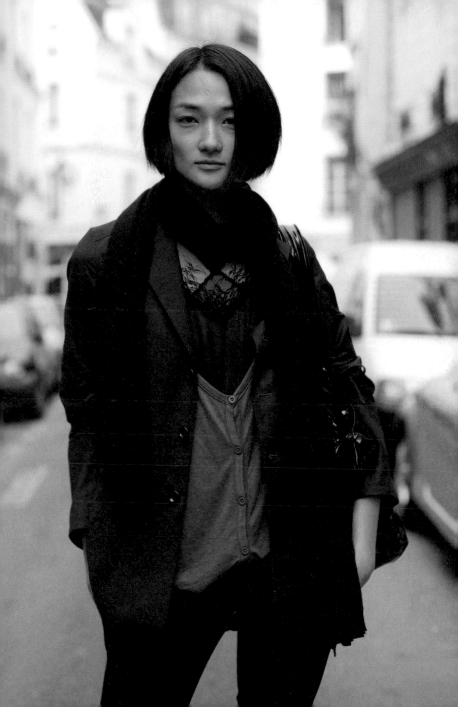

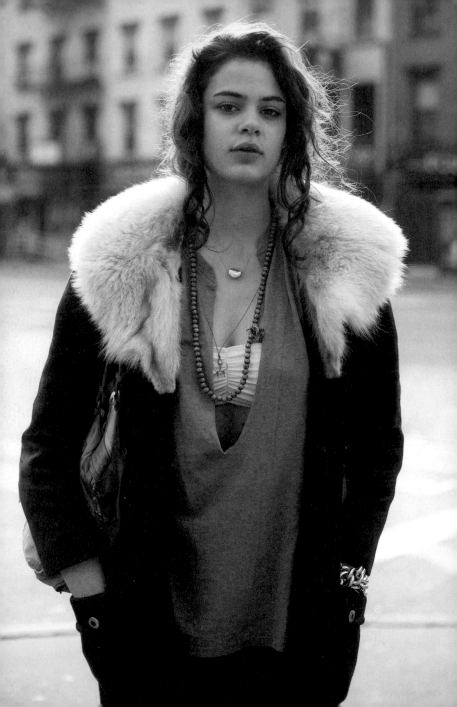

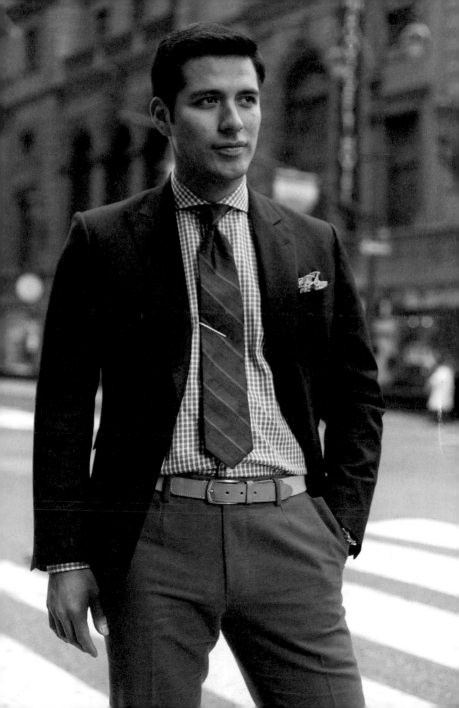

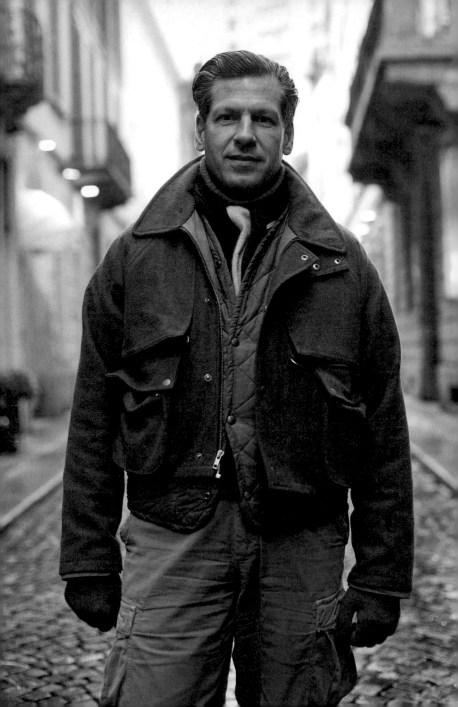

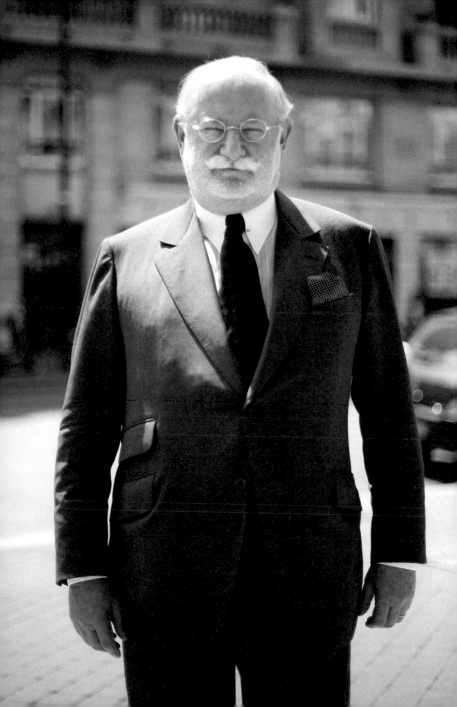

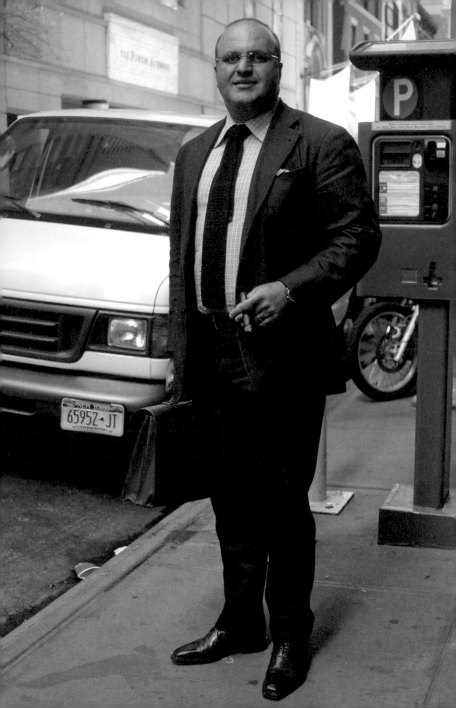

'Bald fat man', New York

This is one of my first breakthrough shots for the blog. The response that this post received confirmed in my mind that I was on to something.

I saw this gentleman on Fifth Avenue around 56th Street. Instantly I could tell from the Italian cut and sophisticated colour and fabric of his jacket that he was special. I stopped him and asked if I could take his photo, and he looked at me suspiciously and replied, 'Why do you want to take a picture of me? I am a bald fat man.' Now, I am a very polite and positive person, so I started to reply that, 'No, you are not ...'; but then I caught myself and instead replied, 'Yes, but you are a well-dressed bald, fat man.'

That caught him off guard. I followed up my first response with, 'So, is that southern Italian tailoring?' It was, and I knew it was, and my recognition of that was what won him over. A longtime friend of mine, David Allen, once told me that one of the basic needs of people is to be understood. I think that the fact that I seemed to understand this man and what he was trying to communicate through his style is why he agreed to let me take his photo.

As a result of this shot appearing on my blog I received lots of emails from guys around the country saying they had a body shape similar to this gentleman's. They would print this photo and take it to their local department store and say, 'I look like this guy, but not quite – help me!' I think what most of them found was that they were able to achieve a similar elegance, not by spending a ton on custom tailoring but by focusing on a few subtle alterations that helped their suits fit their body type.

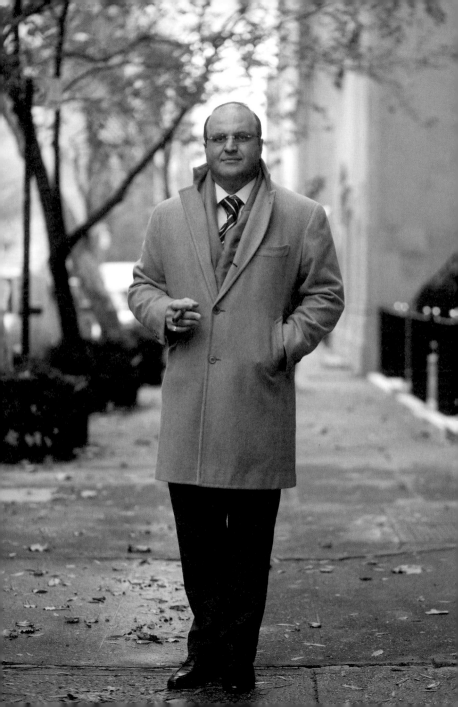

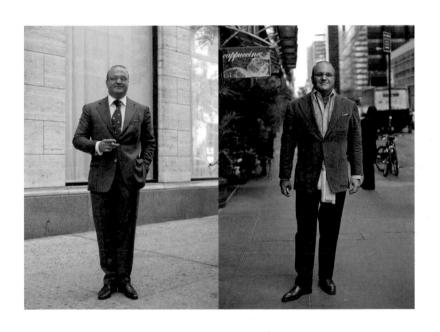

Kanye

Kanye is one of the few 'stars' I shoot consistently, maybe because we are both from the Midwest and I totally relate to his fascination with style and design. On a deeper note, what I appreciate is his utterly naked ambition to succeed artistically and how he has used style and design to craft his message. I relate to his ability to blend macho aggressiveness with a refinement that allows him to easily move between the worlds of hip-hop and haute couture.

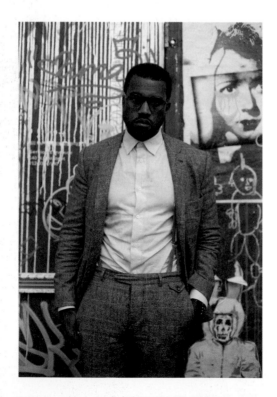

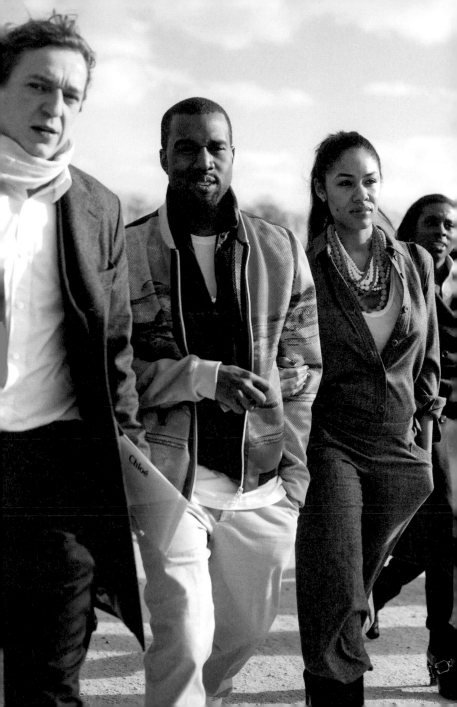

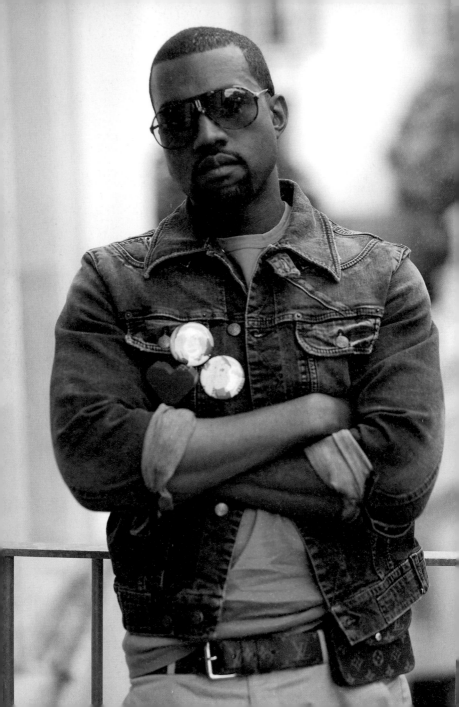

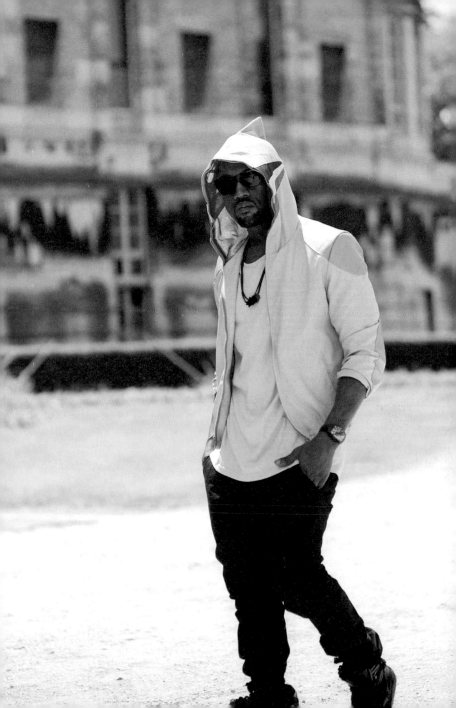

Molto elegante, Milan

I saw him as he was coming out of the subway. Usually, old guys like this don't speak English. The first time I approached him he shooed me away, but I knew it was going to be a great shot so I followed him a while, still trying to get his picture. Luckily, someone came by who helped explain that I wanted to take his picture. When he finally said yes he pushed back his coat so that I could see how his jacket matches his hat. I like to think he was out for his evening stroll, still wanting to show himself in the best way he can.

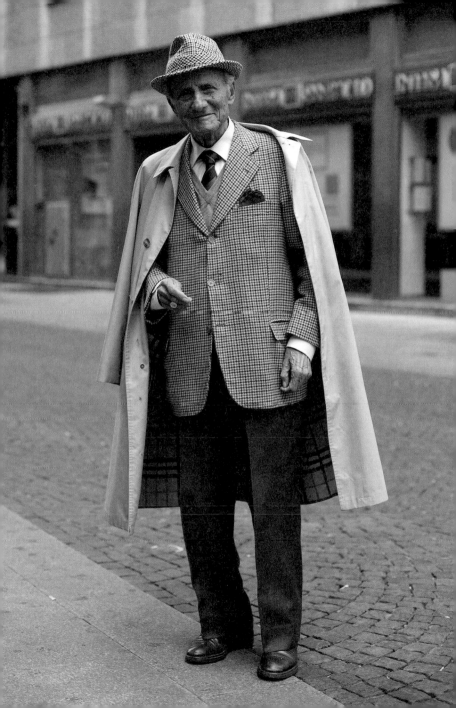

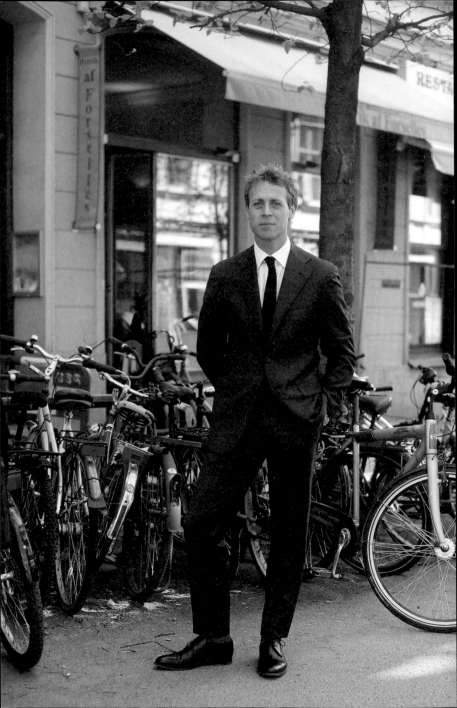

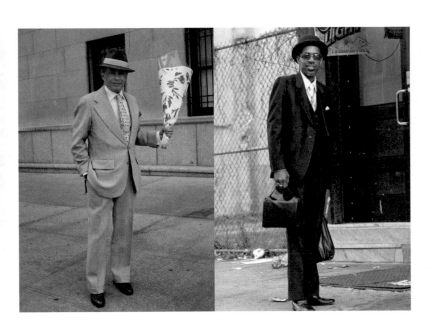

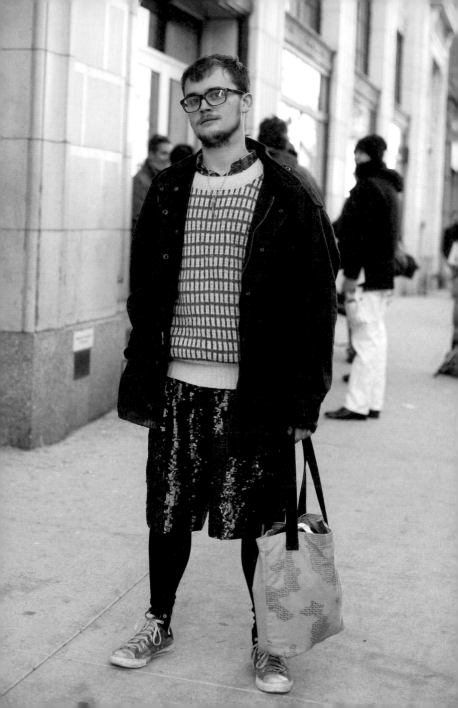

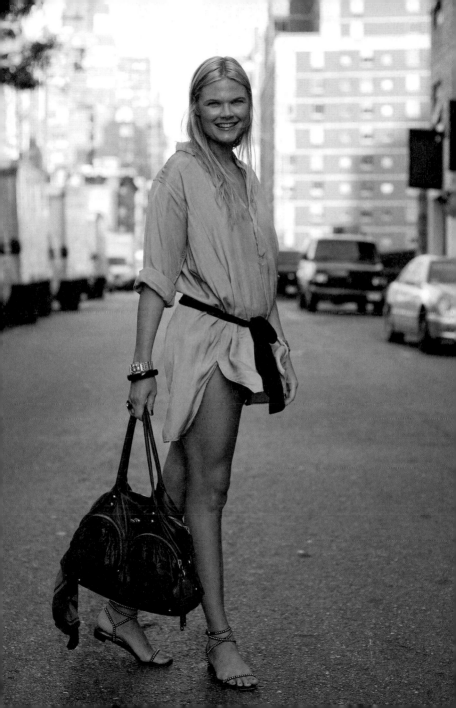

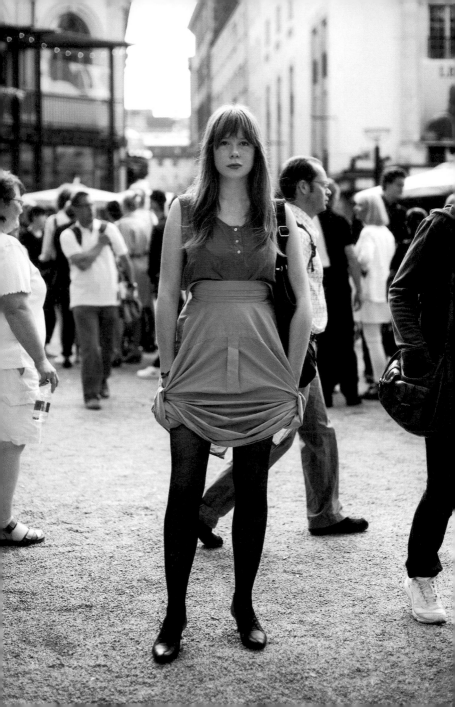

Shirt as skirt, Stockholm

I love DIY design, especially if it doesn't seem like DIY. This young lady used one of her dad's shirts as a reconfigured skirt. What I love about it is that it doesn't immediately read as 'fashion-student-getting-arty'.

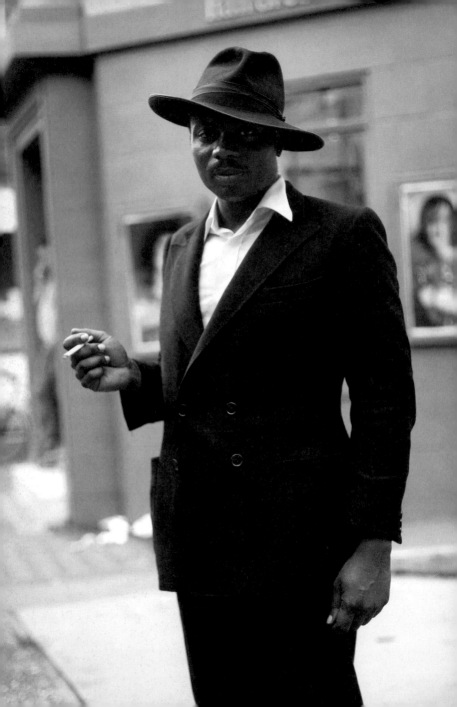

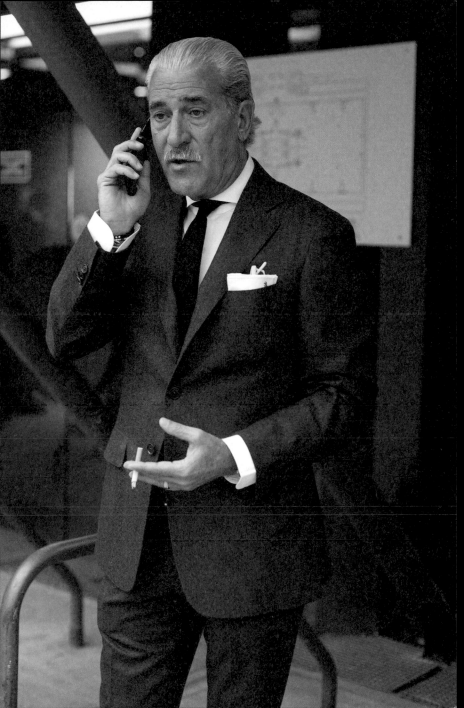

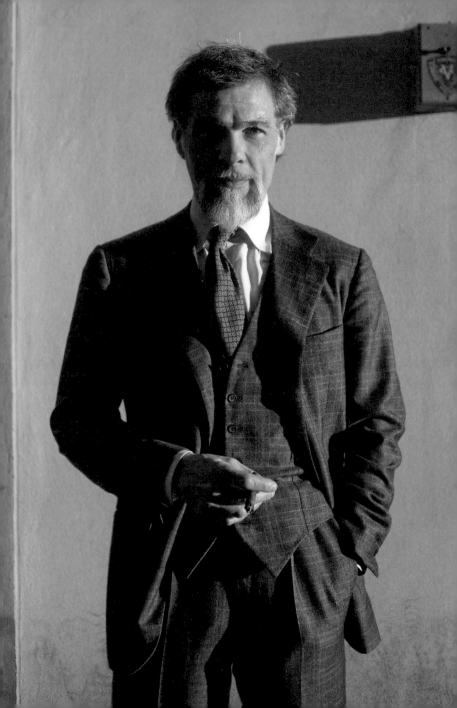

The concept,
Florence

This young man, Simone, reminds me of Robert De Niro in *Angel Heart*. There is a sinister sexiness to him. He has a charming smile that can lead to trouble.

When I started The Sartorialist it was expressly to capture the allure of guys like this, who I would see around in New York or wherever but rarely in the pages of high-fashion magazines. To me, a guy like this is so much more inspirational than a typical nineteen-year-old model who, in real life, only wears jeans and a dirty tee shirt. Simone has a swagger and a style that is so subtle that it is hard to define – you just know it when you see it.

After doing this for a while you realize that the key is to focus not just on what the subject is wearing but to take it to a more meta-level, of 'Why am I reacting to this?' Simone is a perfect example, because he's equal parts exquisite tailoring and macho swagger. Sometimes it is not the designer label but a gesture or a physical stance that exudes a covetable level of chic.

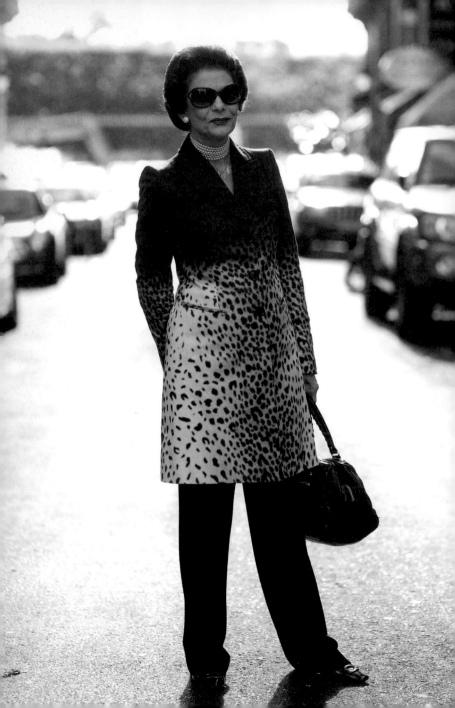

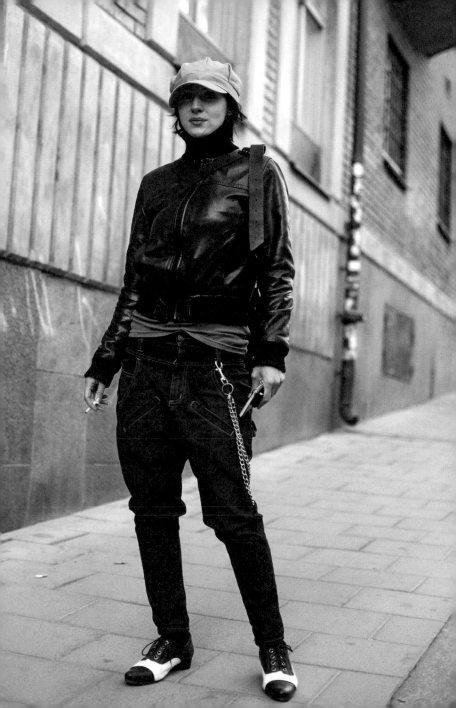

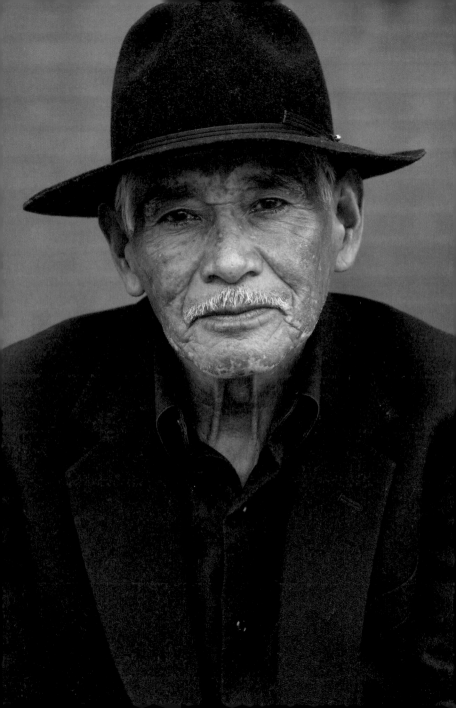

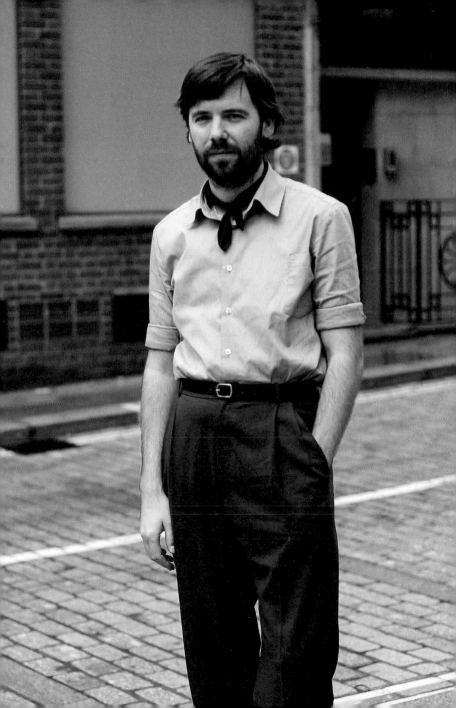

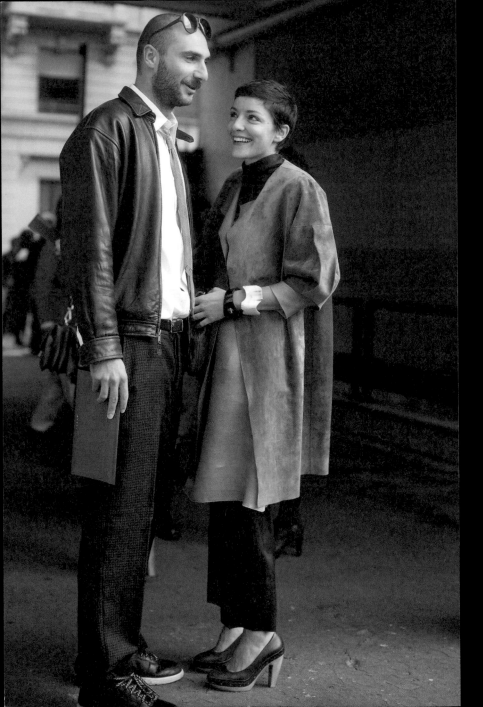

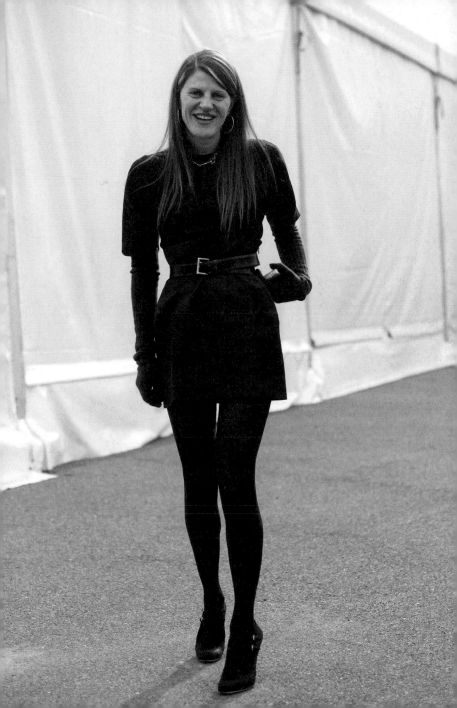

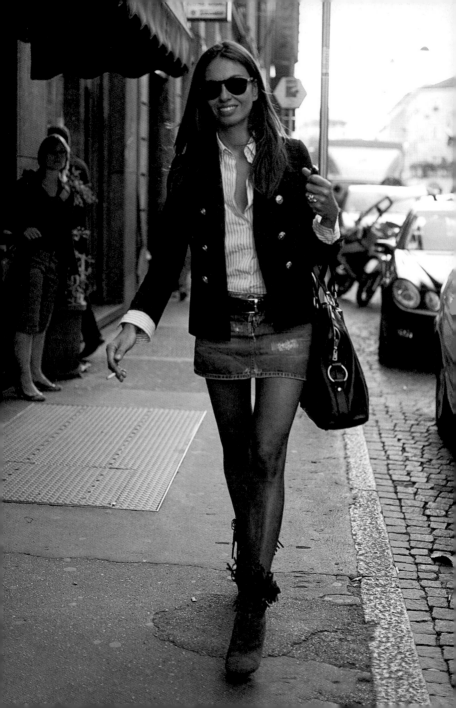

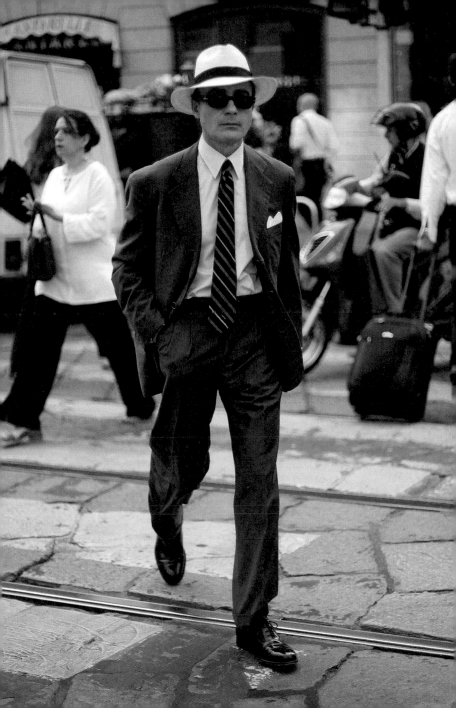

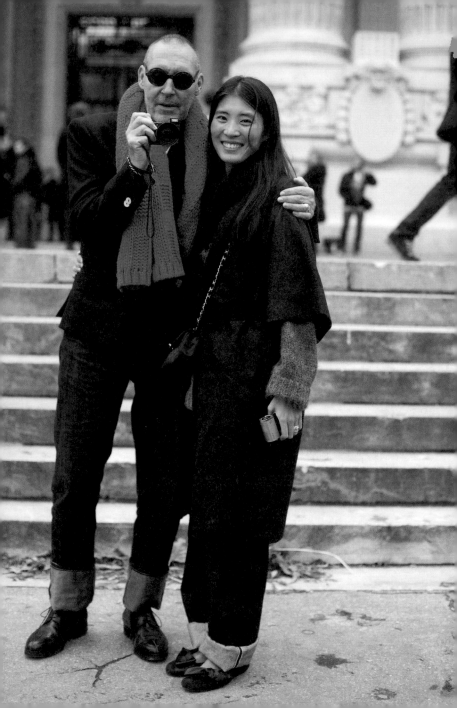

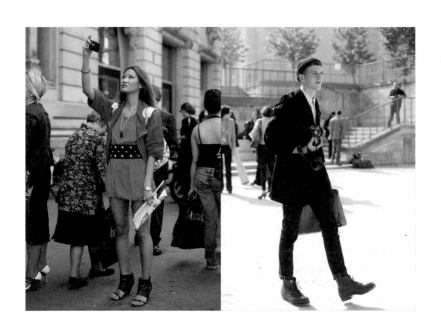

Five dollar doctor's coat, Stockholm

I saw this young man walking down the street in a very hip area of Stockholm, and I thought for sure this guy was a model. He looked like he'd just stepped off a Prada runway – slim, stylish clothes, incredible high cheeckbones and extremely stylized hair. There are lots of male models from Stockholm – I think it is a calculable portion of their gross domestic product. As it turned out he wasn't a model and was simply on his way to try to sneak into a party. As we talked I kept looking at his coat and finally asked if it was Prada or Jil Sander. It had the clean lines and austere colour that are hallmarks of those two collections. Apparently, it was a doctor's lab coat that he picked up for $5 at a flea market. I had never seen such a cool lab coat or at least not such a cool lab coat that colour. I didn't think to ask him if he had dyed it himself.

Again, his ability to carry off this look so well was not about the coat itself but how he wore it with a cool nonchalance. I know if I tried to wear a lab coat outside as a regular coat I would feel so self-conscious that people would think that I had just stolen something.

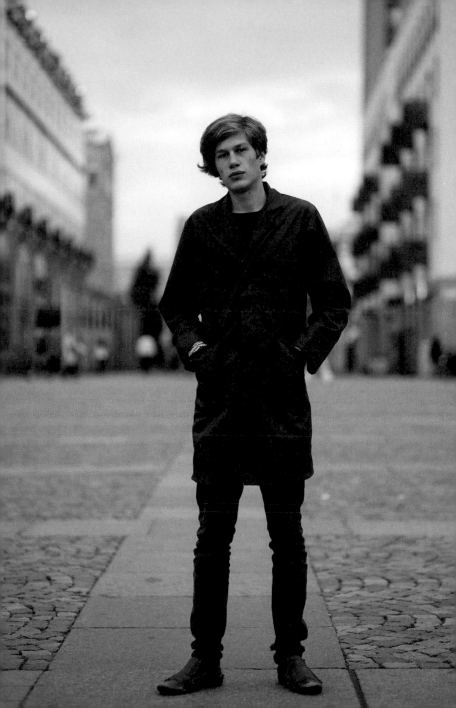

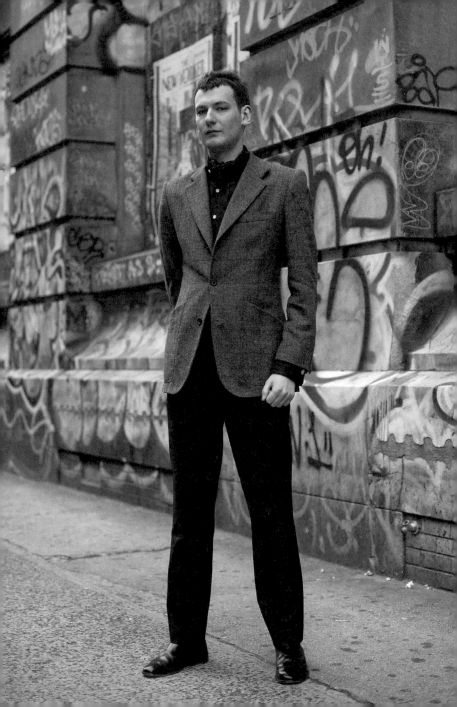

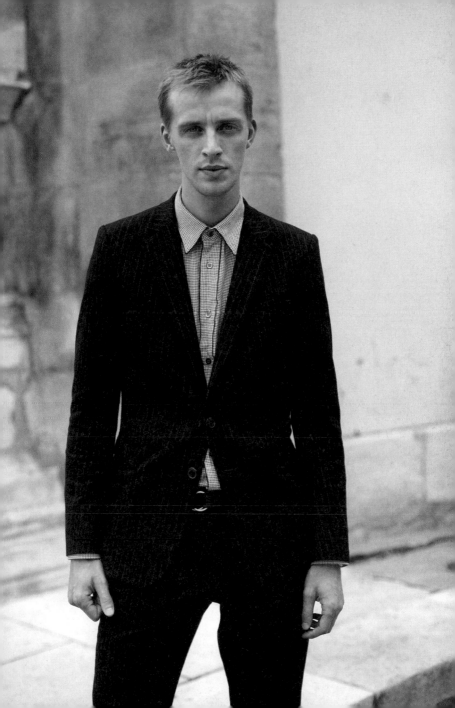

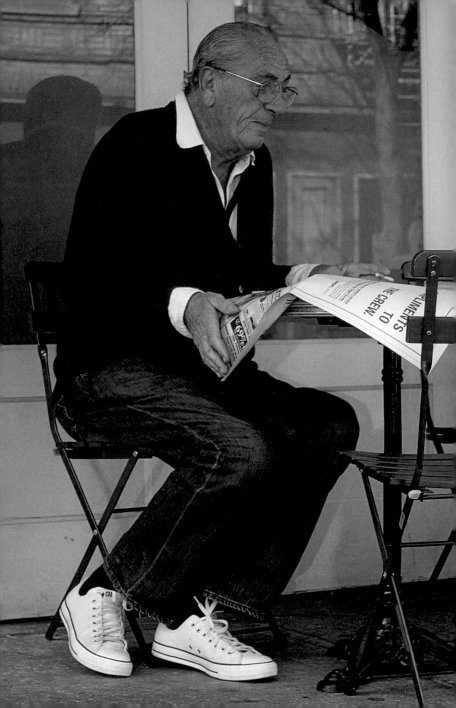

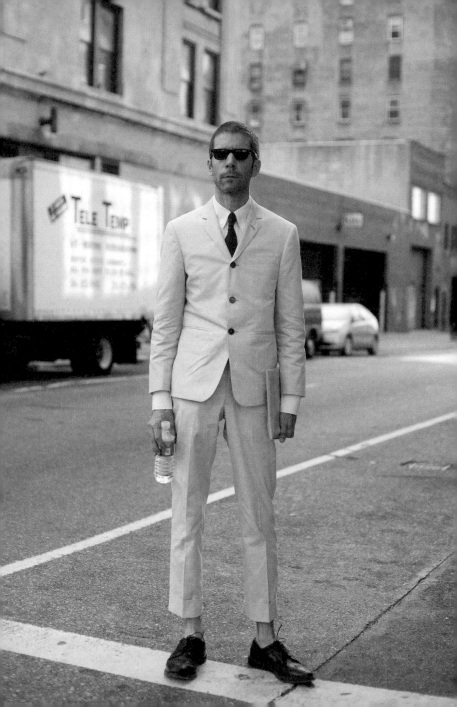

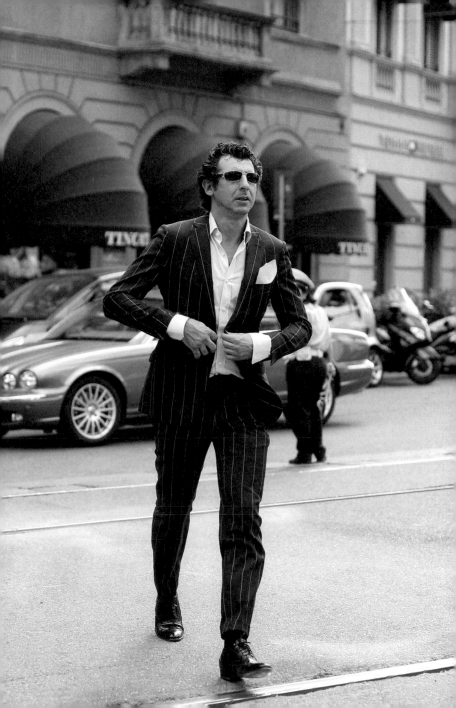

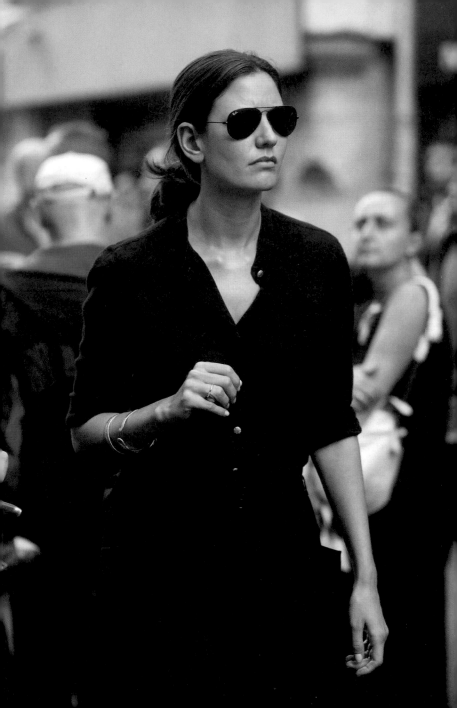

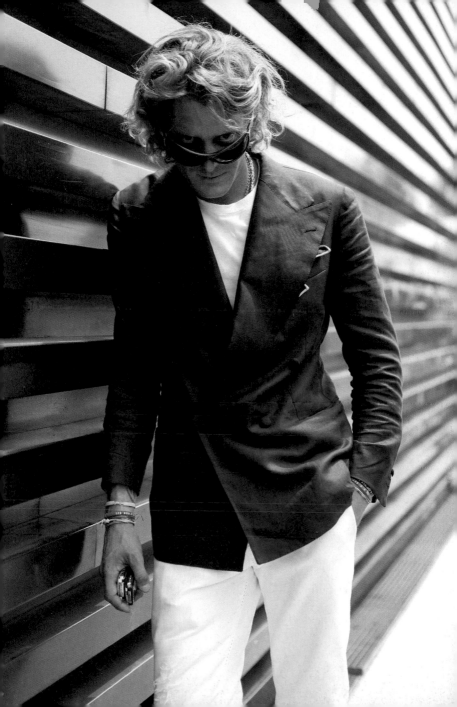

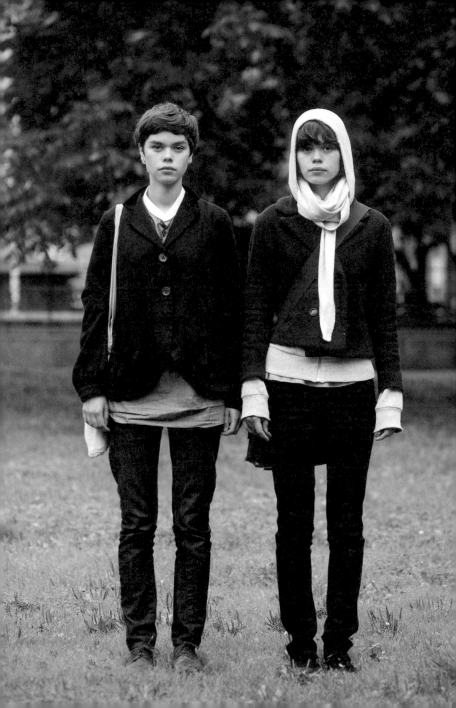

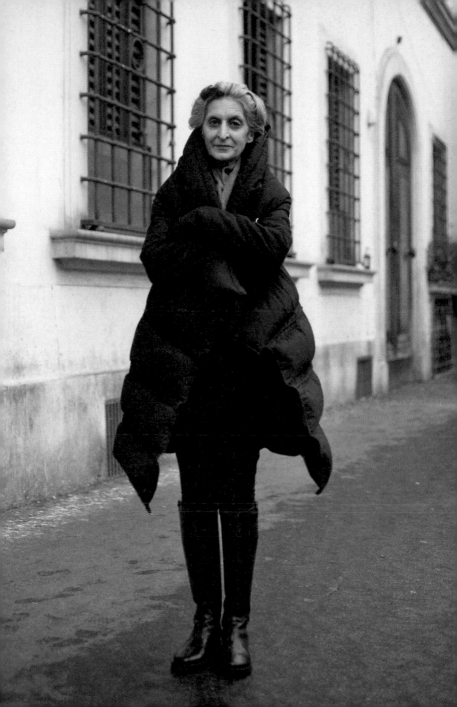

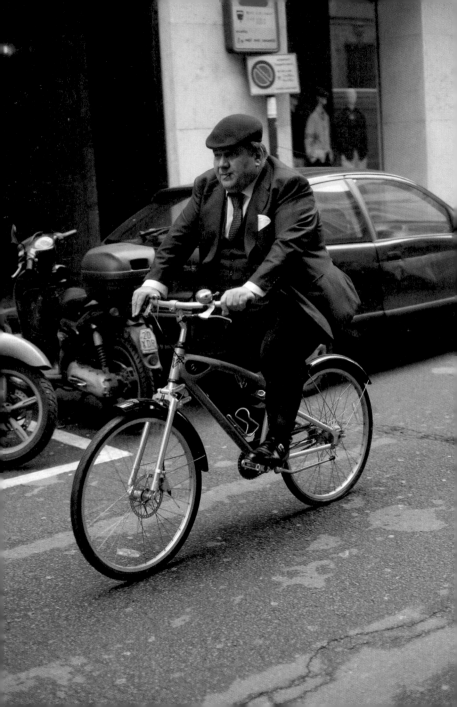

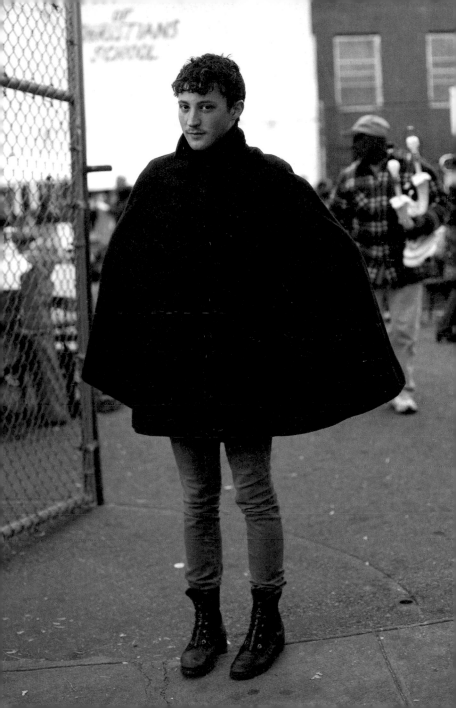

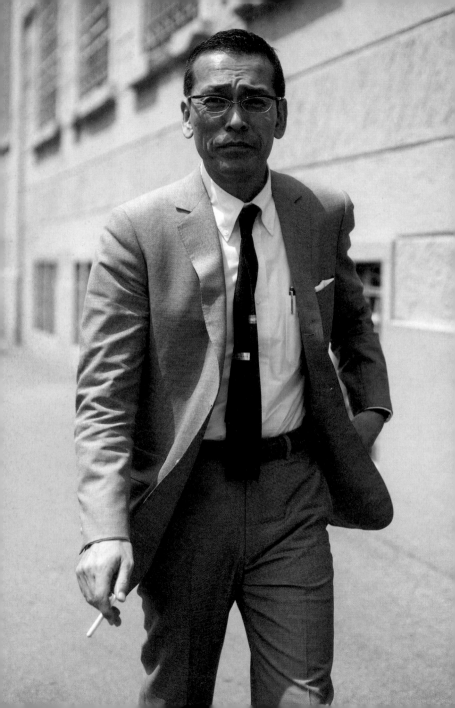

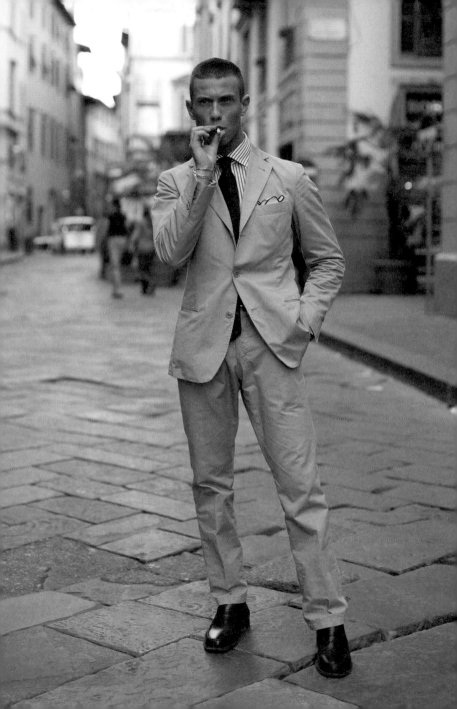

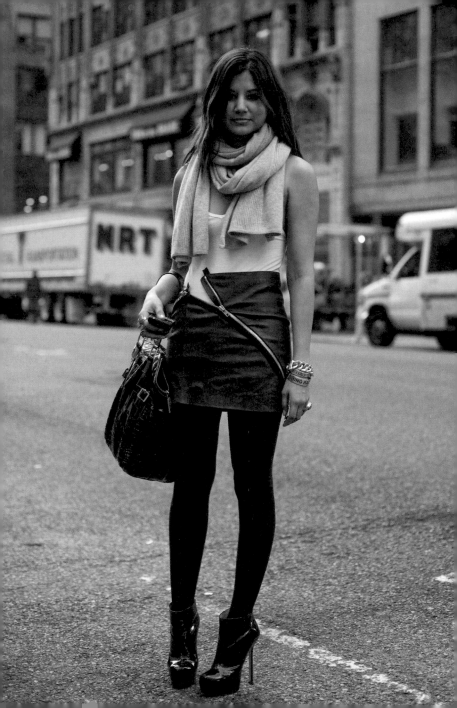

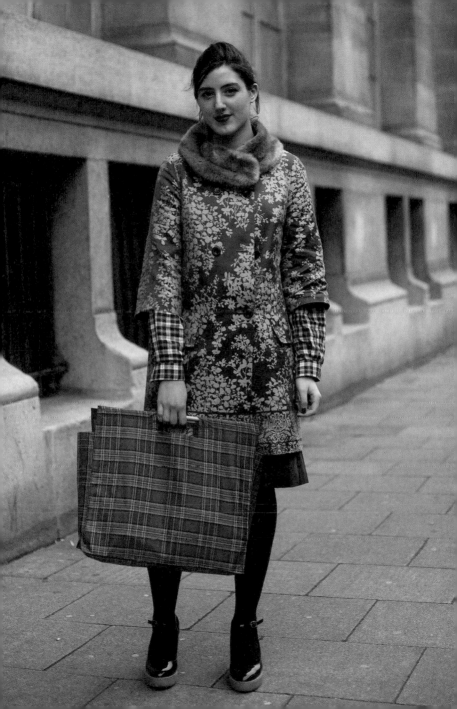

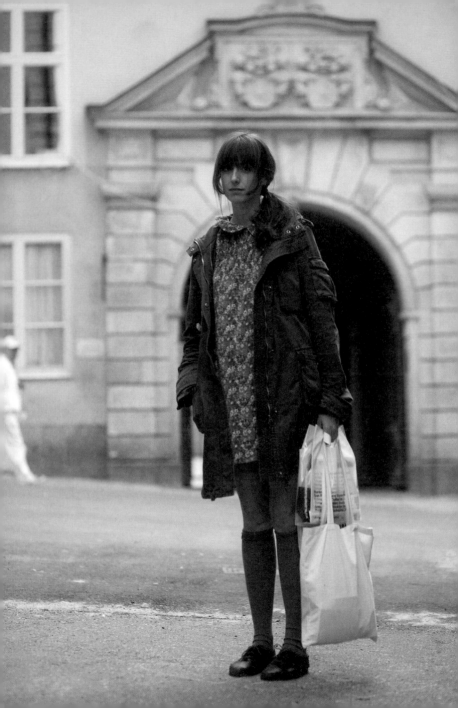

Conflict of expression, Stockholm

I was in Södermalm, the hipster area of Stockholm, and saw this young lady walking quietly down the street. She had a very shy demeanour and yet she was very noticeable to me because she just wasn't dressed like the other trendy young women of Stockholm. Stockholmians have great style, but they are also extremely fond of following the locally accepted 'hot trend' and not straying from the three or four current looks. Anyone that is outside of the accepted 'cool' is instantly noticeable.

When I asked to take her photo she was hesitant but accepted on the condition that we step around the corner so no one could see her. She was very shy, but I thought it was charming that she had a difficult time looking directly at the camera. I think that most people feel that great style has to be big, obvious and make a loud statement about the wearer. I often hear people say that someone has to really know themselves to attain and communicate a great personal style. Yet a young lady like this shows that a conflict in personality – wanting to remain anonymous and yet consciously dressing in a noticeable way – can lead to equally great expressions of personal style.

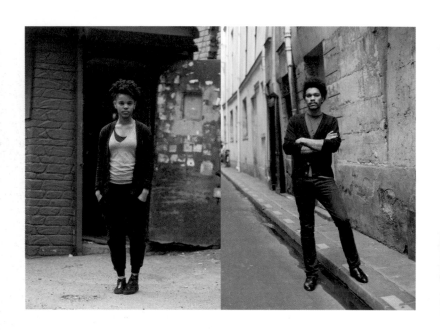

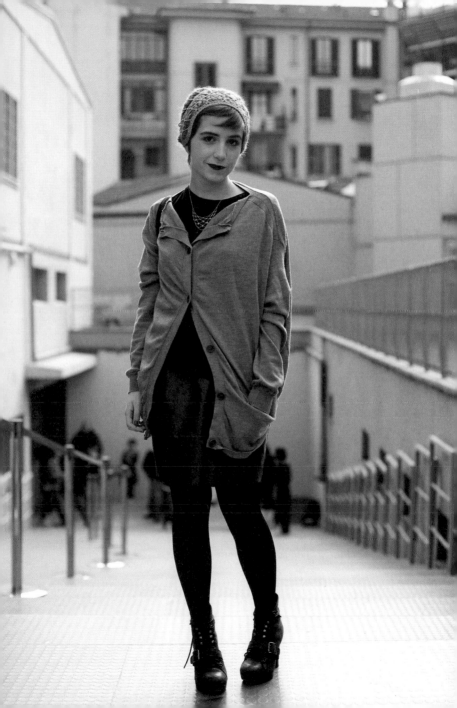

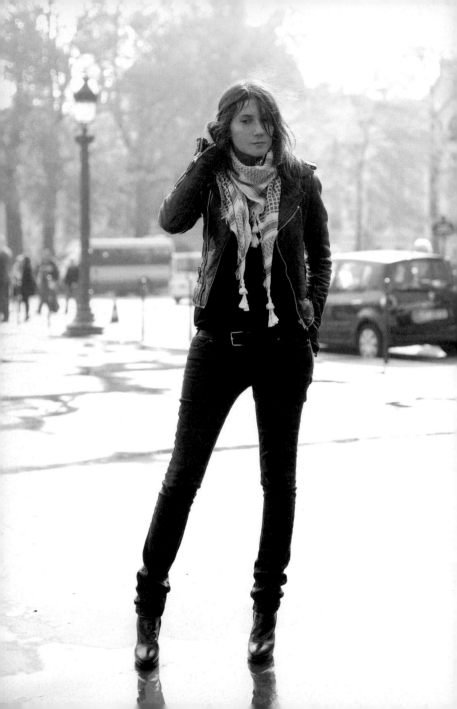

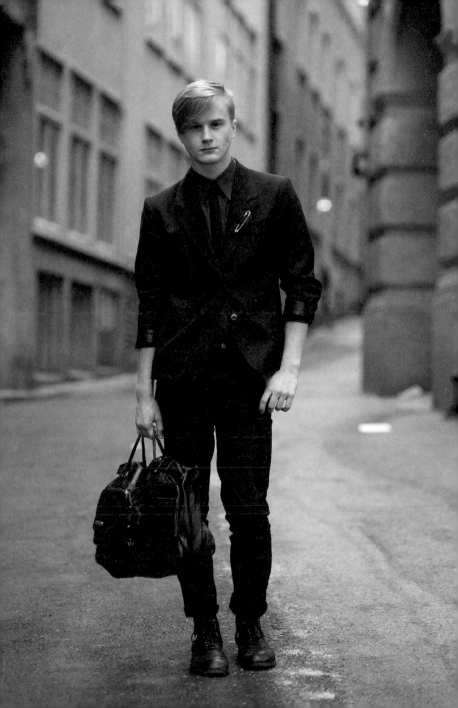

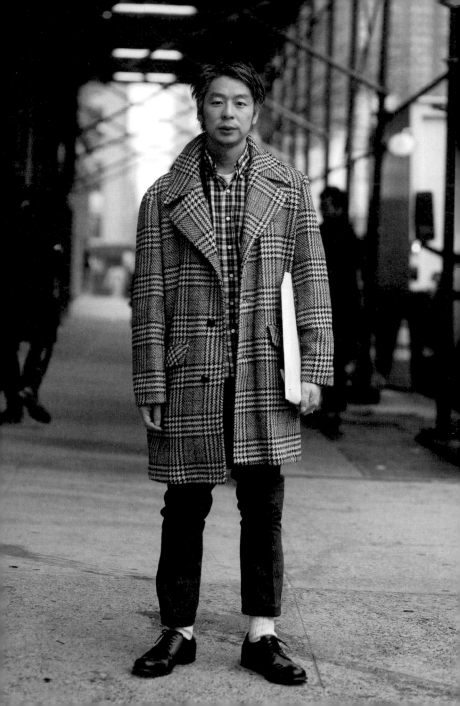

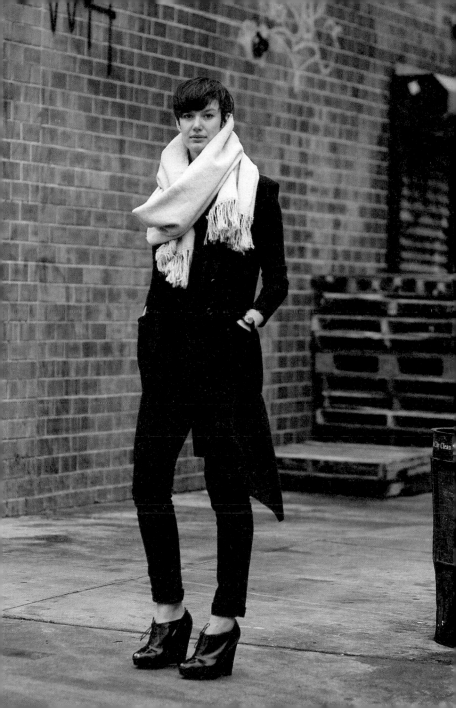

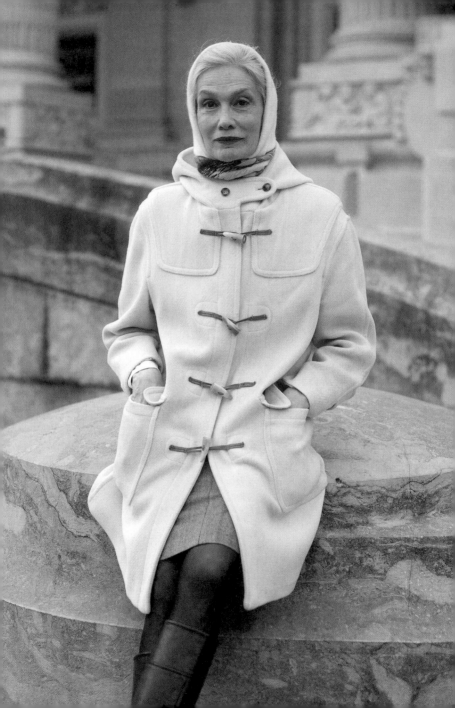

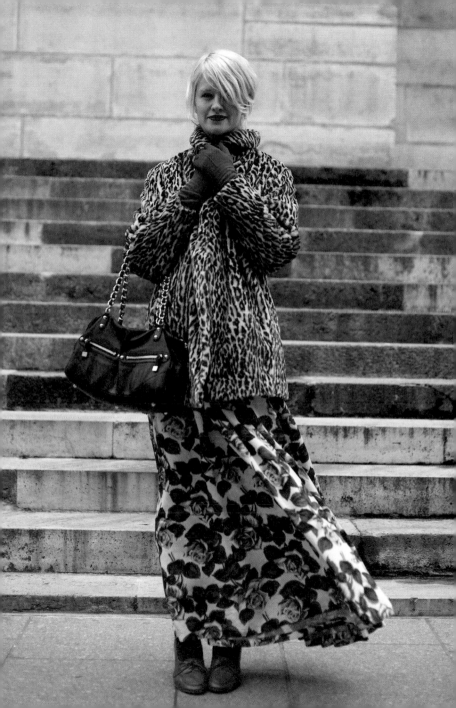

The original,
New York

Bill Cunningham is the modern master of fashion street photography. I can't say that he had a direct influence on my photography, but he has had a strong impact on my fashion awareness since I first moved to New York in the early nineties. When I moved to NY after college I never imagined I would end up as a photographer. When I looked at Bill's photos each Sunday in *The New York Times* it was not with a photographic eye but with a fashion eye. If I am ever able to carry on in his tradition it will be because I am able to capture street style not with a photographer's eye but with a fashion editor's eye, and that is what Bill has done so successfully at the *Times*.

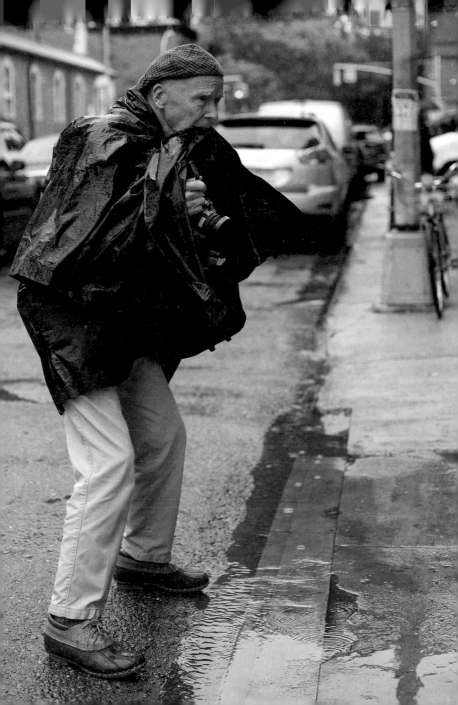

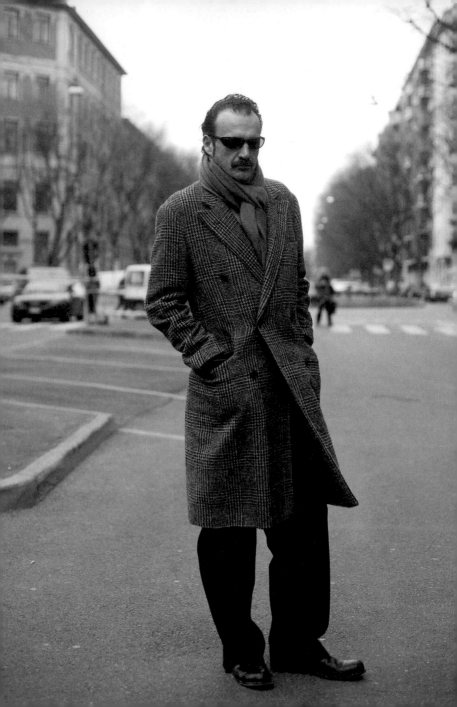

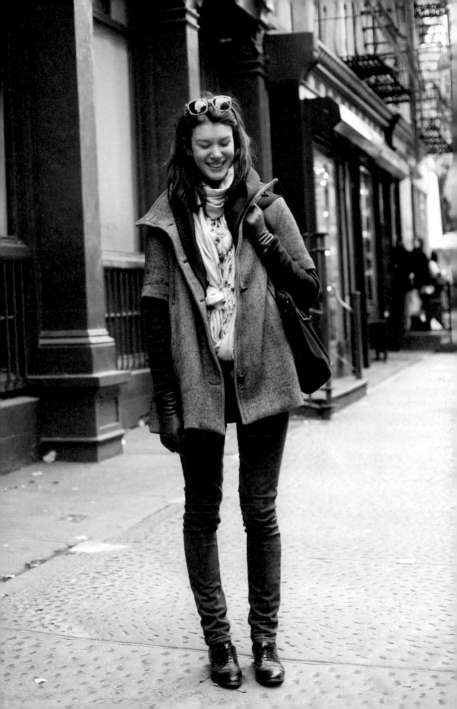

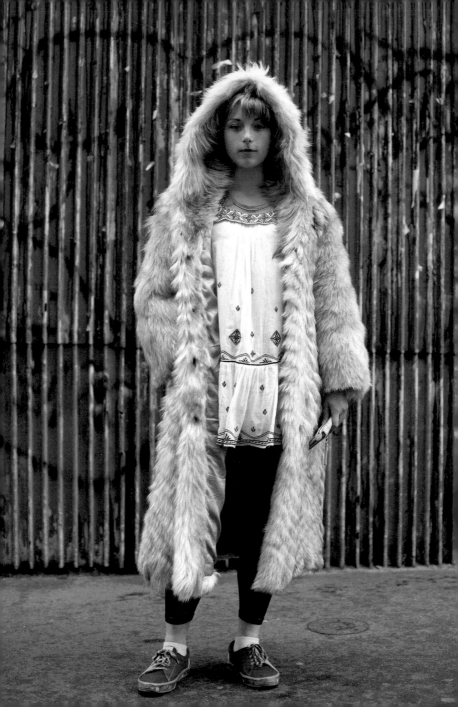

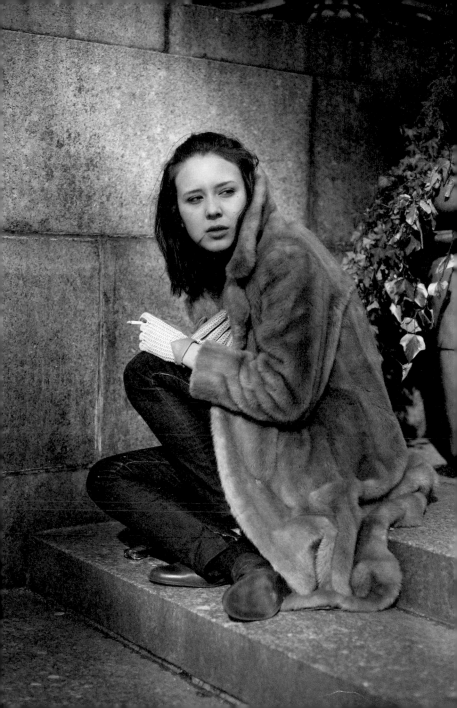

Creative uniformity, Milan

Even in the rigidly uniformed Italian military there are small allowances made for the expression of personal style. I loved how these young men could created a visually cohesive unit while still being able to express a sense of personal flair by intricately weaving these golden braids around the jacket's buttons. I can just imagine the internal contest to outdo each other with the most intricate pattern.

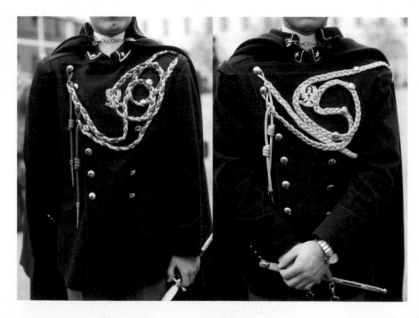

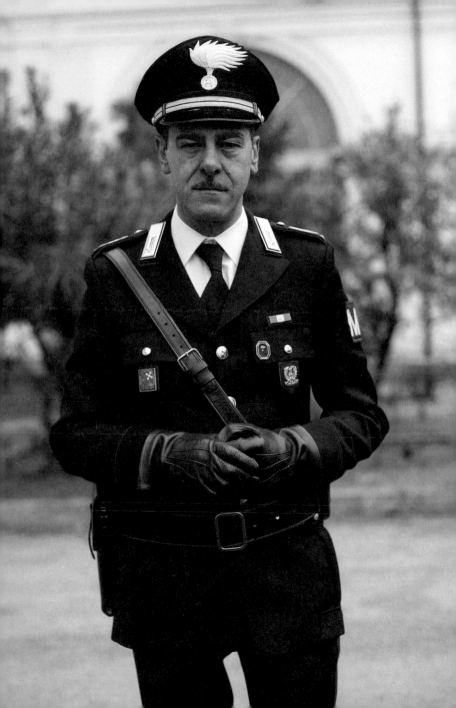

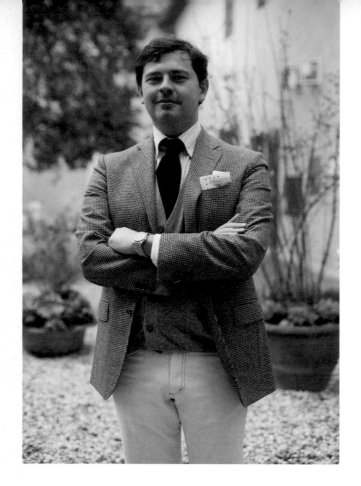

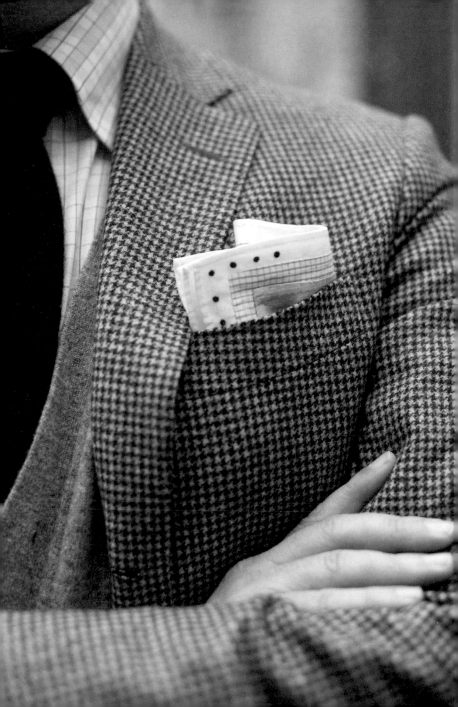

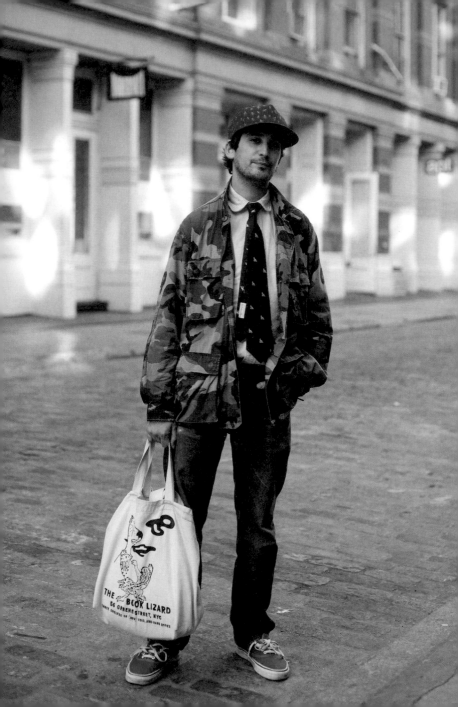

Luciano Barbera, Milan

Mr Barbera has such a wonderfully classic Italian style. What he does stylistically is so subtle that the untrained eye can easily miss it. One thing that he is well known for is wearing his watch on the outside of his shirt cuff, alla Gianni Agnelli. Though few will notice one of his brilliantly orchestrated shirt/tie/jacket combos, everyone spots that watch on the outside of the cuff. It seems funny to me that something so practical as that is considered by most as affected. I guess for those people function follows fear.

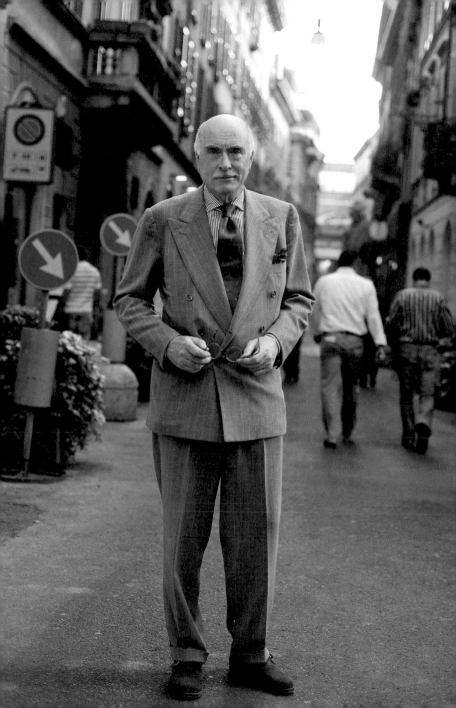

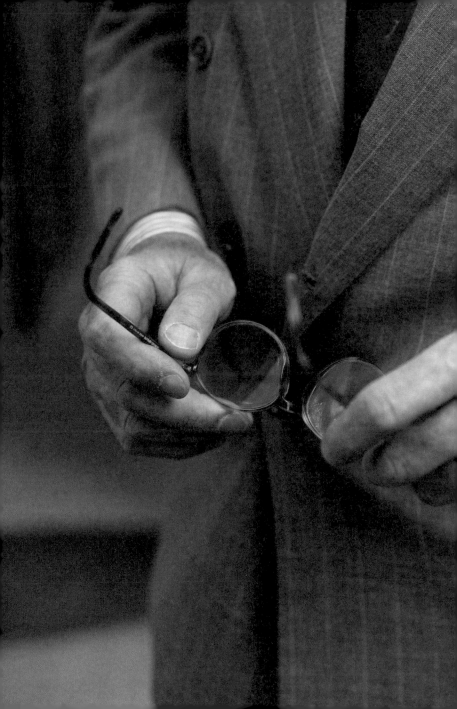

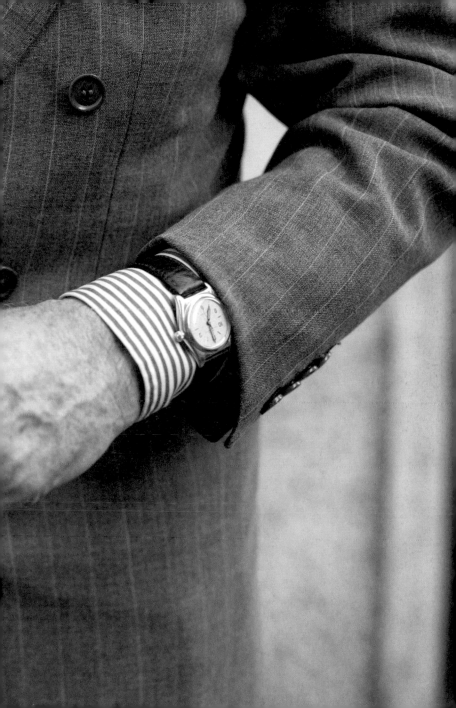

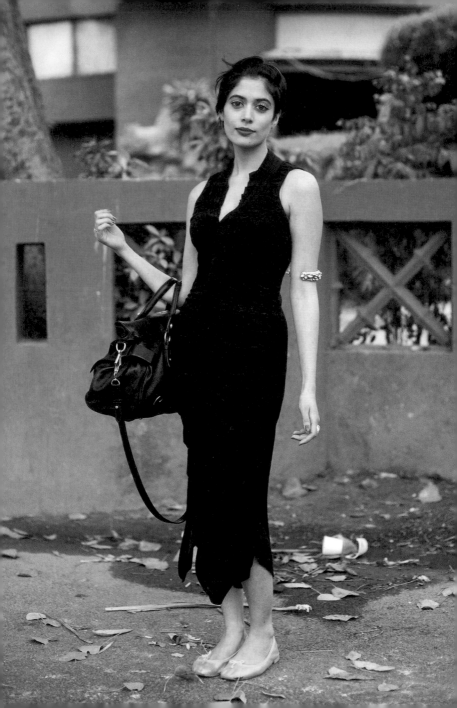

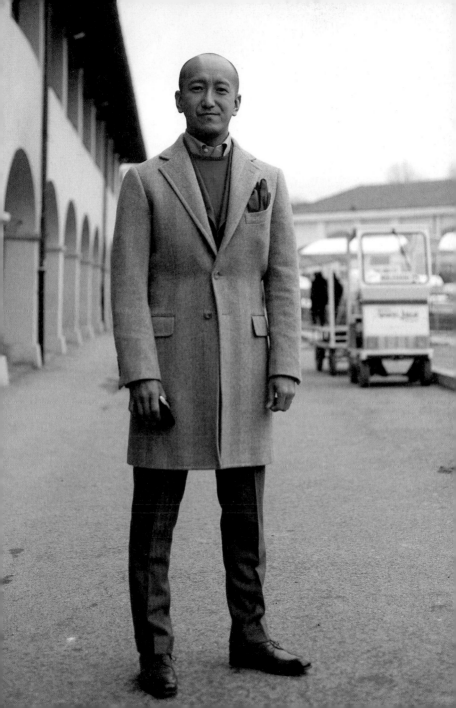

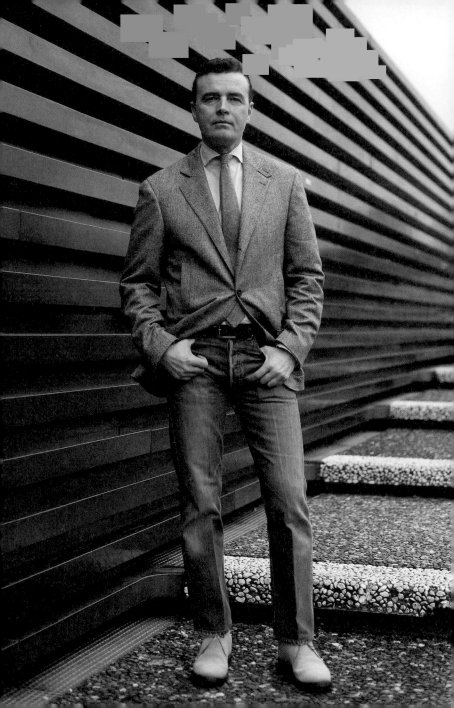

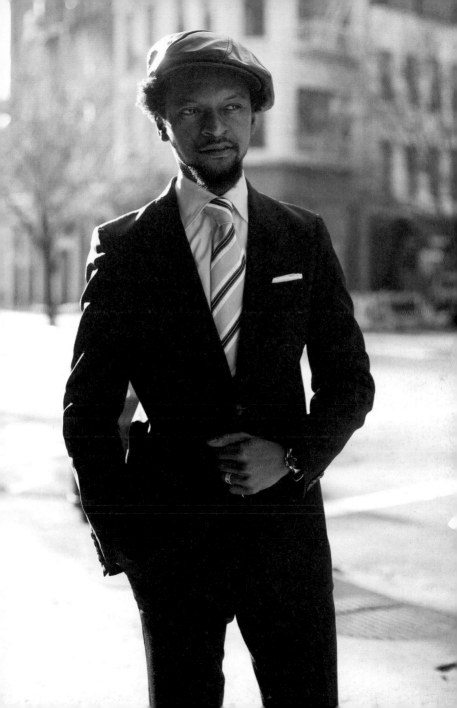

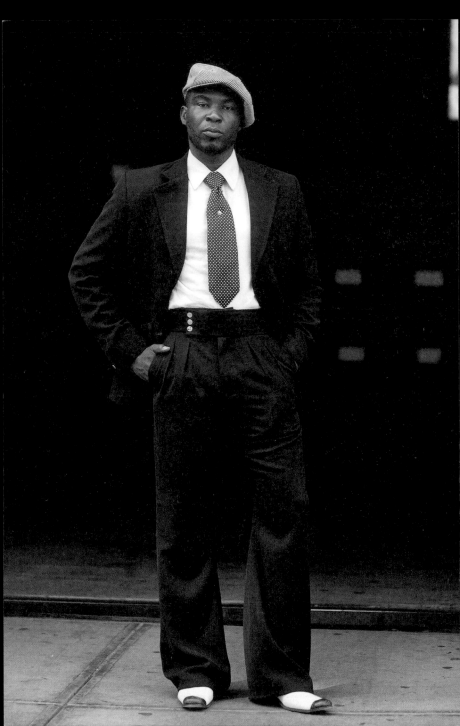

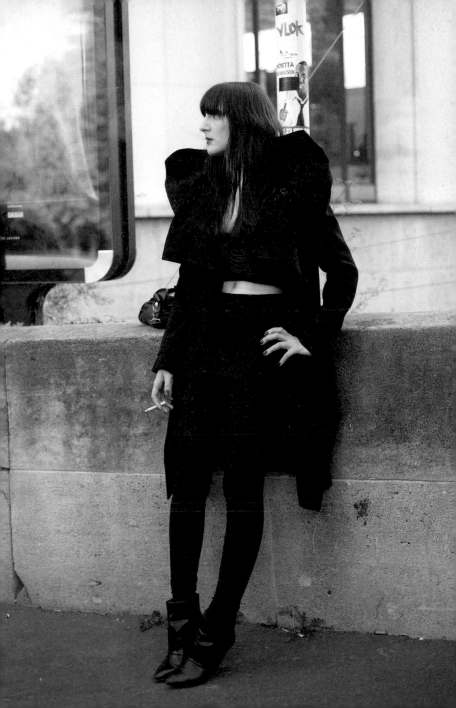

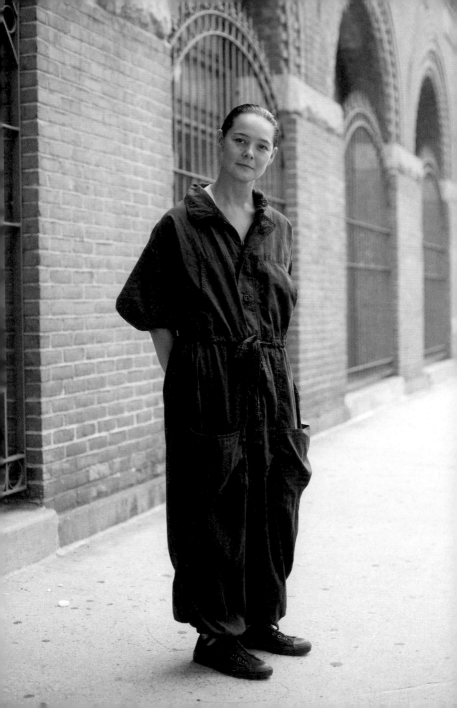

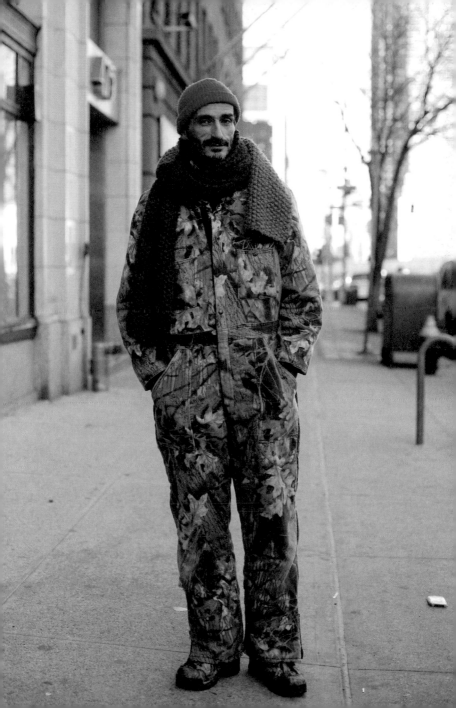

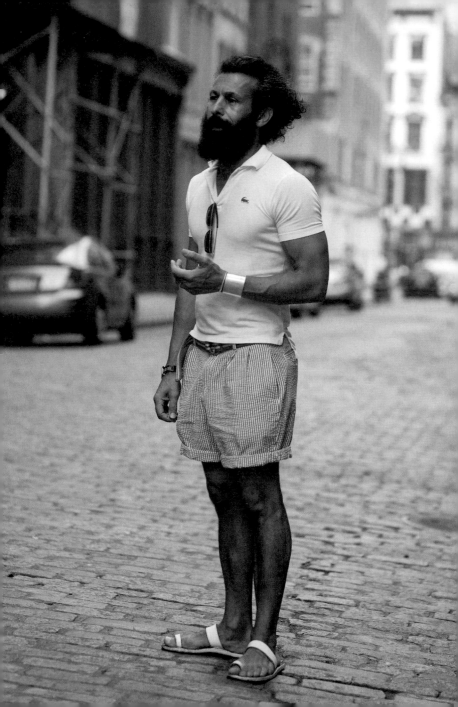

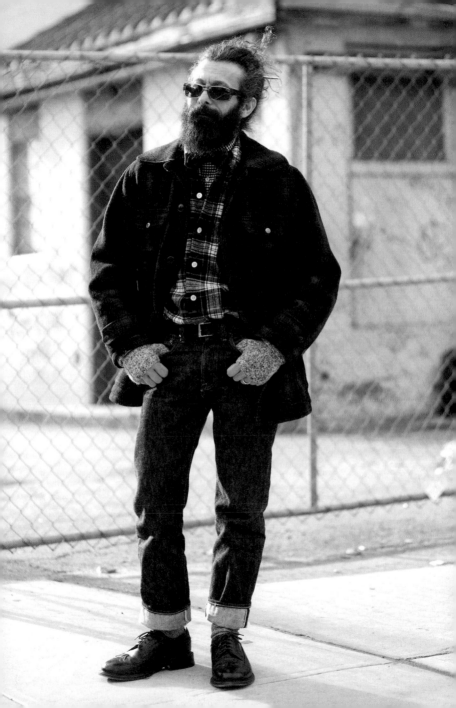

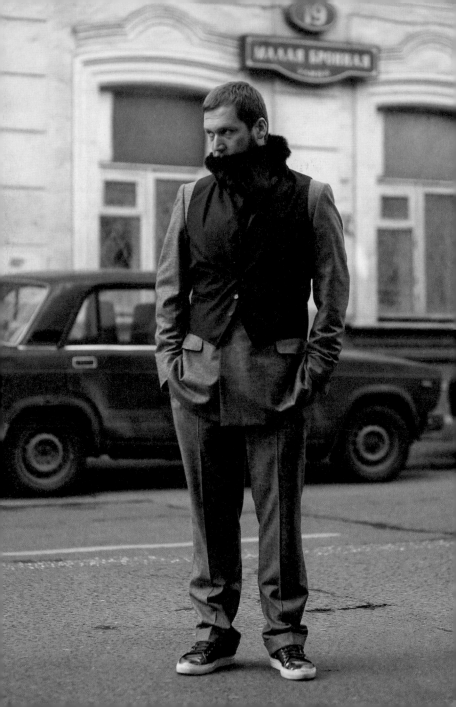

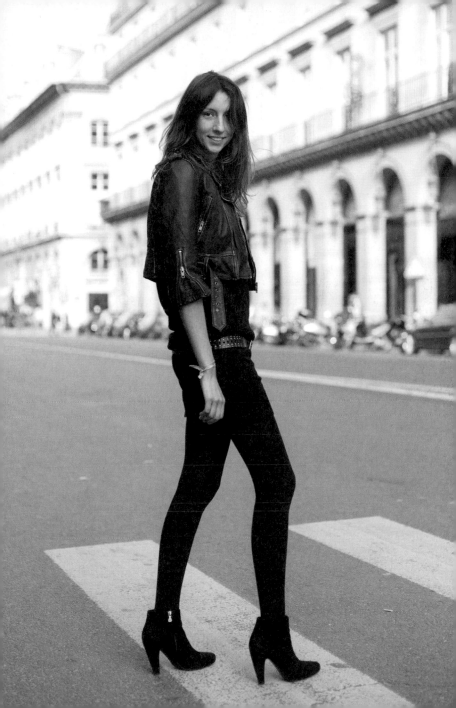

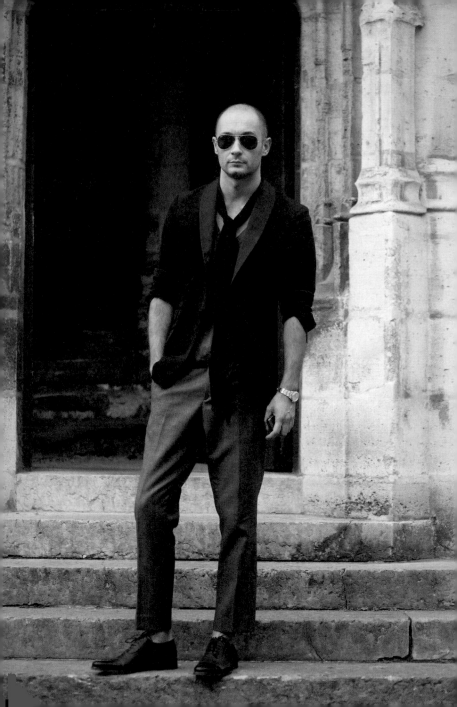

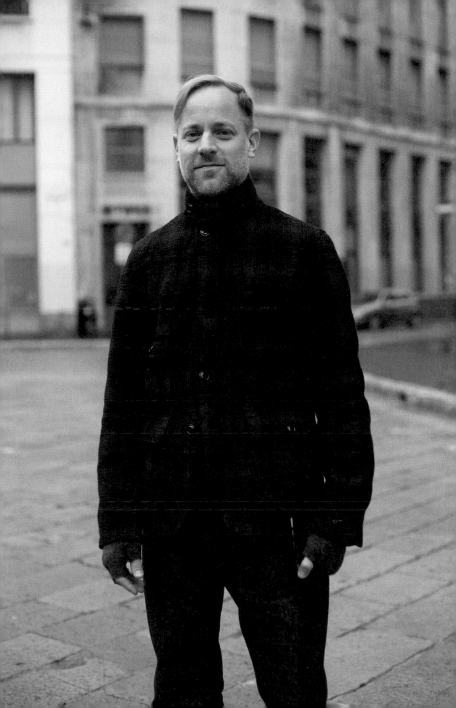

Eva

I absolutely love to shoot Eva; she has one of those killer smiles that just melts your heart. To be honest, though, a lot of girls have a great smile. Eva somehow combines an Audrey Hepburn charm with the style of a budding star stylist. She has one of those personal styles that is maddening to try to describe. She can wear a look that on paper should never be tried but that somehow on her just works – I mean, it just works. I have had friends try to duplicate some of the looks that she has created but with disastrous results. When the basketball player Michael Jordan was at the top of his game, they used to say, 'You can't stop him, just try to contain him.' Well, with Eva, don't try to copy her; just try to enjoy the show.

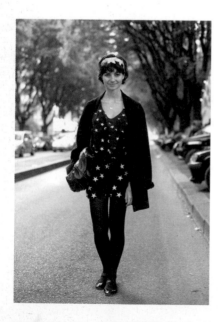

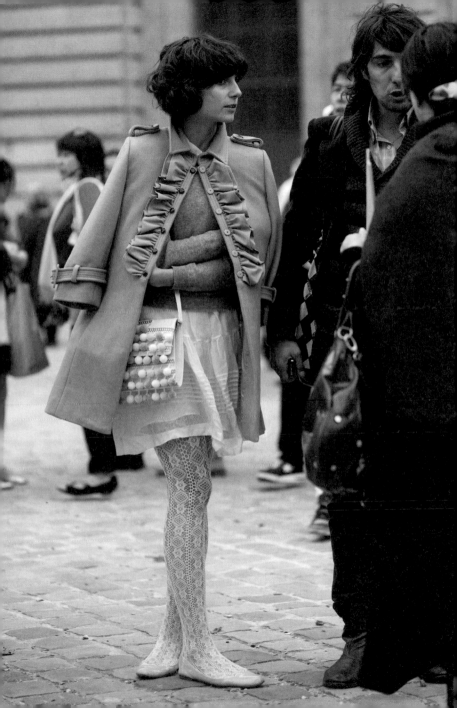

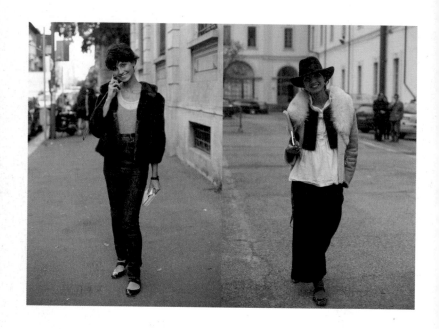

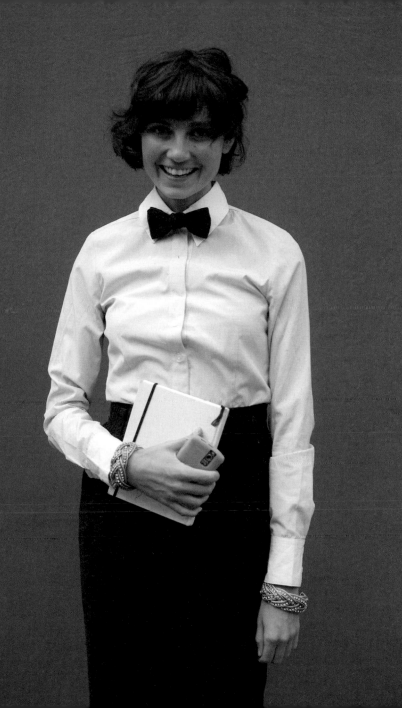

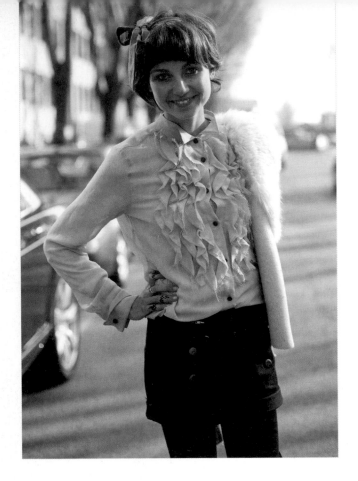

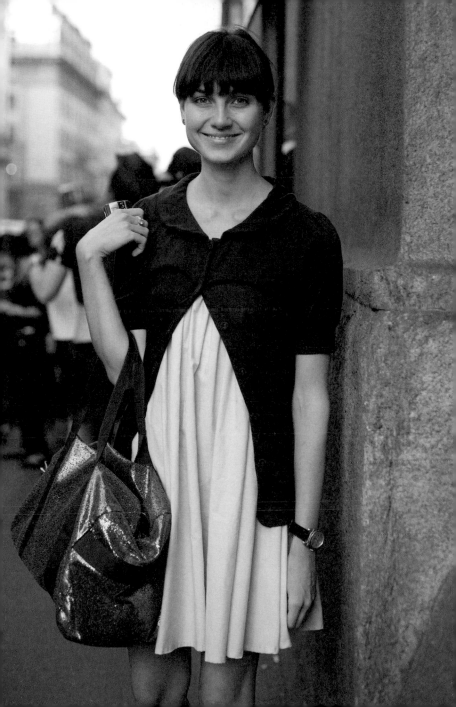

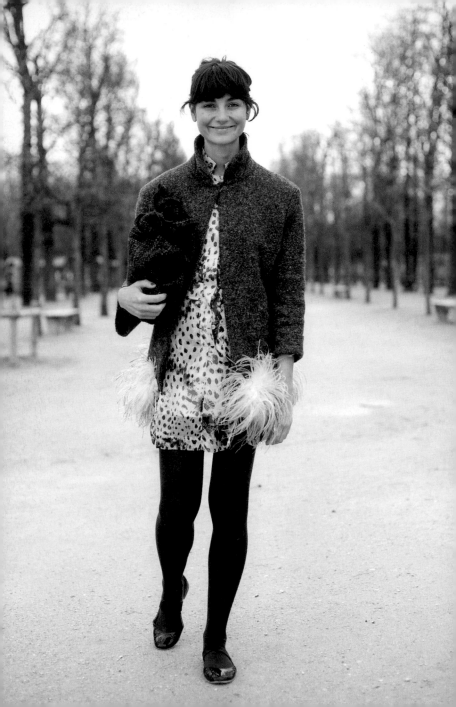

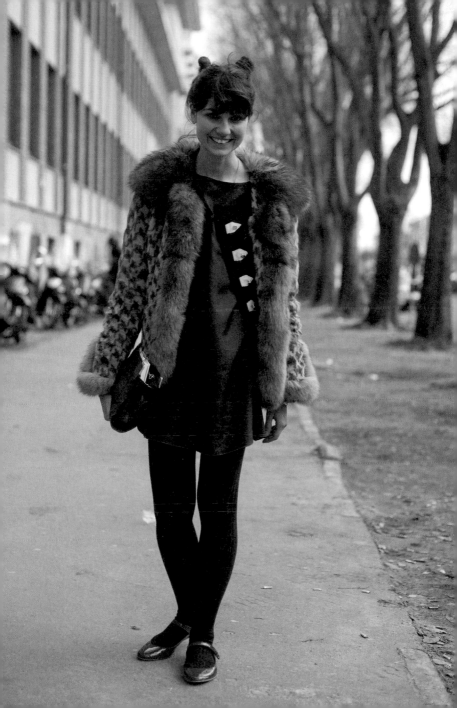

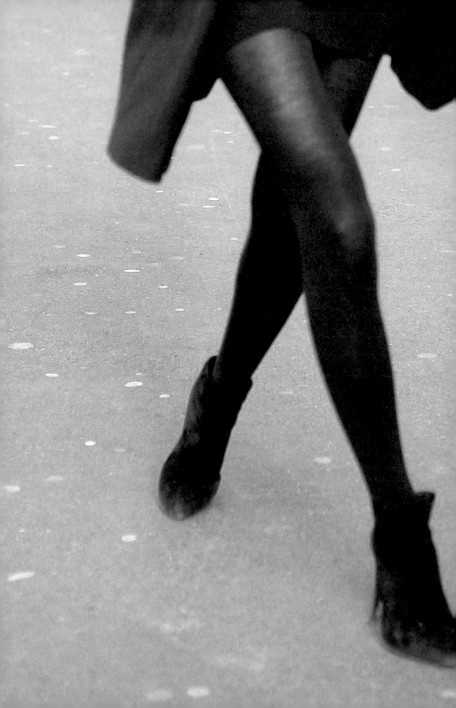

Studio A, Paris

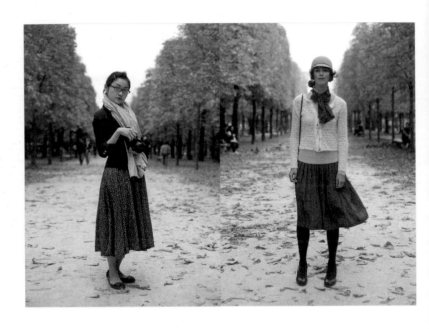

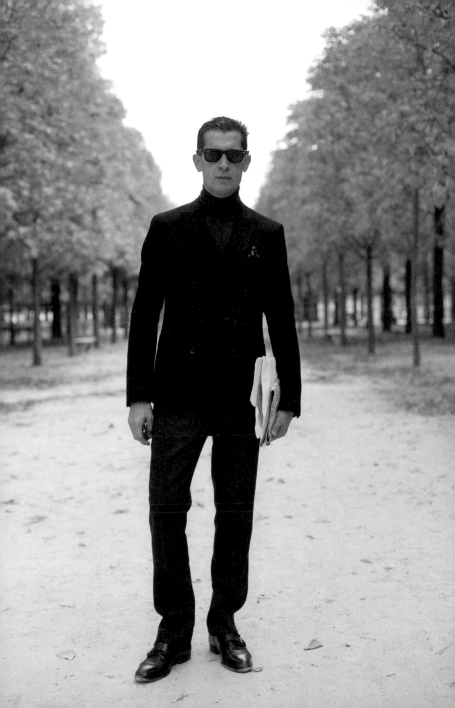

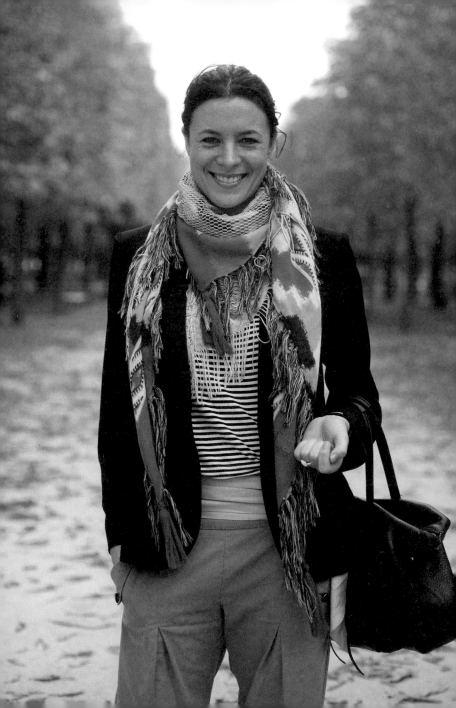

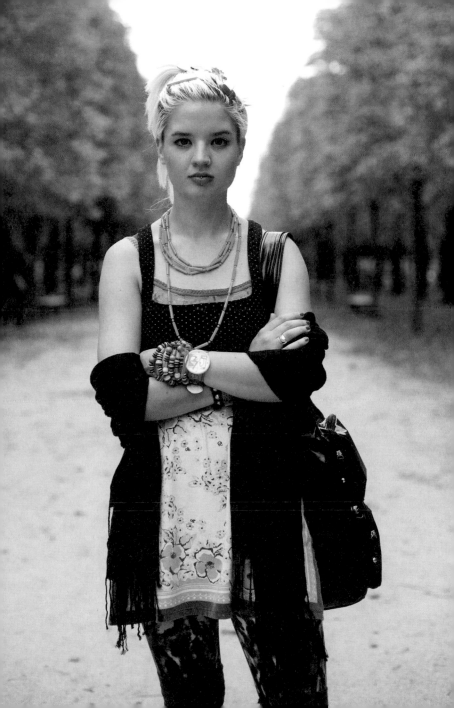

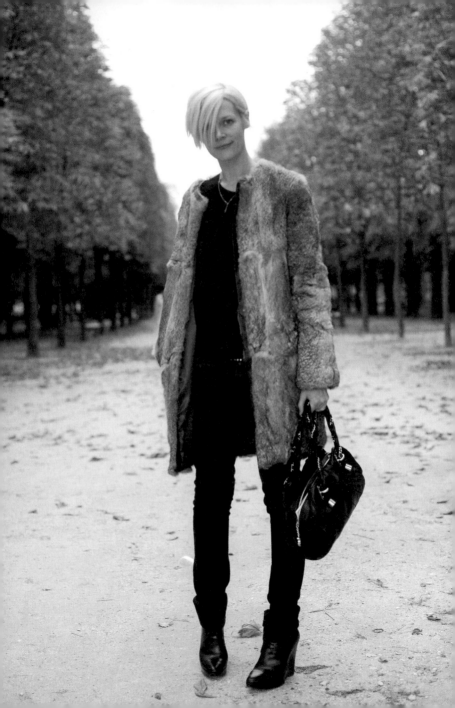

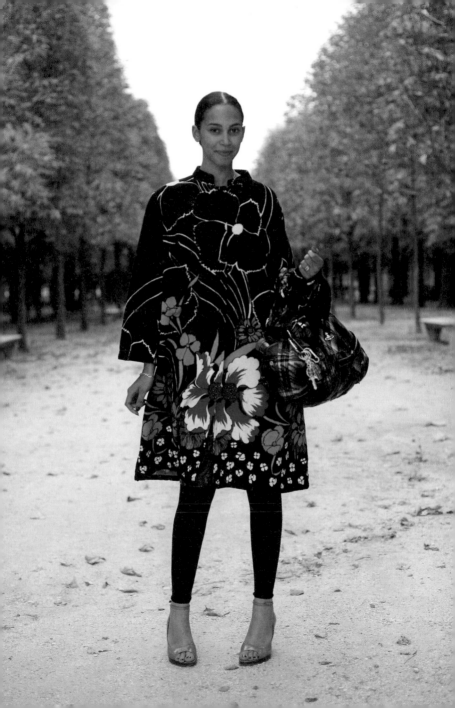

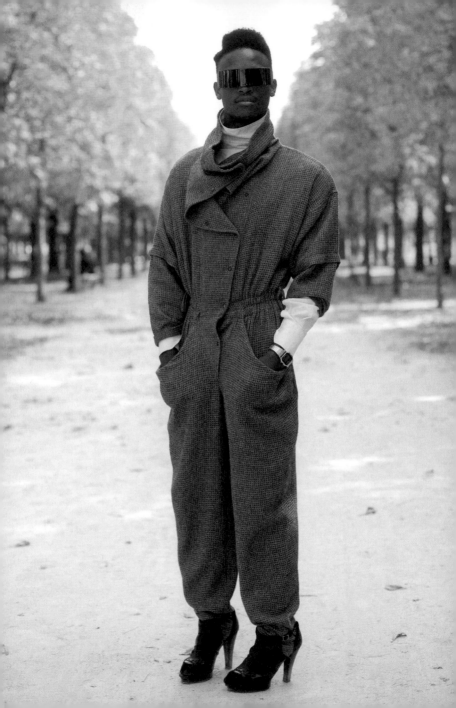

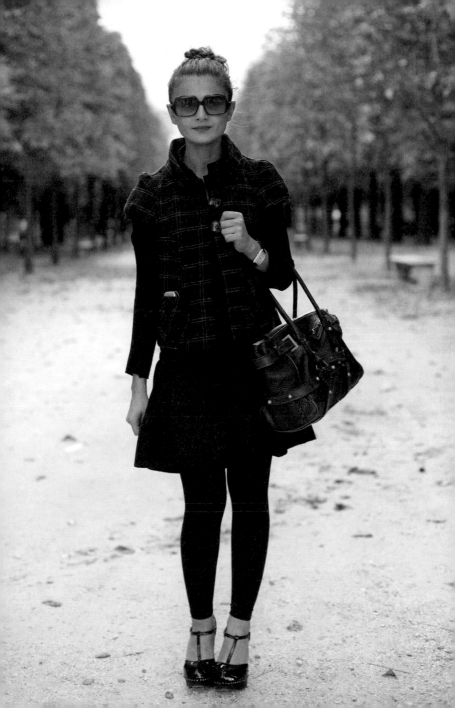

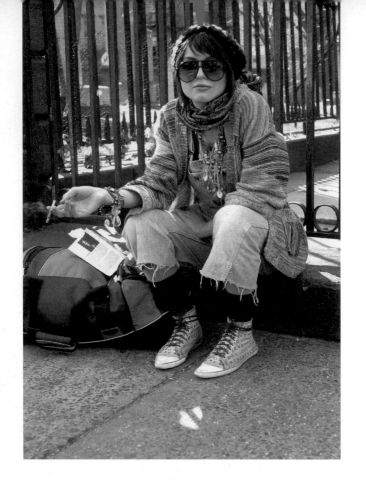

One Year Later, New York

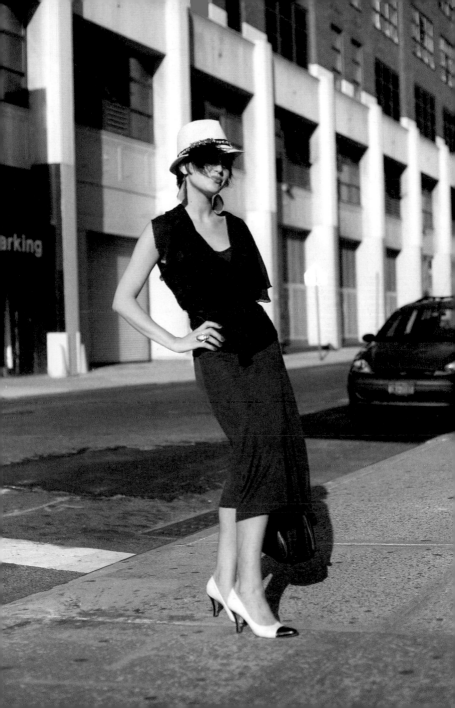

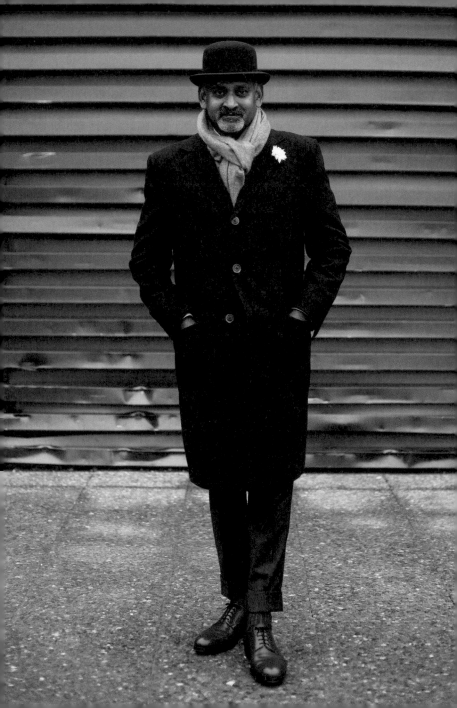

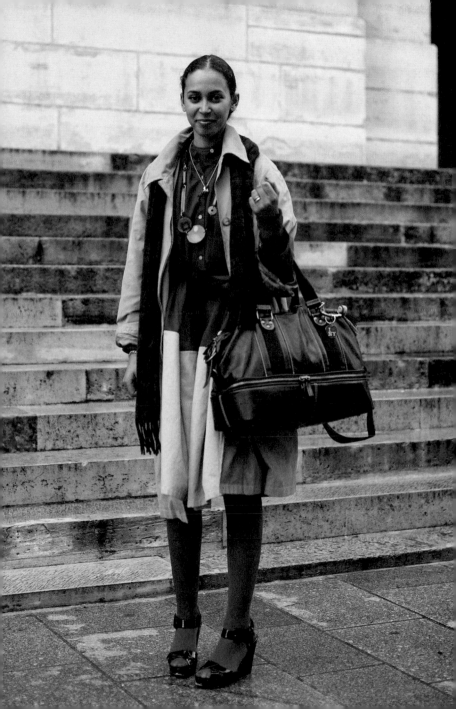

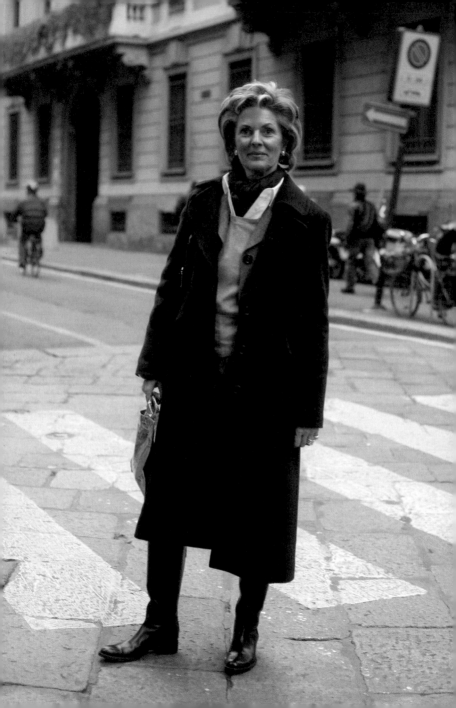

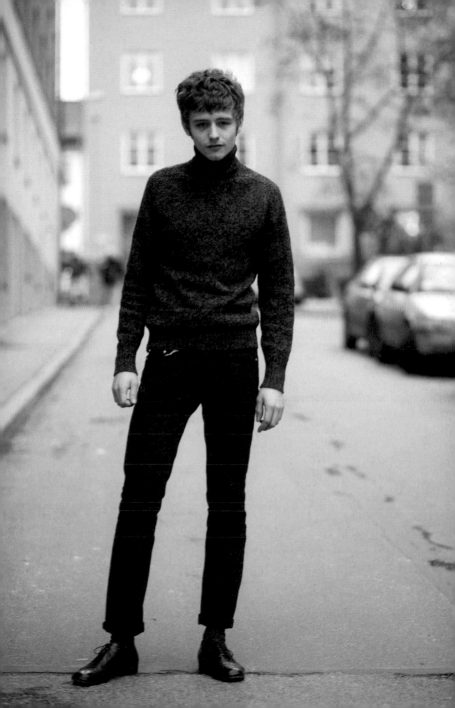

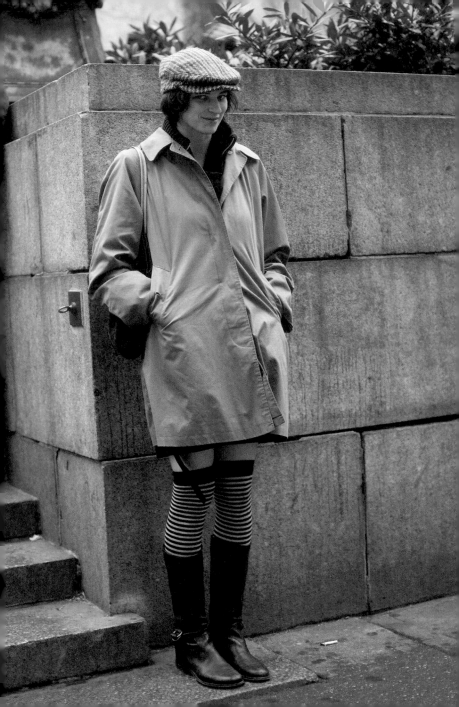

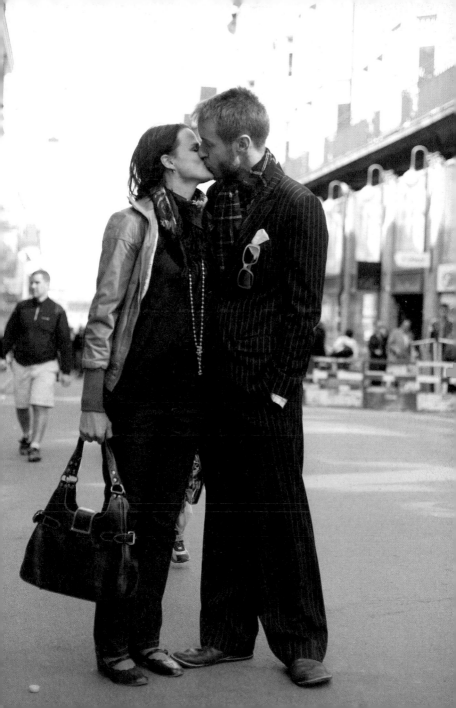

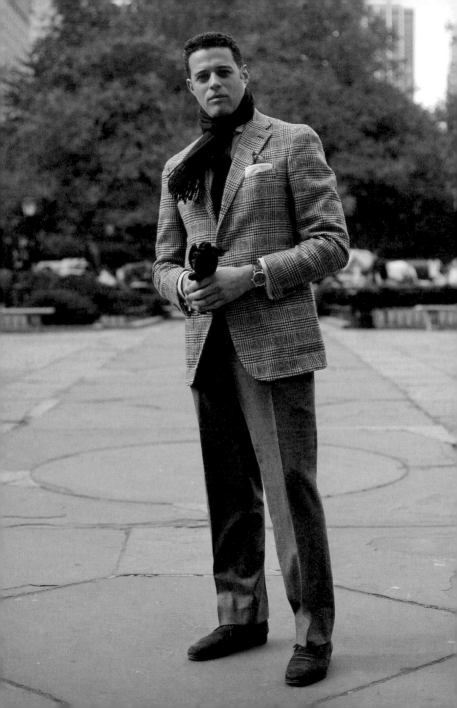

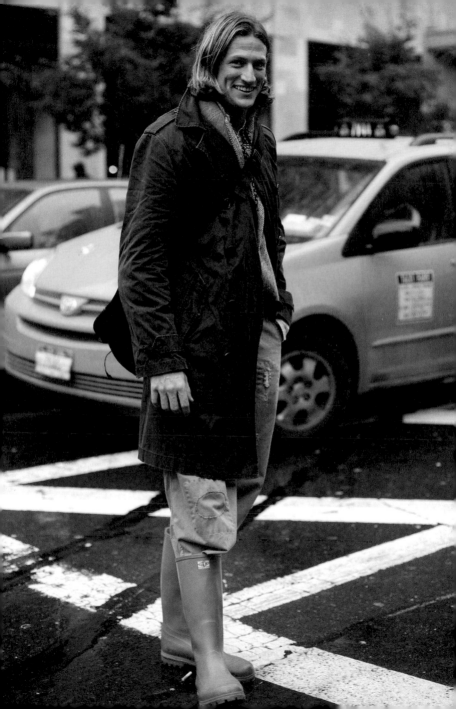

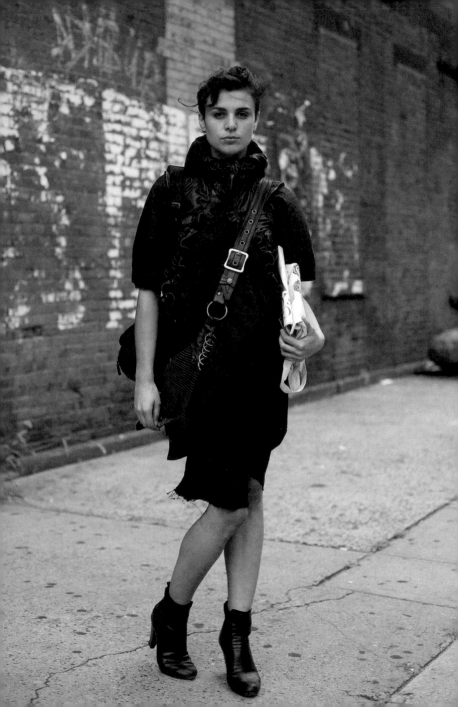

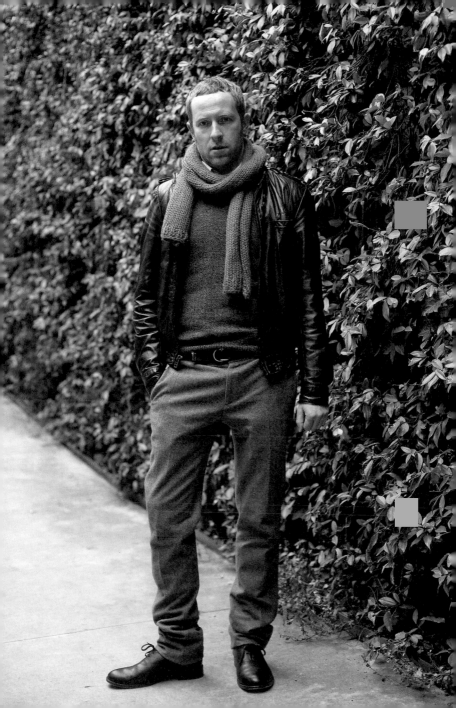

Luca Rubinacci, Florence

I hate to put so much pressure on young Luca Rubinacci but, to me, he needs to be the future if Neapolitan tailoring is to survive. Luca is the third generation of Rubinacci tailors, whose store is in the heart of Napoli. Luca has developed a style that is both a celebration of hand craftsmanship and funky Italian boho playboy. Luca loves talking about a hand-rolled lapel or vintage fabrics, but he is just as happy talking about a recent kite-surfing trip to South America. I guess what Luca has done is take the preciousness out of a bespoke lifestyle. So many modern guys become stiff when they put on a suit. Luca on the other hand wears a suit like he wears pyjamas (not like I know if he wears pj's or anything).

What I think people respond to in my photos of Luca is one part style and two parts pure swagger or, as the Italians say, *spezzatura*!

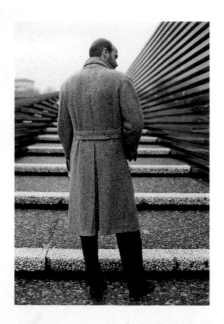

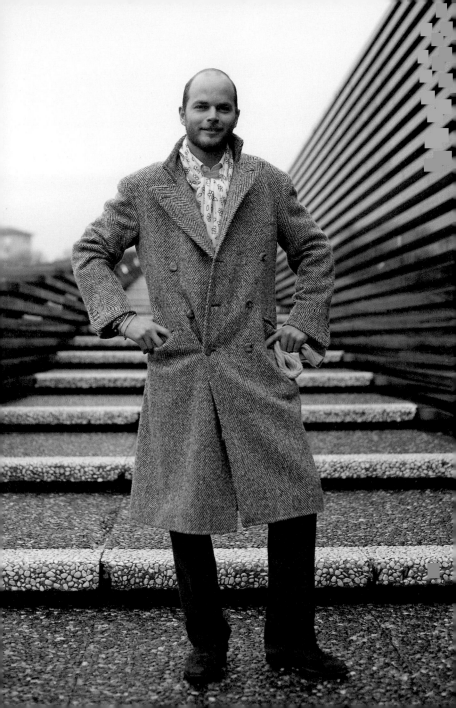

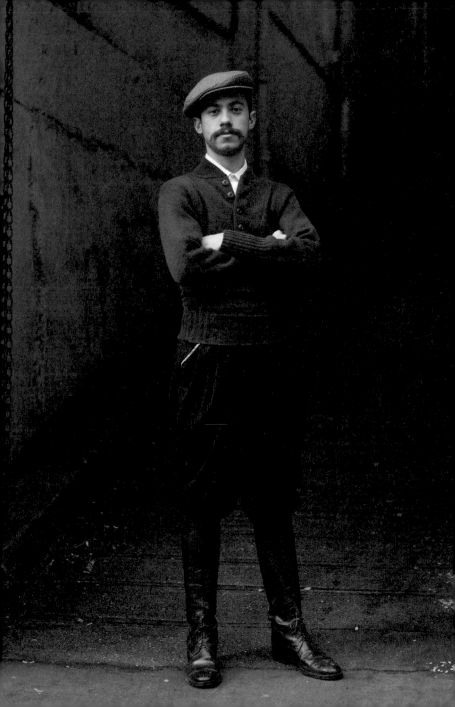

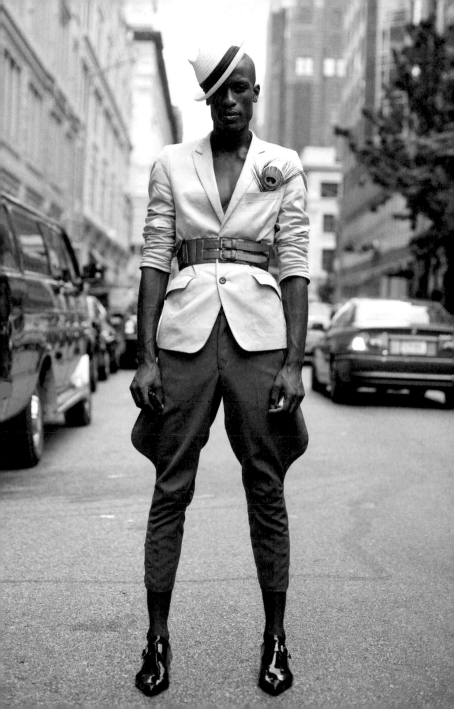

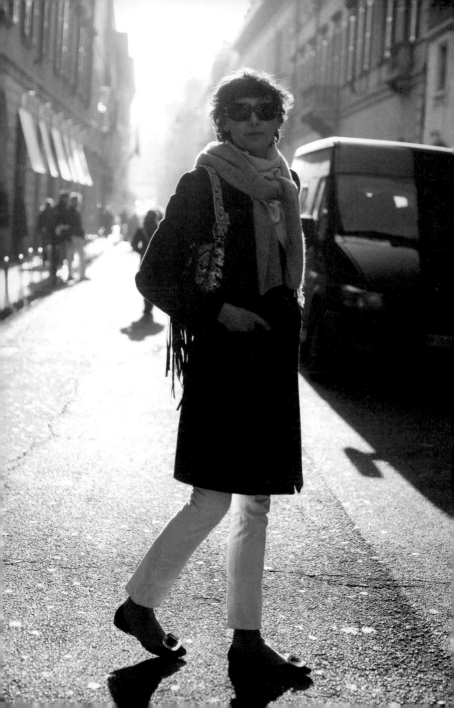

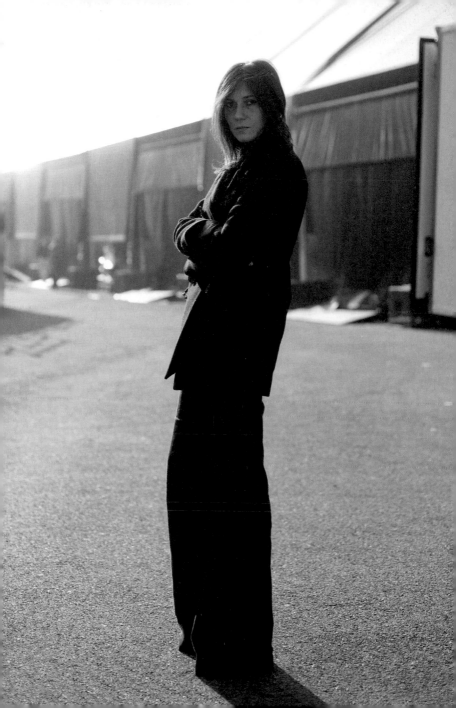

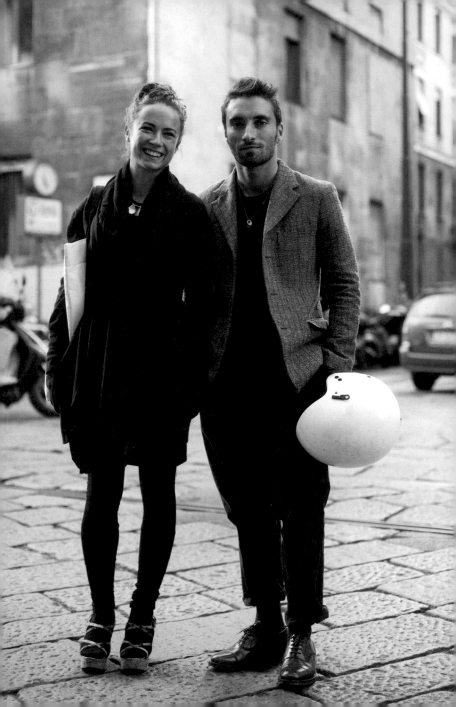

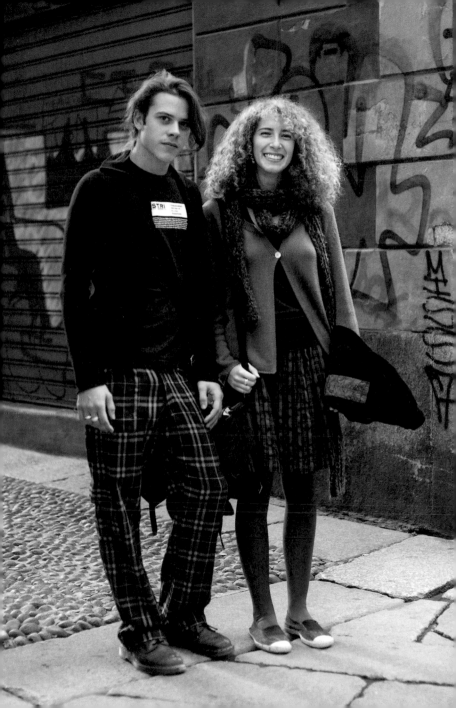

Polka dance, Milan

It was an early Friday evening in Milan and the men's fashion week had just ended. Walking back to the hotel I heard polka music coming from somewhere nearby. I don't often associate polka music with Milan, but I soon realized it was coming from the church I had just passed.

Inside I found a collection of retired Milanese dancing around like it was their high school prom. Age was not a factor here. You had the same cliques of girls standing on one side looking at the boys and the boys on the other side looking at the girls. There was such an energy and such a joy for life in that room. In this case though that joy was fuelled by Viagra not Everclear.

As I continued to watch I found this gentleman, not really dancing, more just shuffling to the music. He had such a stoic elegance and an undeniable virility to him. I really wanted to shoot him, but the dance floor was very crowded. I didn't want to change the atmosphere in the room so I decided to only take two tries at getting the shot. As the gentleman rounded the far corner of the room he was hidden behind a mass of the other dancers' arms and legs. Luckily, just as he approached the last possible spot I could shoot him in, the crowds separated and I caught him in all his reserved splendor.

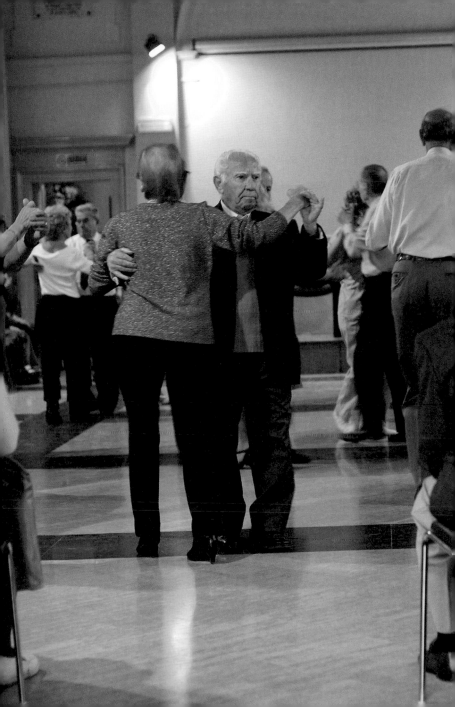

Loudly Vague

I am fascinated by androgyny. I think it is the vagueness that is so appealing. I appreciate people that don't feel the need to clearly communicate who they are to the outside world. We have called this period the 'Information Age' and so their comfort in remaining mysterious is wonderfully foreign.

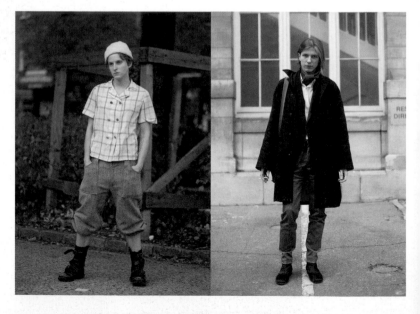

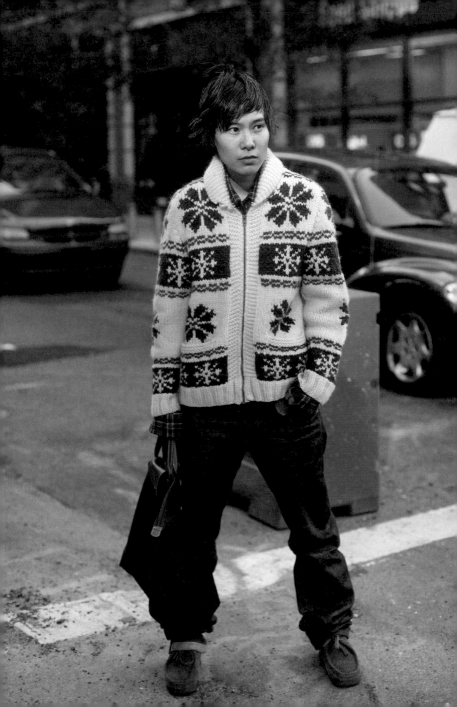

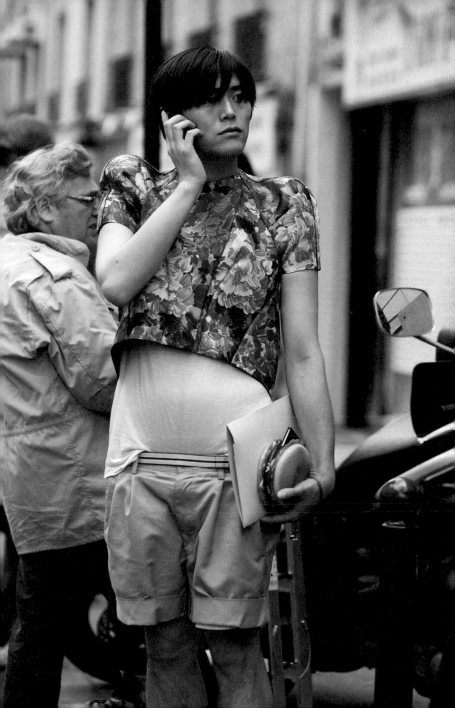

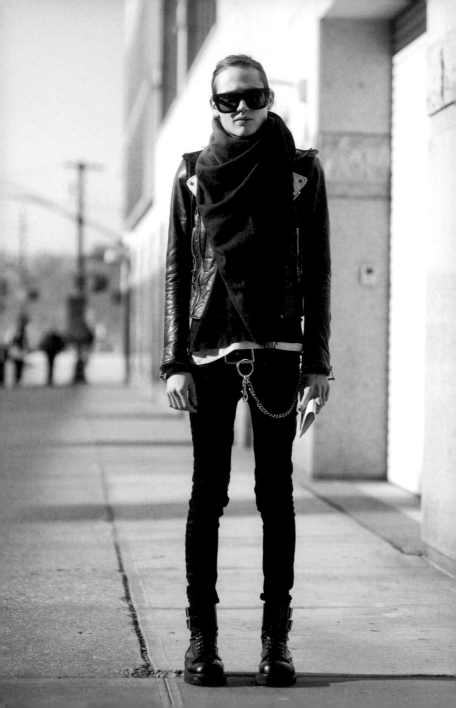

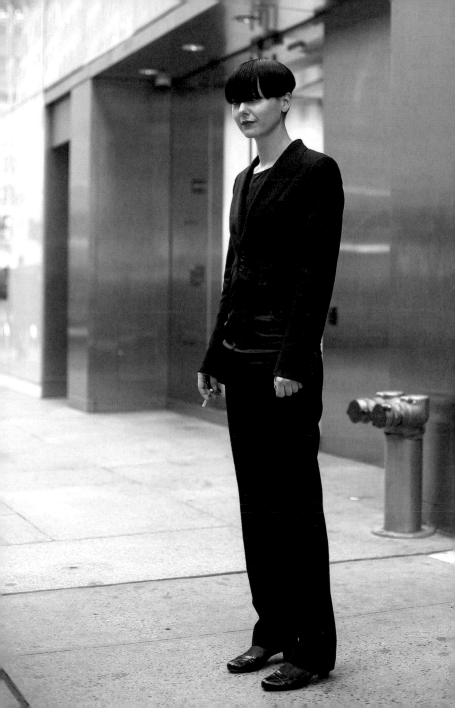

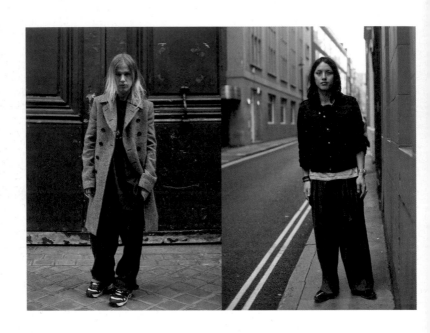

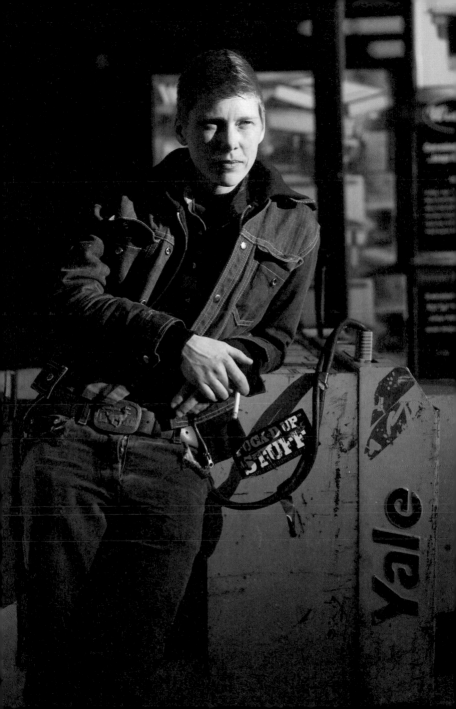

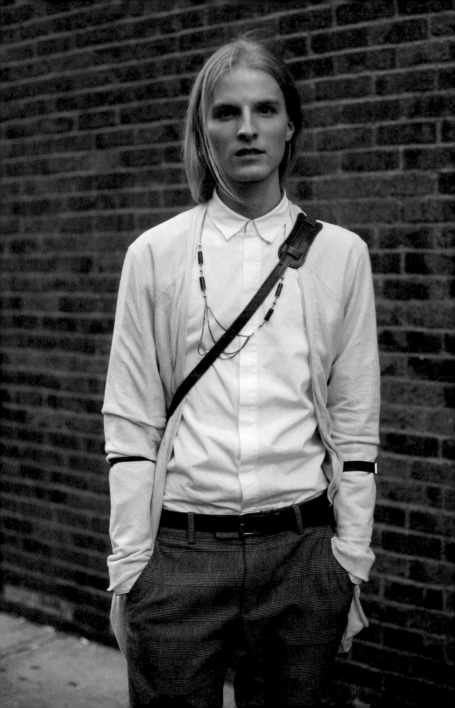

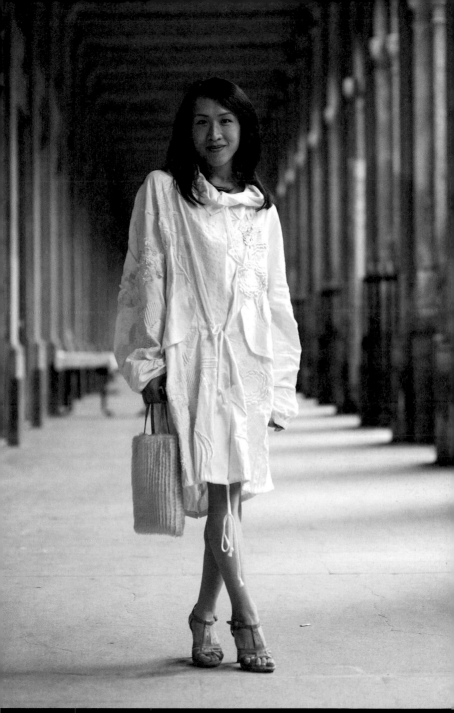

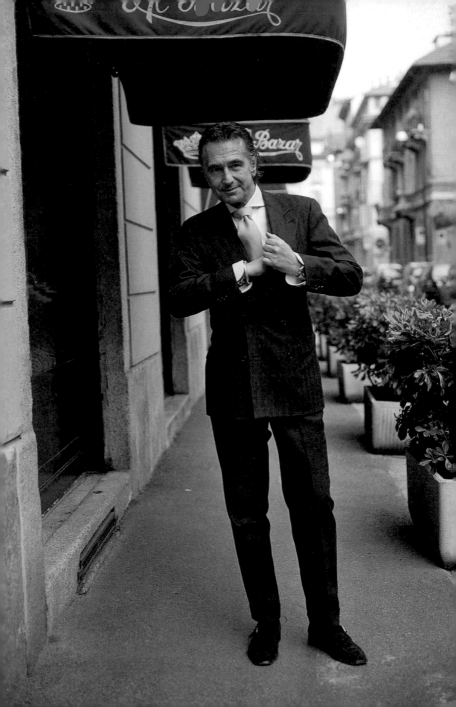

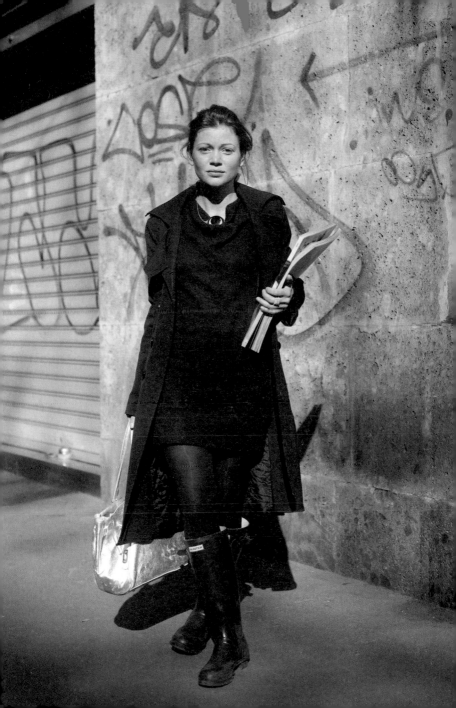

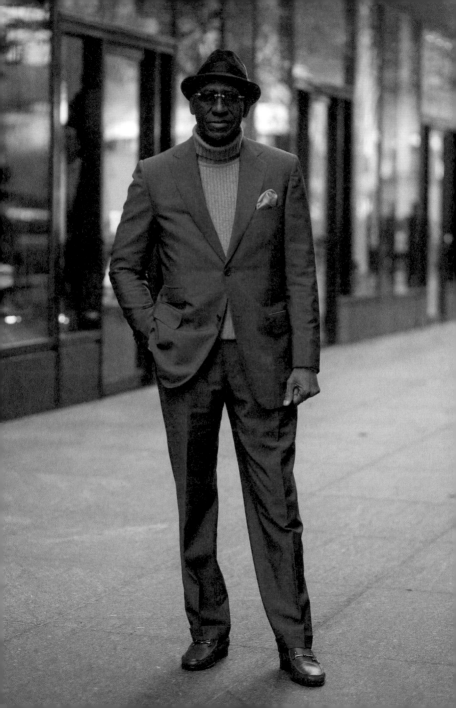

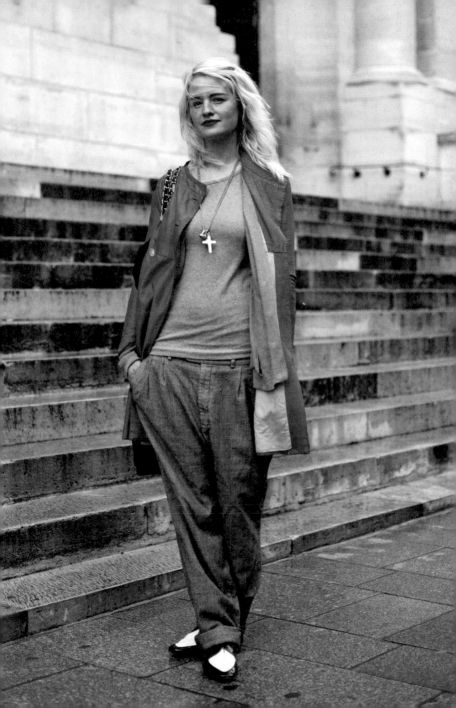

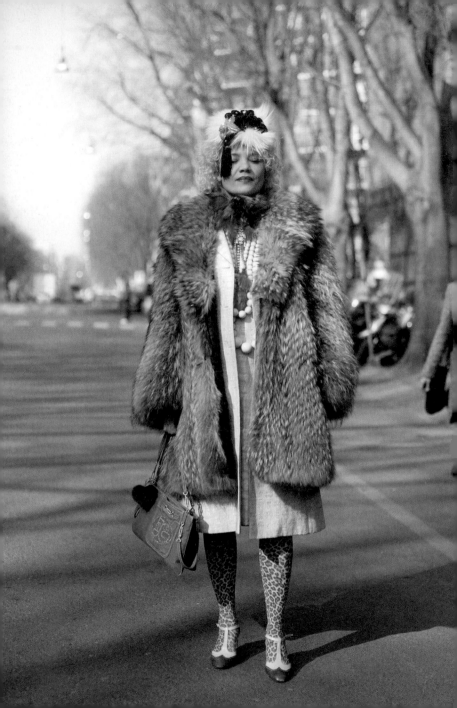

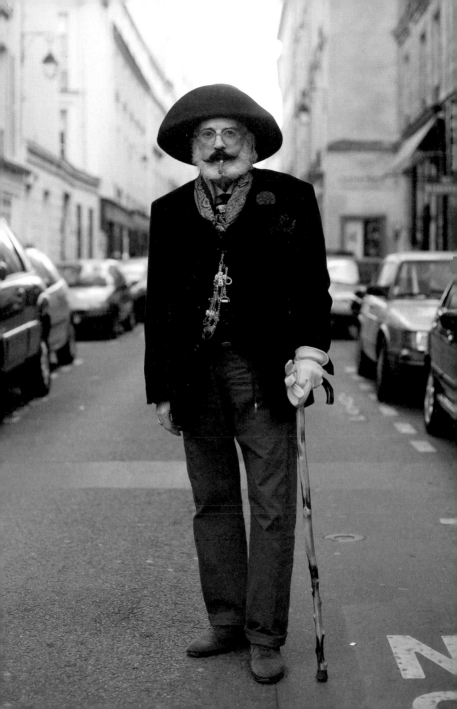

Rich man? Poor man? New York

When I am out on the street shooting I like to keep my eyes scanning as far down the block ahead of me as possible. This way I can have plenty of time to decide if I want to shoot a potential subject. I remember when I saw this gentleman in the distance. As he came closer and more clearly into view, all I could think was, 'Is this guy poor or just eccentric?' He was wearing a lot of elements that people might call hobo chic – the beard, the knit cap, the patches on his jeans. By the time he was only a few feet away I could clearly tell that this beard was too perfectly manicured, the khakis too perfectly patched and the overall fit of his clothes too perfectly dishevelled to be unintentional. As it turned out, he works for Ralph Lauren in their creative services. I think it is funny what we consider to be an unmistakeable outward sign of wealth or poverty. In the US, if a guy has a salt and pepper beard and a knit cap, almost regardless of the rest of the outfit, he will be judged a hobo – that mental image is still so strong in American culture. A year or so later I included this photo in my first one-man exhibition, at Danziger Projects. One of the newspaper critics who reviewed the show mentioned that it was nice that I had included a homeless man among the other high-style people portrayed in the exhibit. I just didn't have the heart to let the critic know that the homeless man probably made twice as much money as he did.

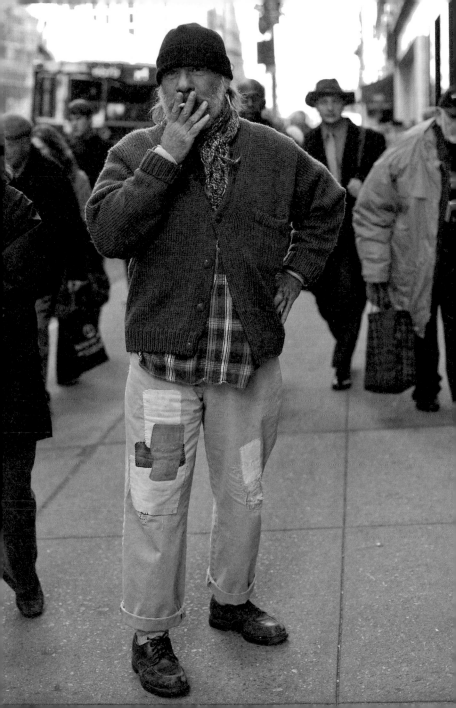

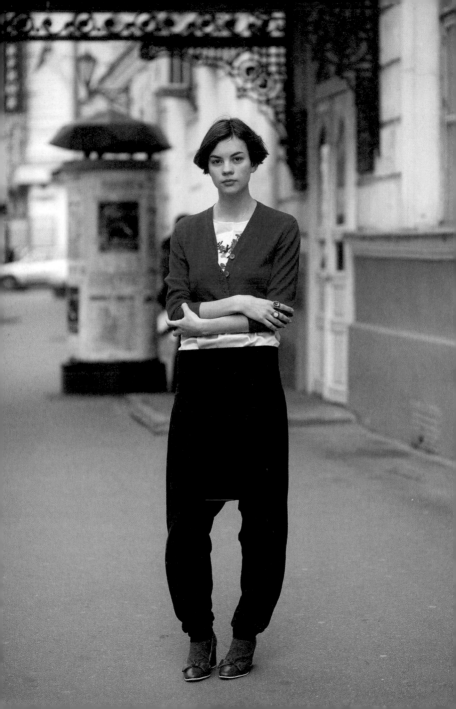

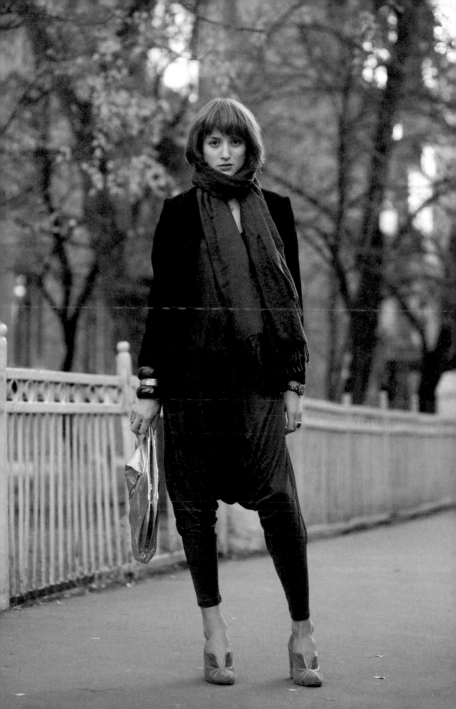

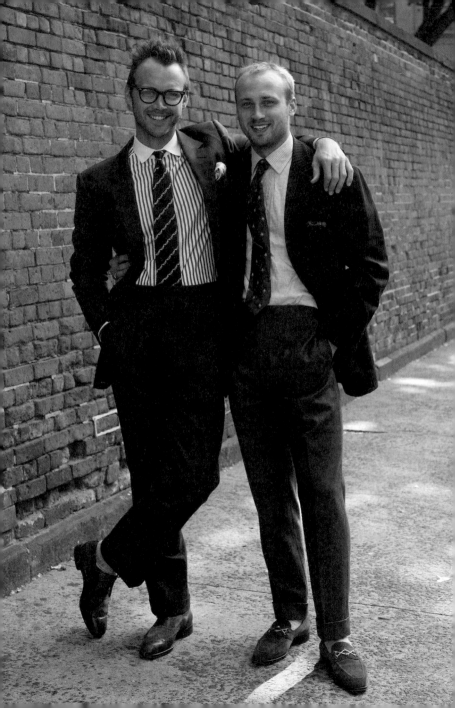

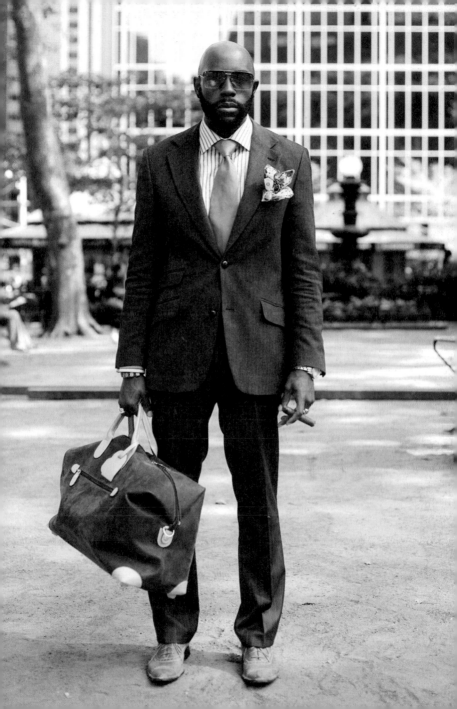

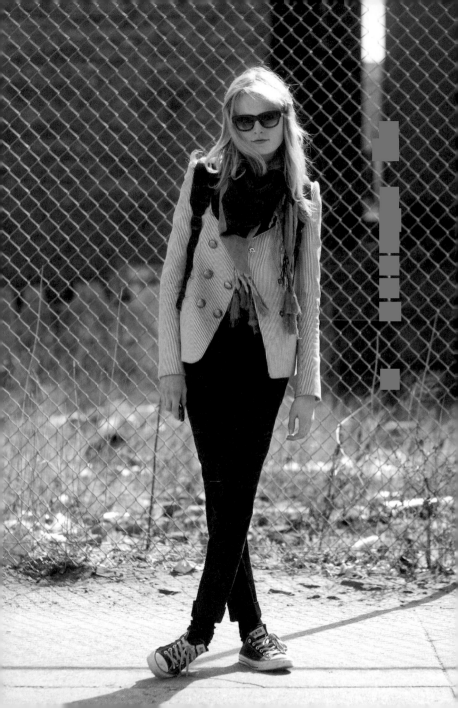

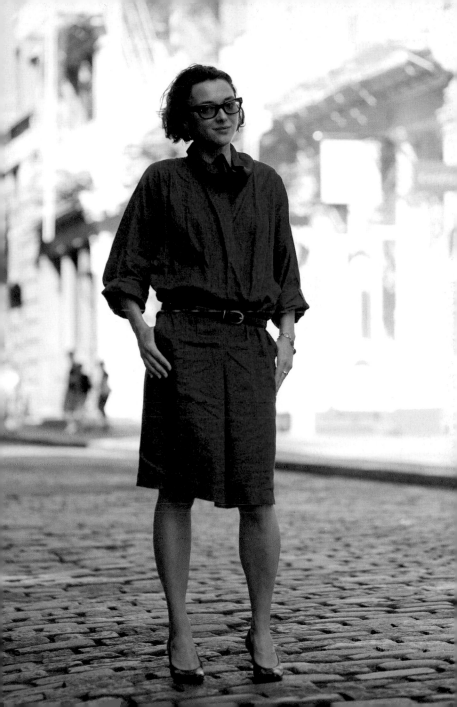

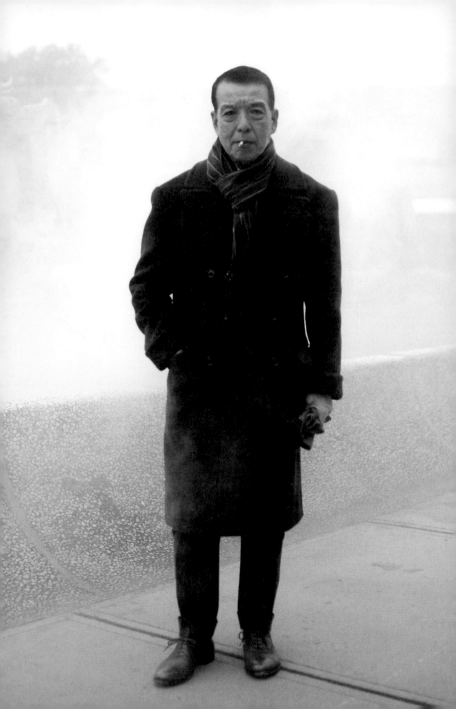

This guy just exudes masculine charisma. I don't know if clothes make the man, but would he look as cool if his clothes didn't fit so perfectly? A lot of the comments on the blog are from people who want to 'look like him when I get older'. I am so proud that I have created a blog that celebrates how to grow old gracefully and stylishly. We are all only going in one direction; why not stop fighting the ageing process and learn to flow with it?

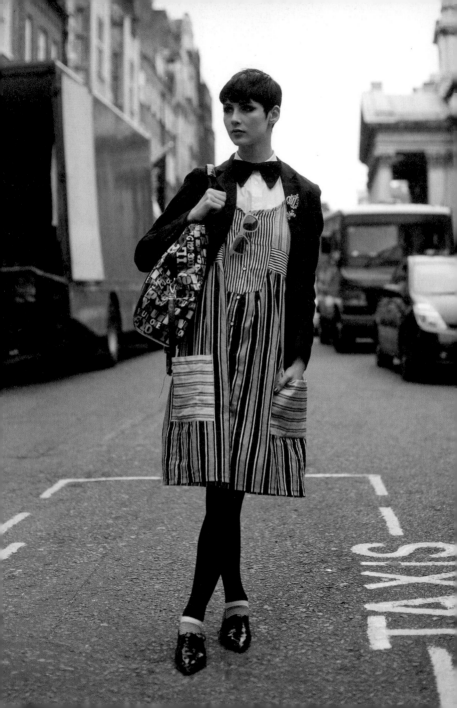

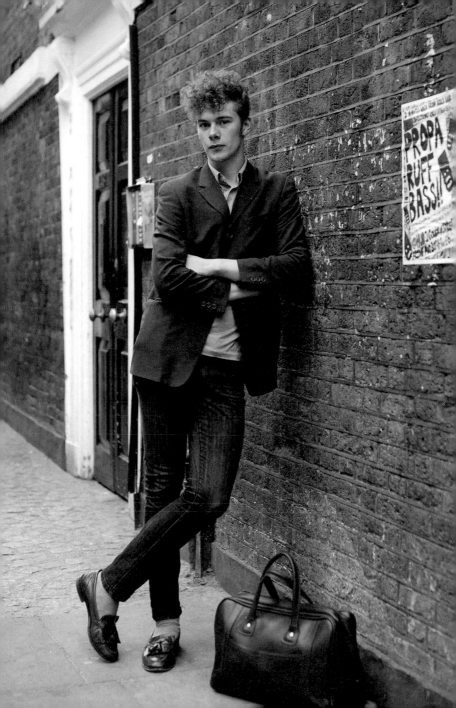

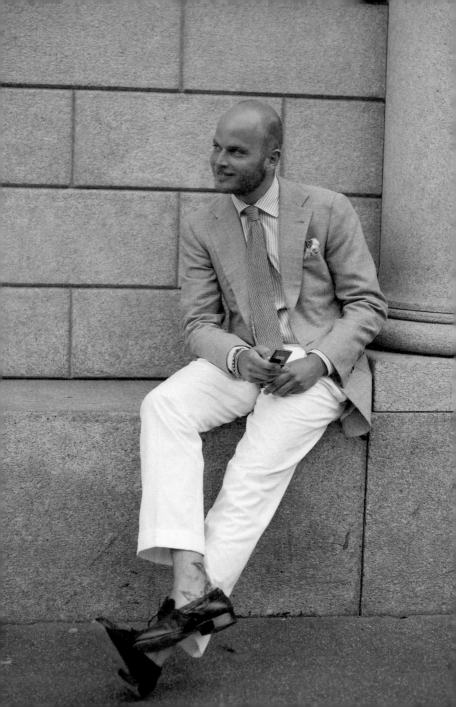

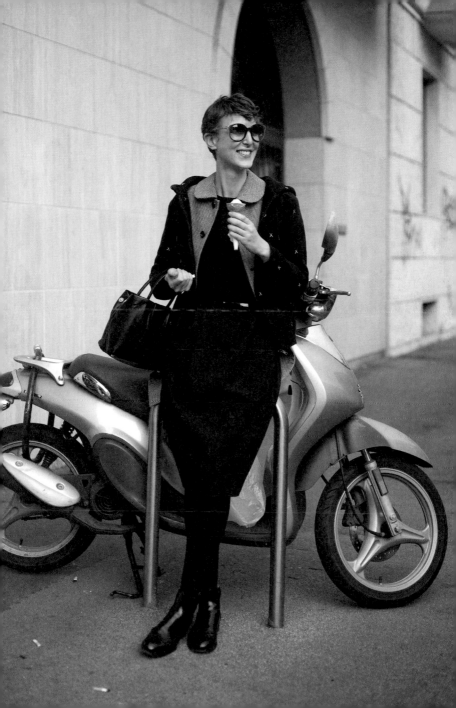

Lynn Yeager, New York

Often, larger-sized women feel alienated from fashion – which isn't very surprising. Where I feel larger women make a mistake, though, is by trying to play the fashion game using the rules stated by magazines that show size 2 eighteen-year-old models. This young woman, Lynn Yeager, always looks so chic to me. She wins at the style game not by following current trends but by understanding and utilizing all elements of design – colour, pattern, texture, proportion – in her look. Her style might be a little over the top for some, but when you see her the complexity of her look draws you in, and one of the last things that you notice is her size.

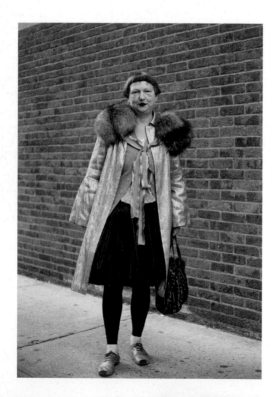

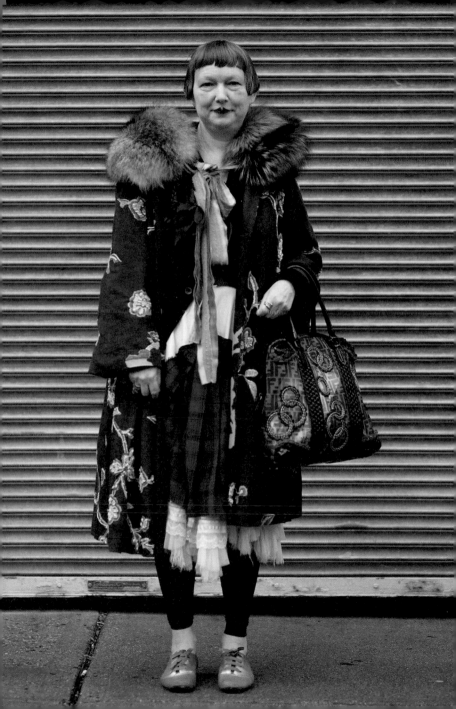

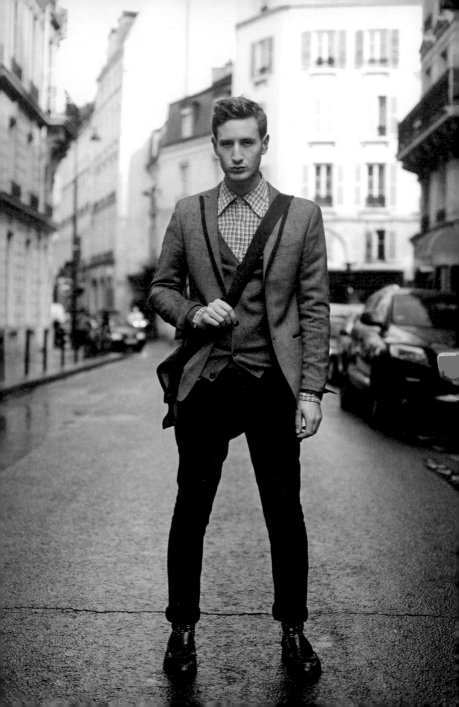

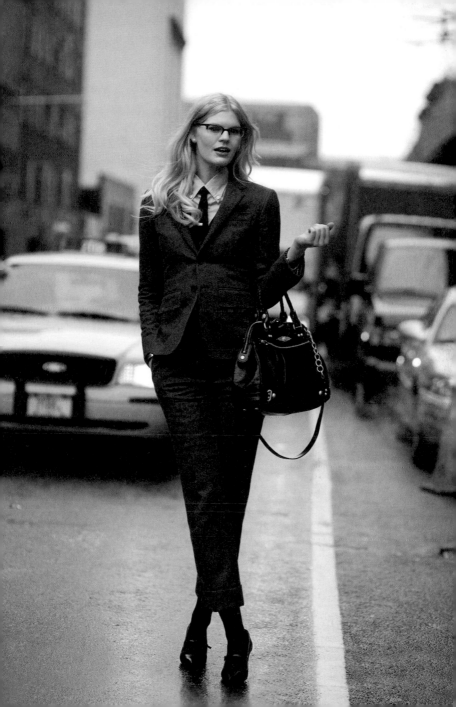

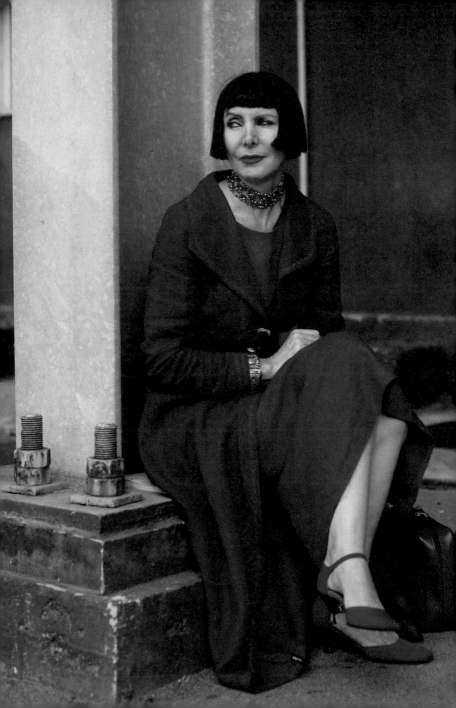

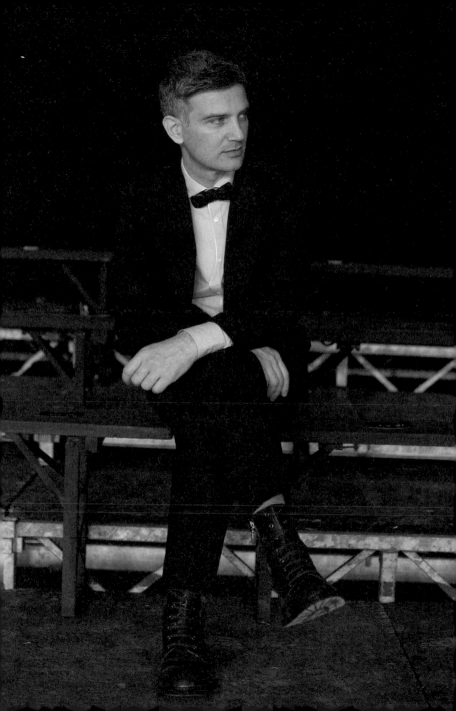

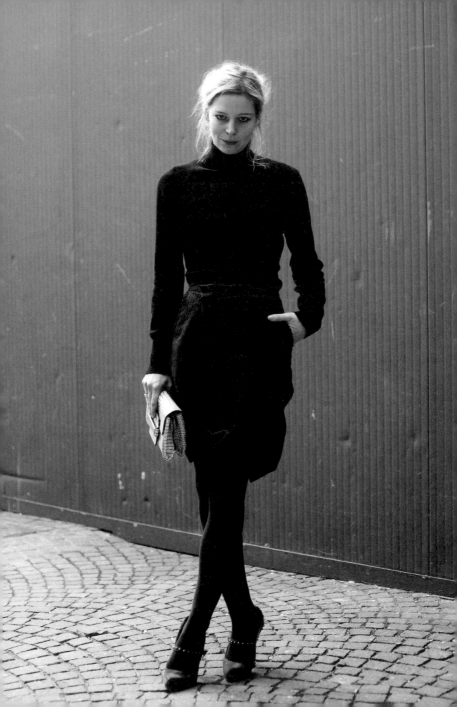

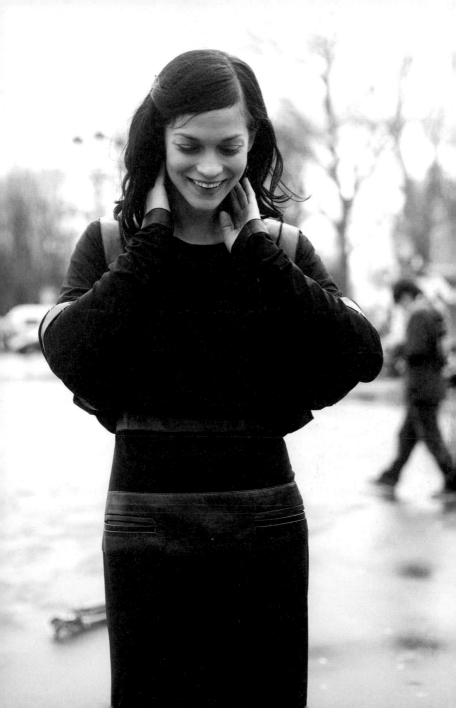

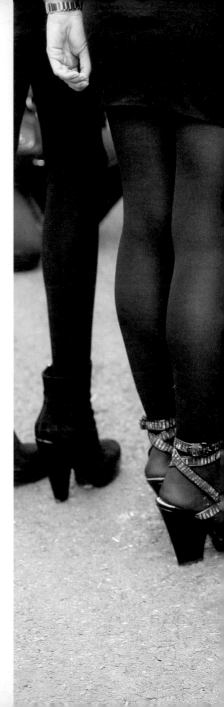

The legs of
French *Vogue*

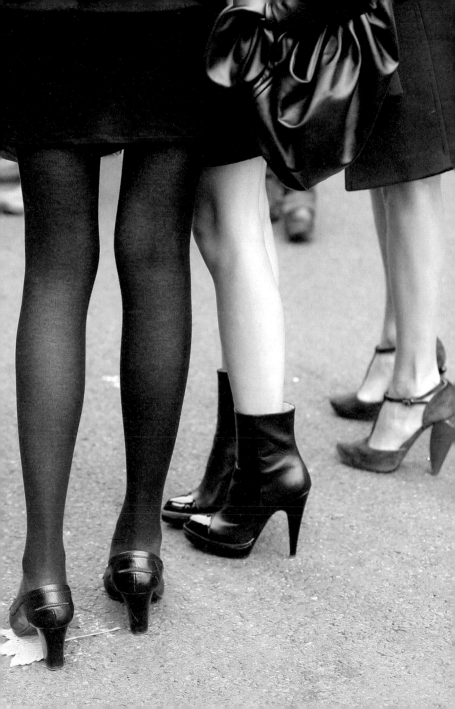

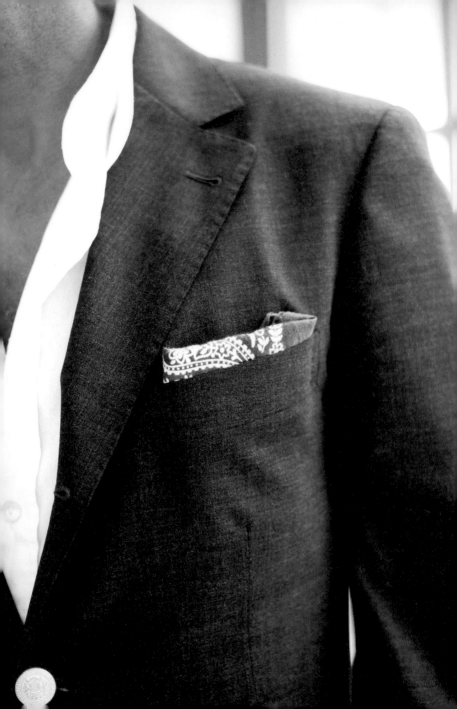

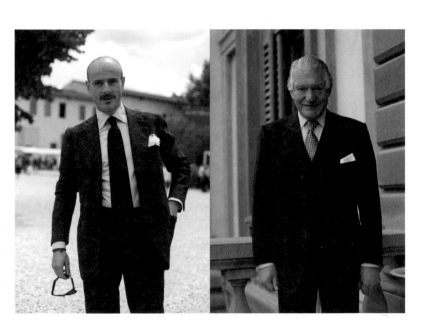

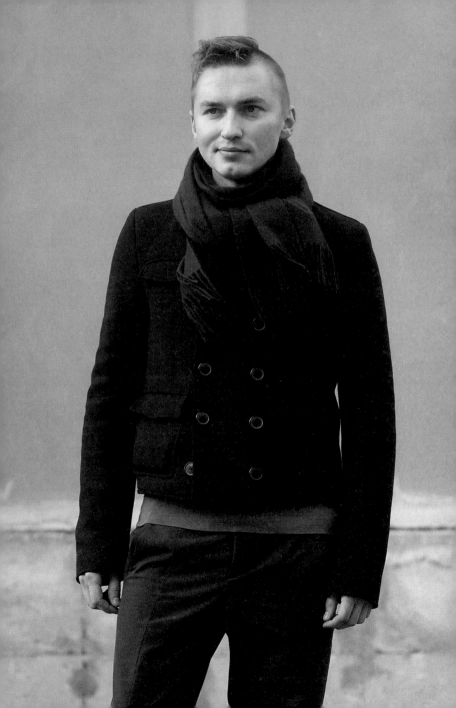

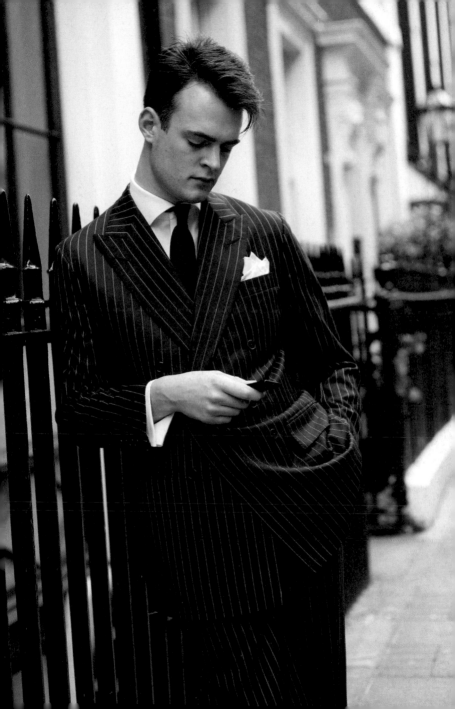

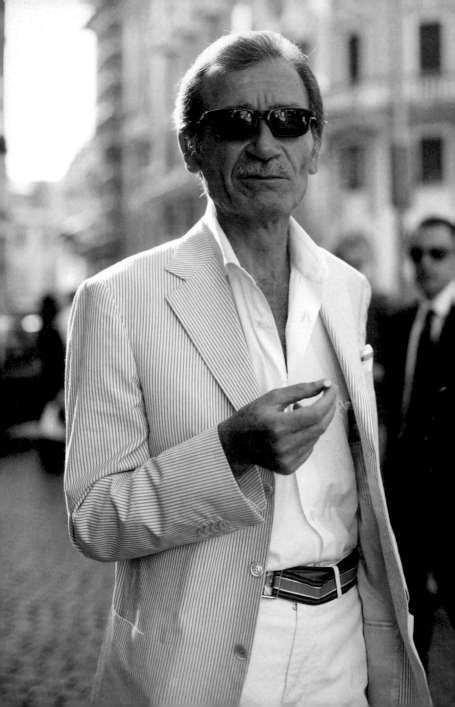

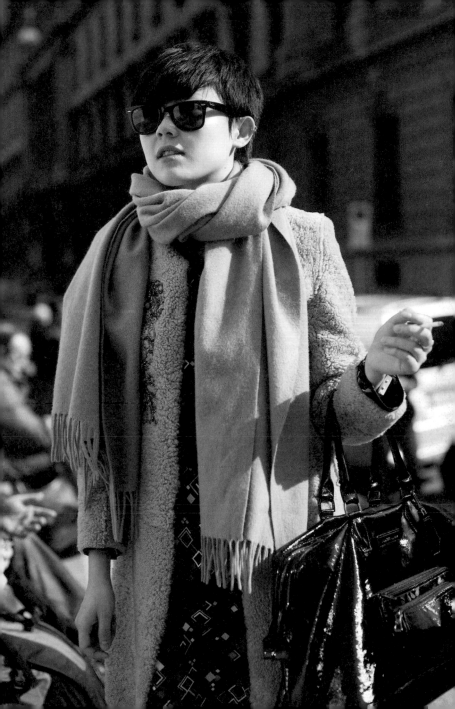

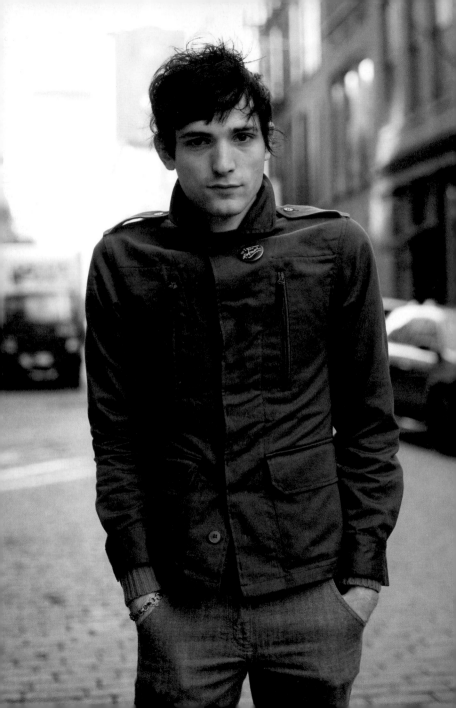

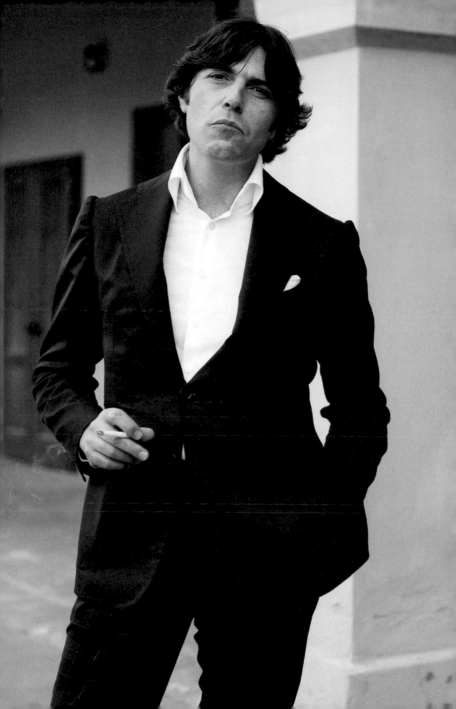

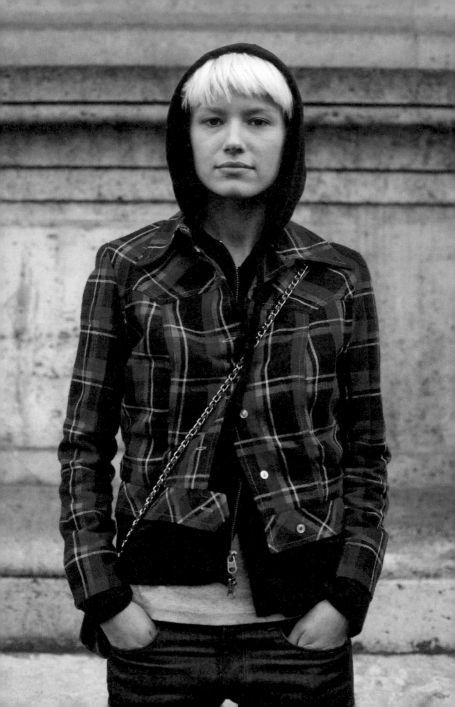

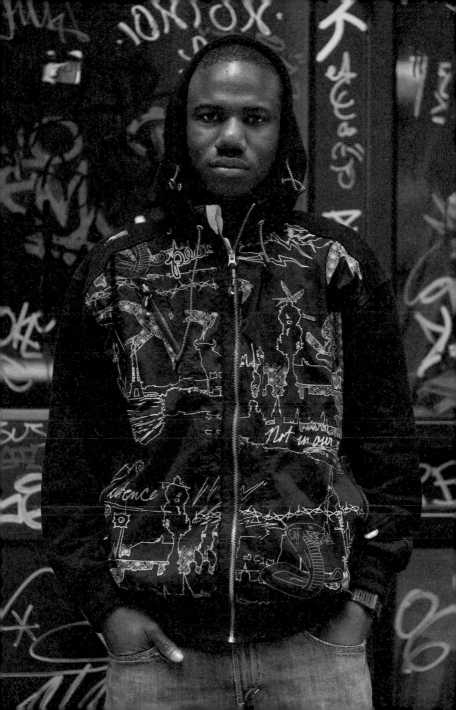

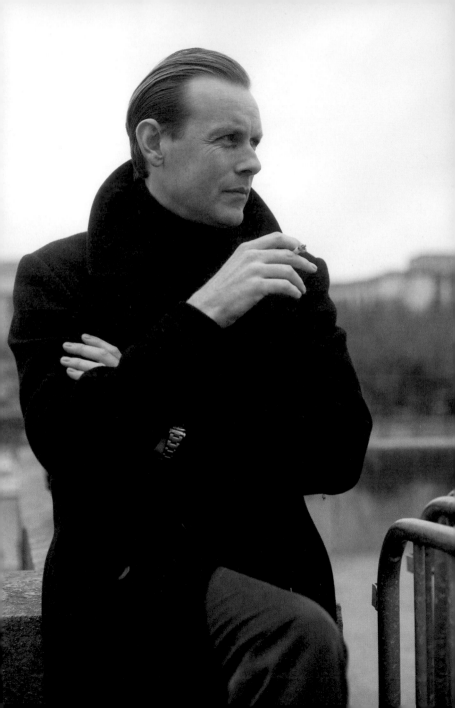

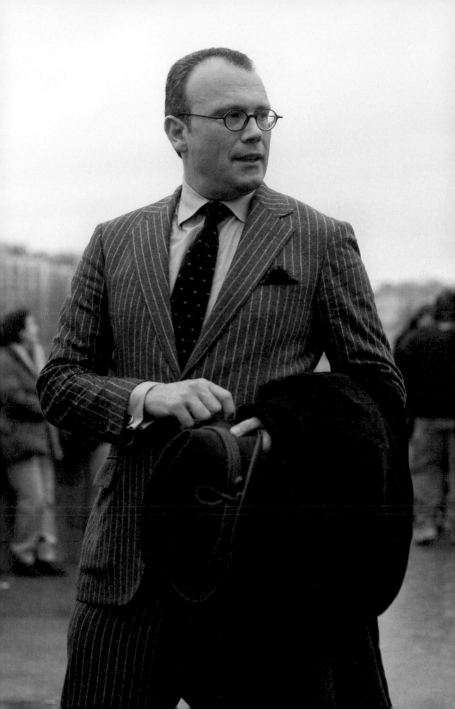

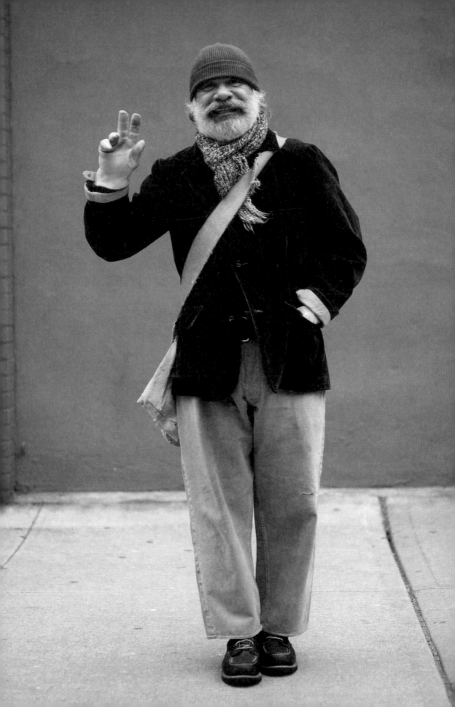

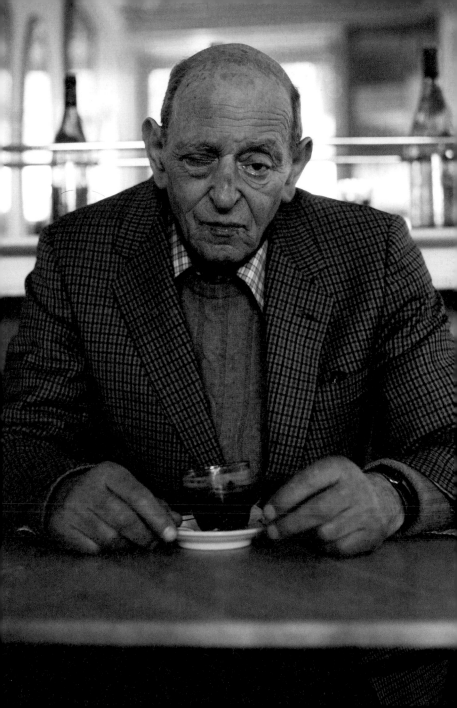

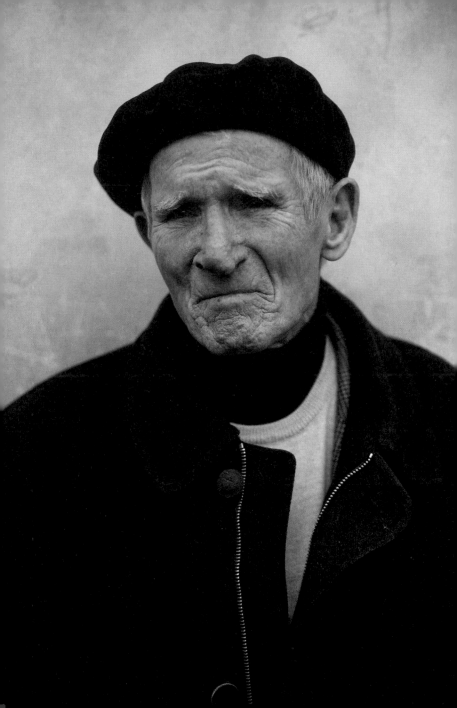

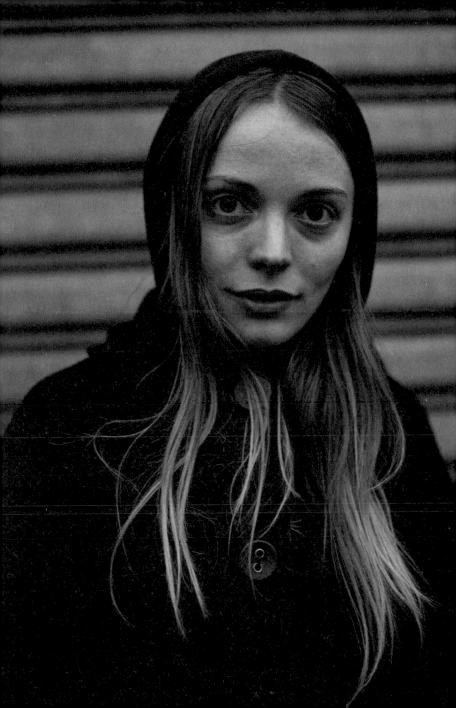

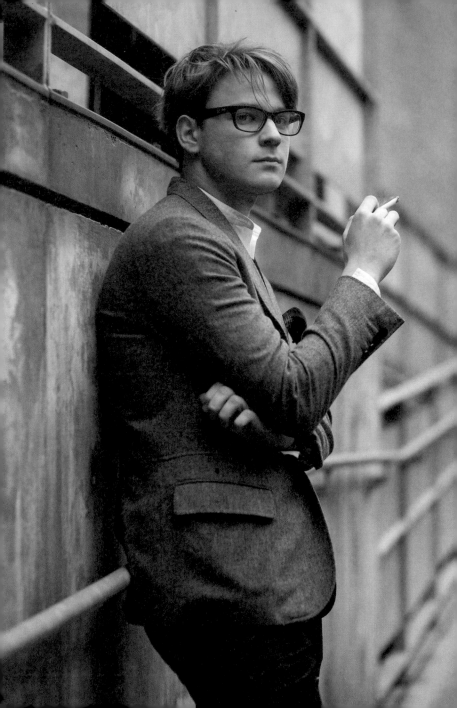

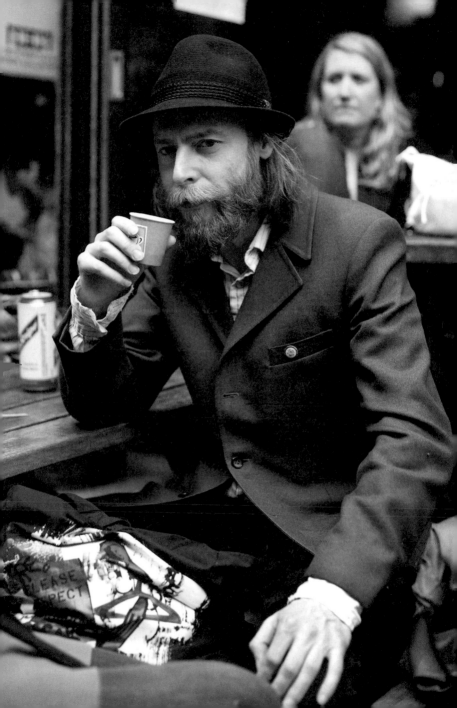

Robert

Robert is one of the few fashion editors whose appearance I am always curious to see each day during show season. His look is never precious or overly manicured; he really lives in those clothes and he makes his clothes work for him. They say women always want to show you their newest purchase and men want to show you their oldest. Robert seems to me to fit that idea: he is always more interested in an unusual mix of textures or colours than he is in what is on the runway that season.

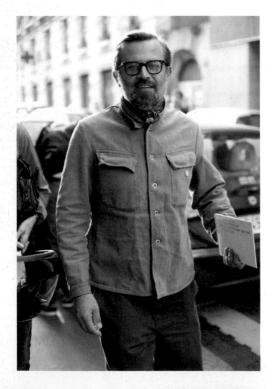

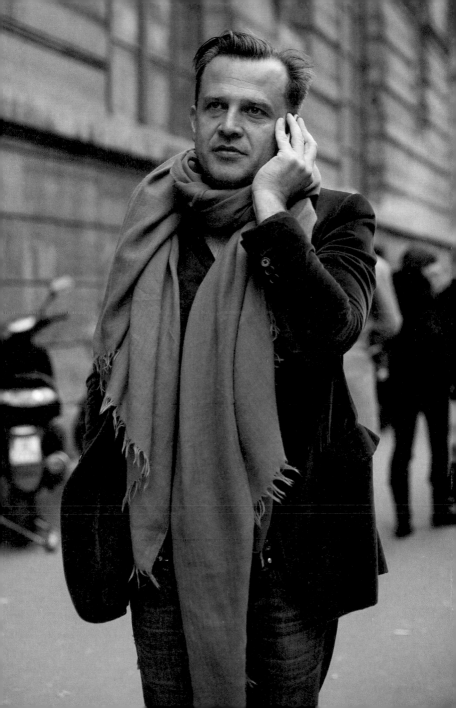

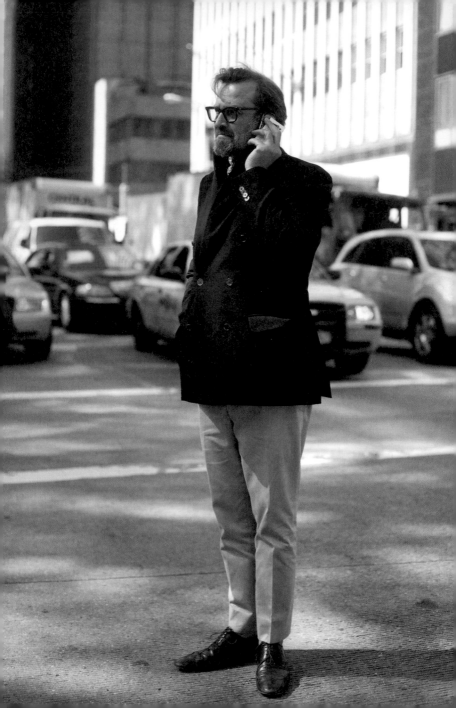

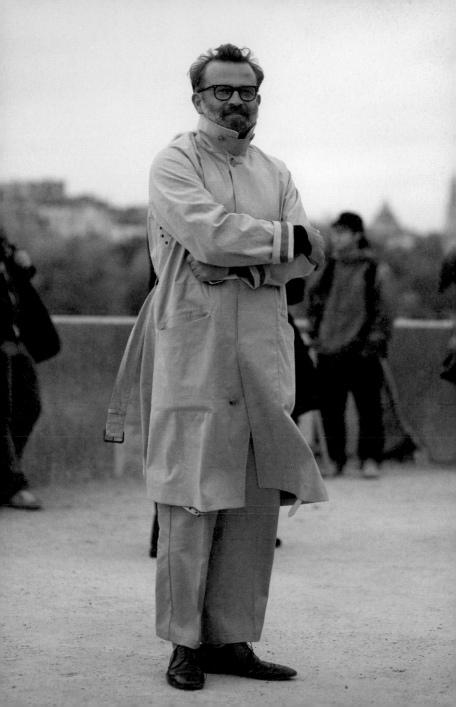

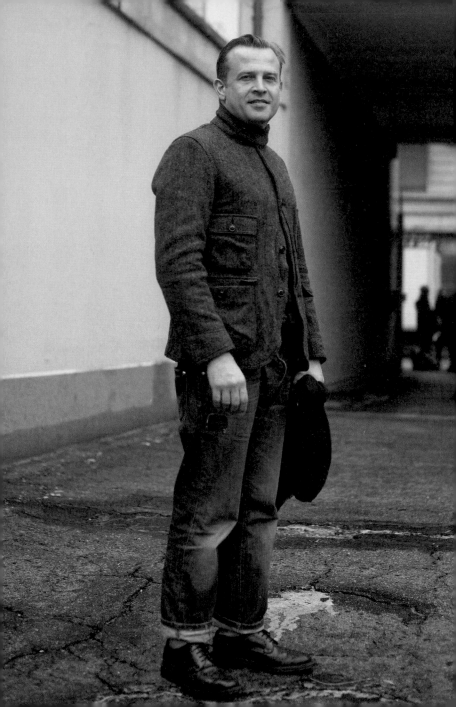

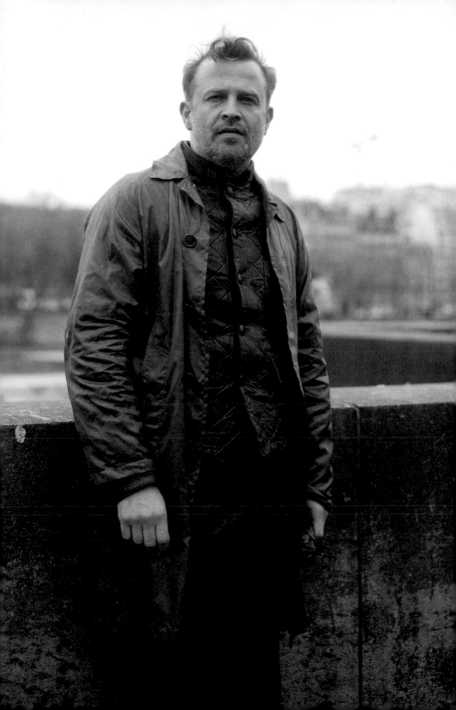

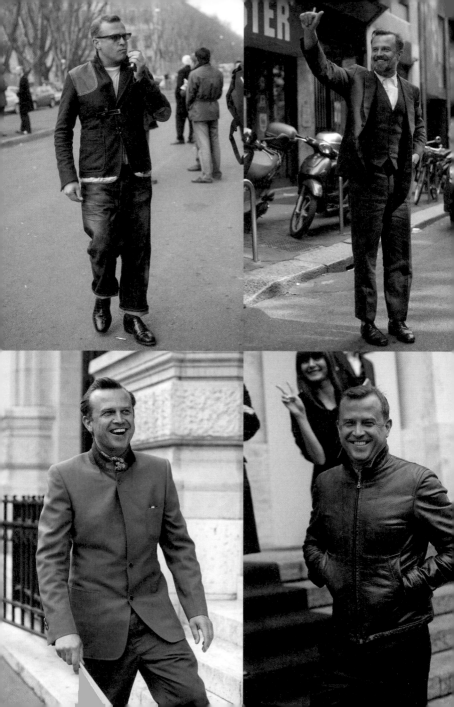

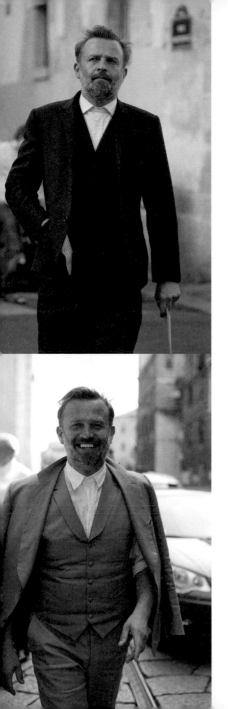

407

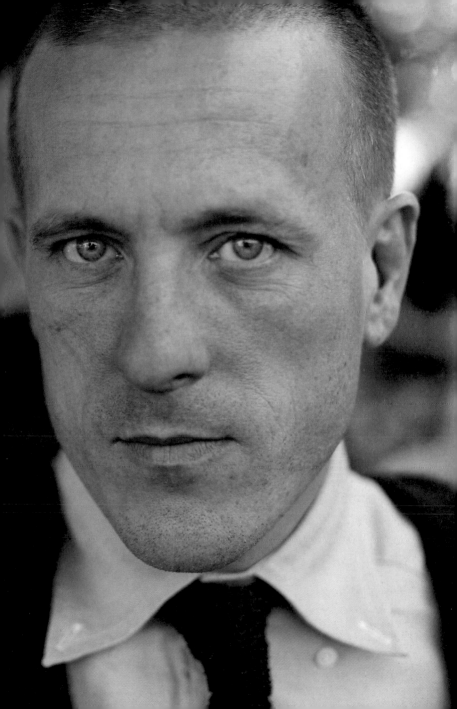

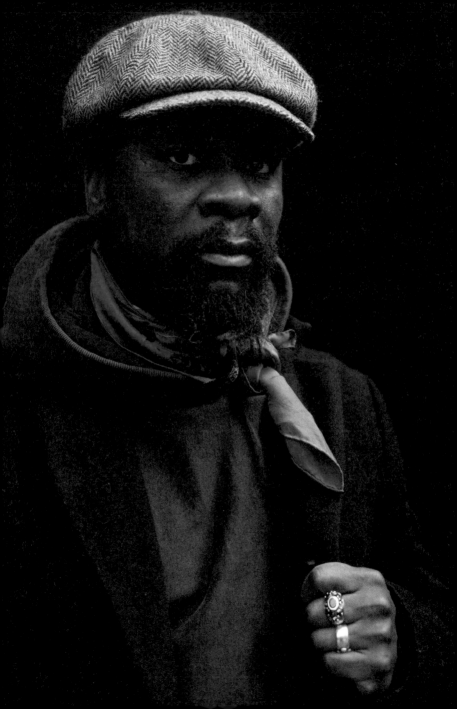

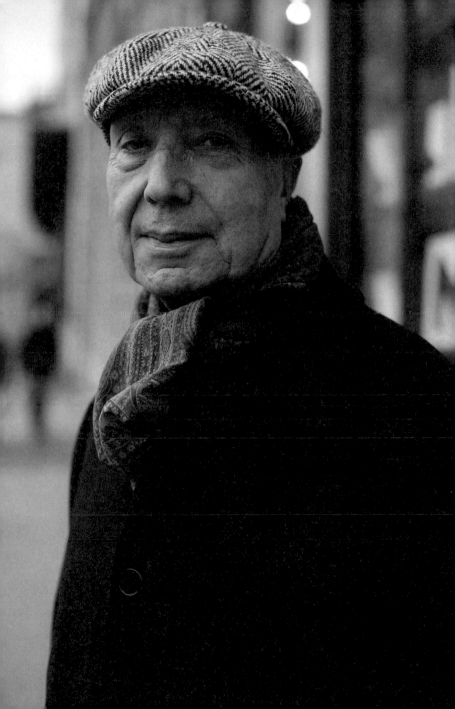

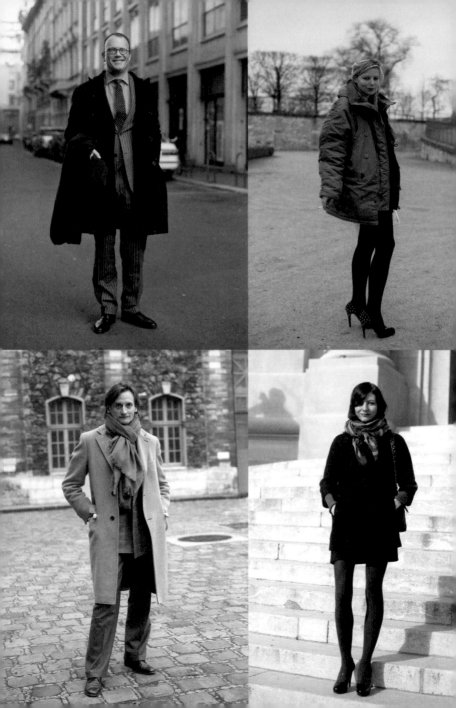

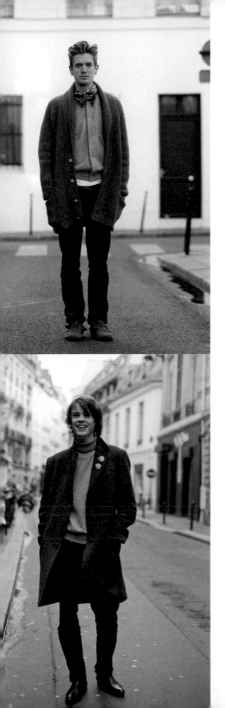

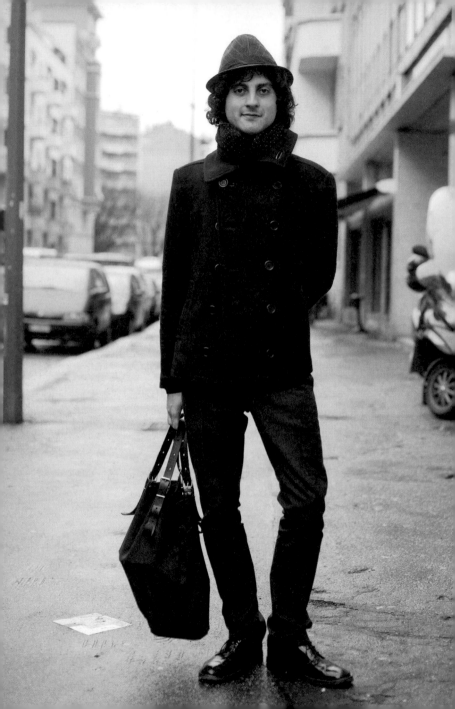

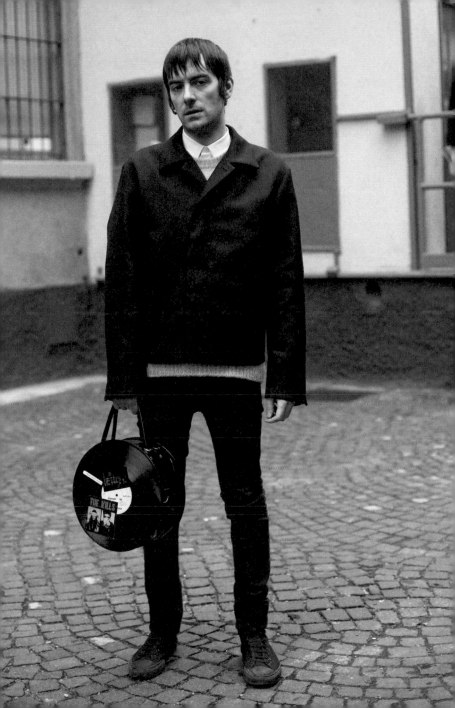

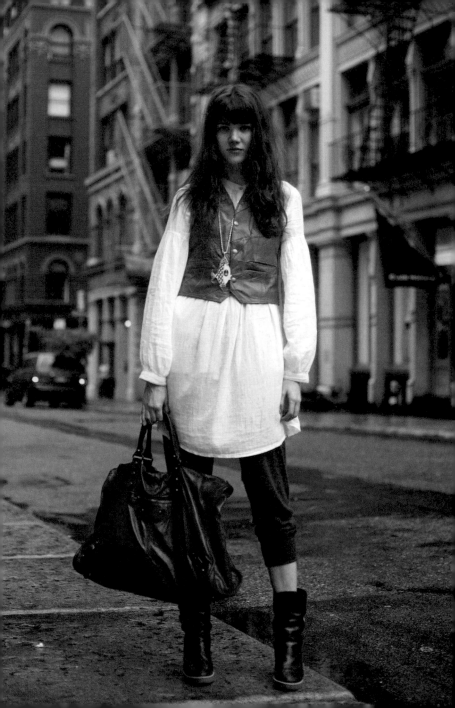

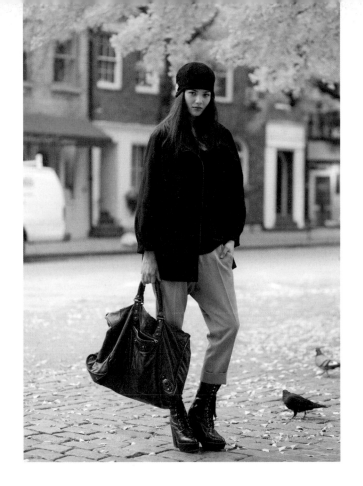

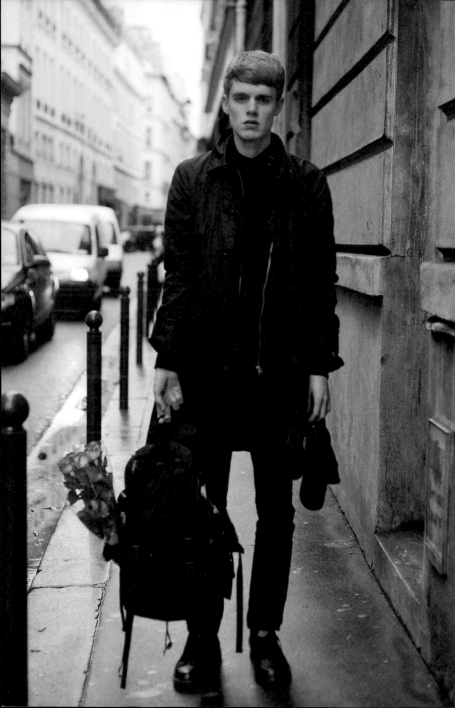

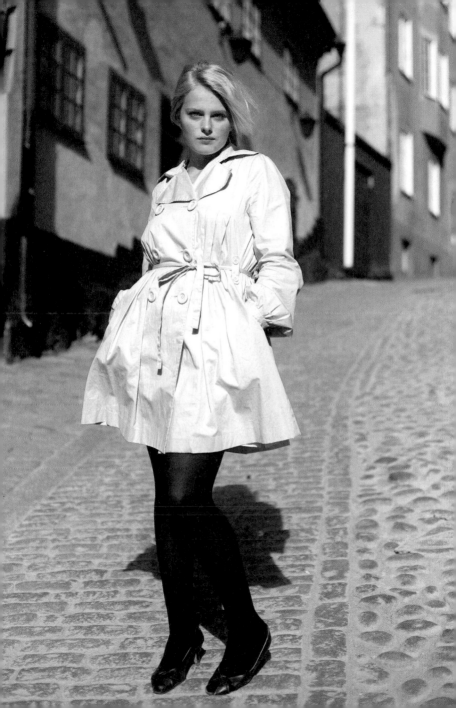

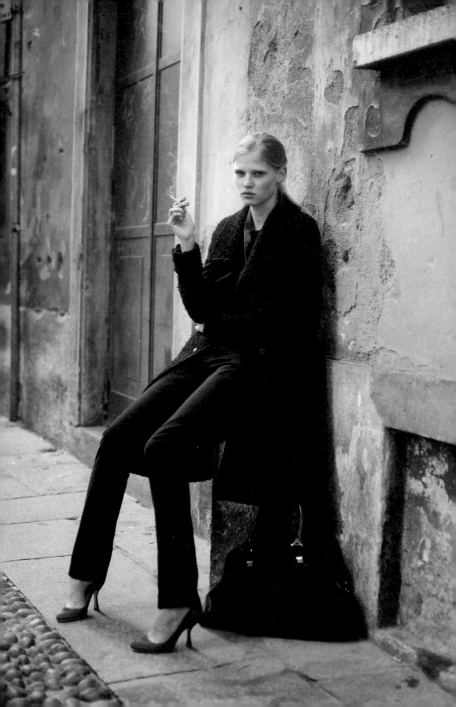

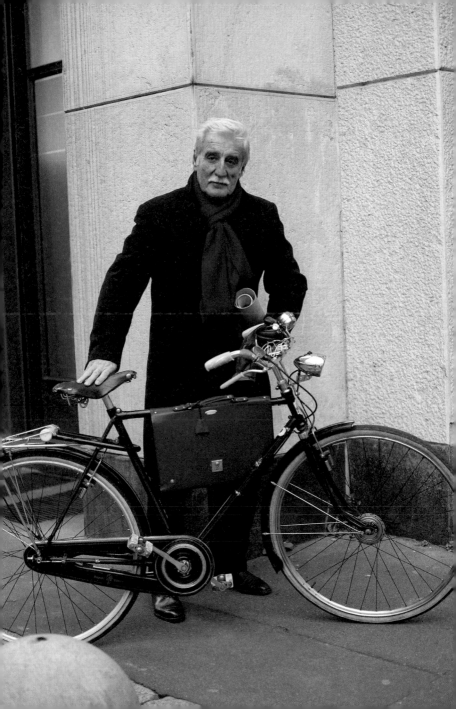

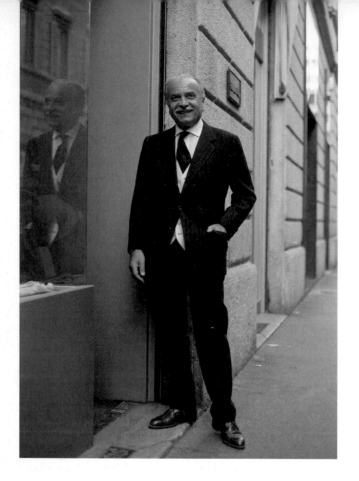

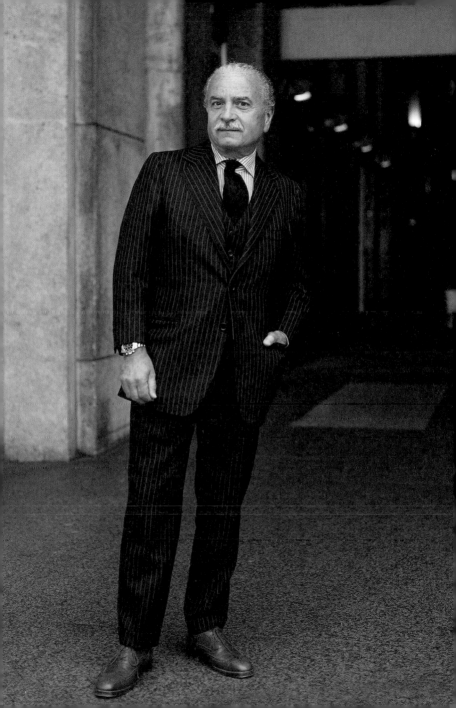

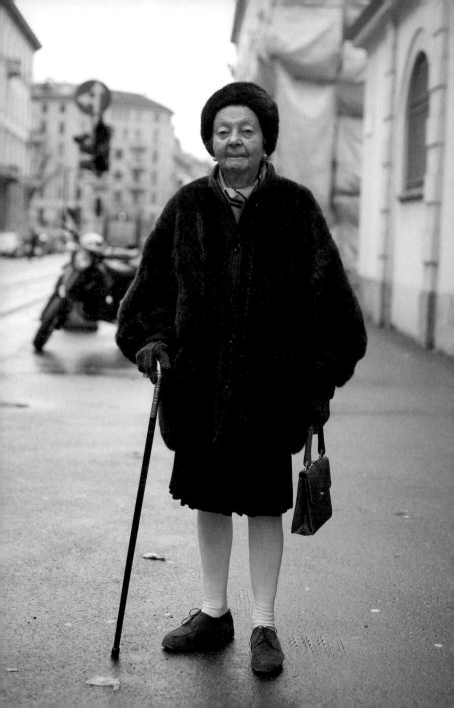

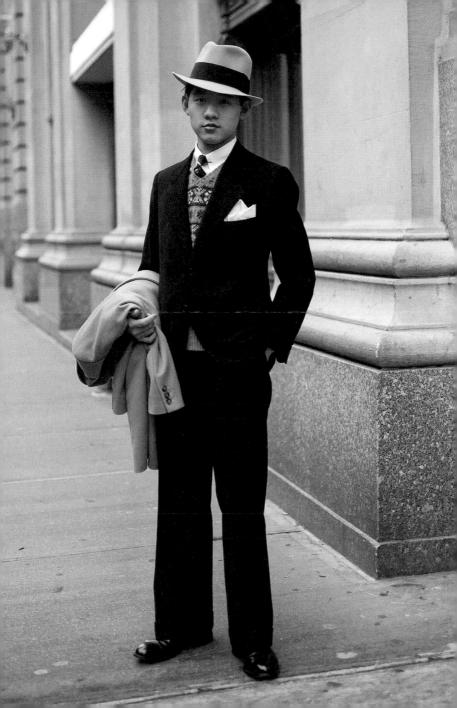

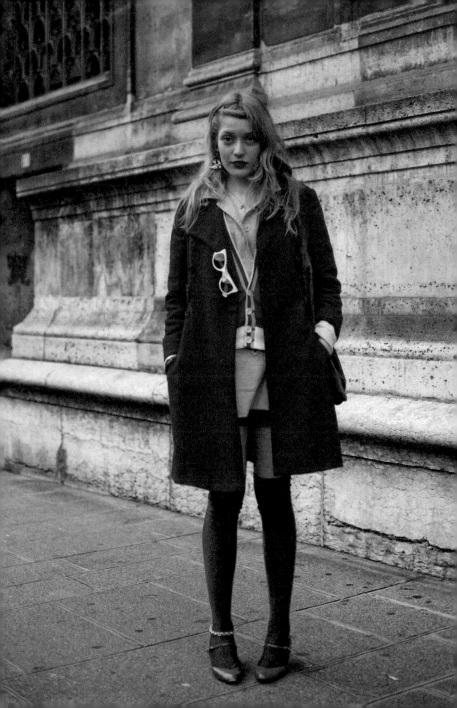

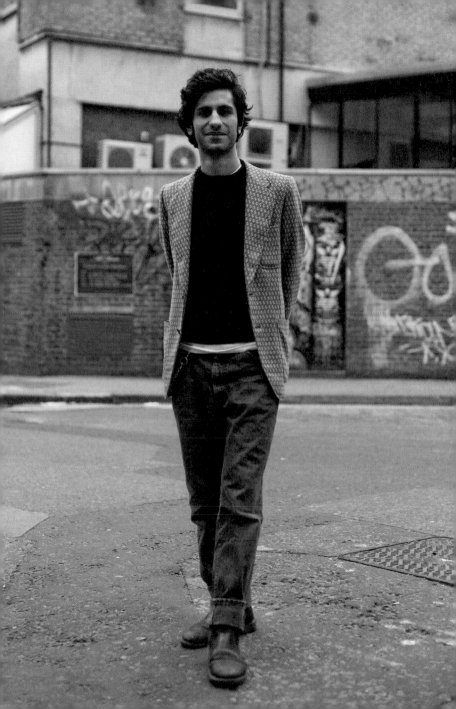

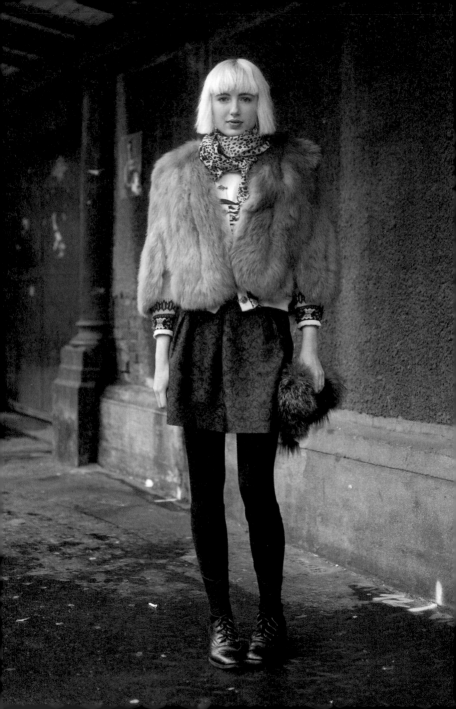

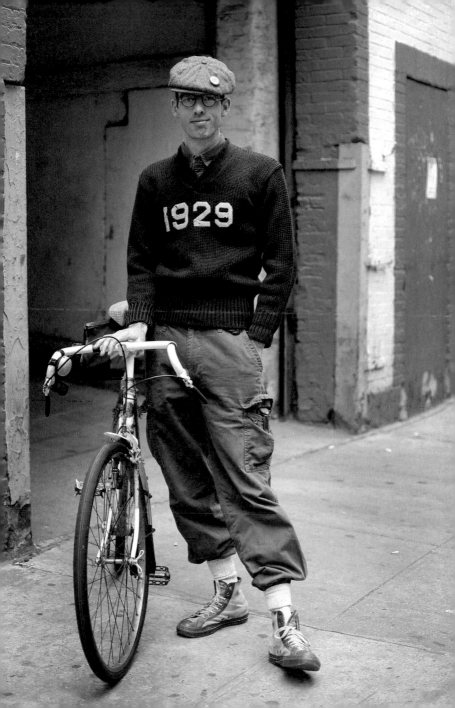

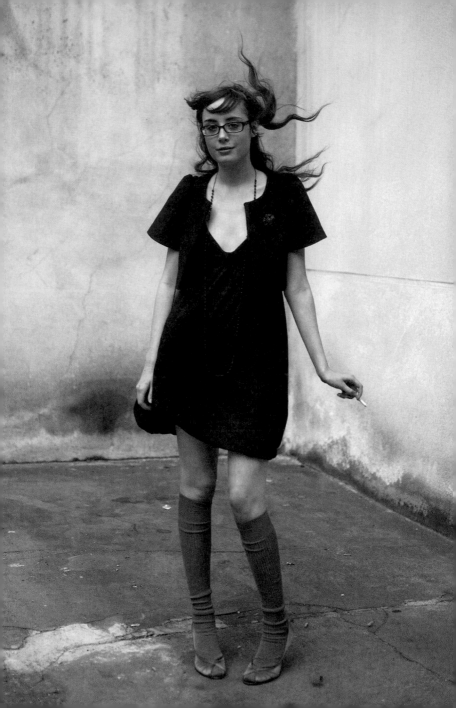

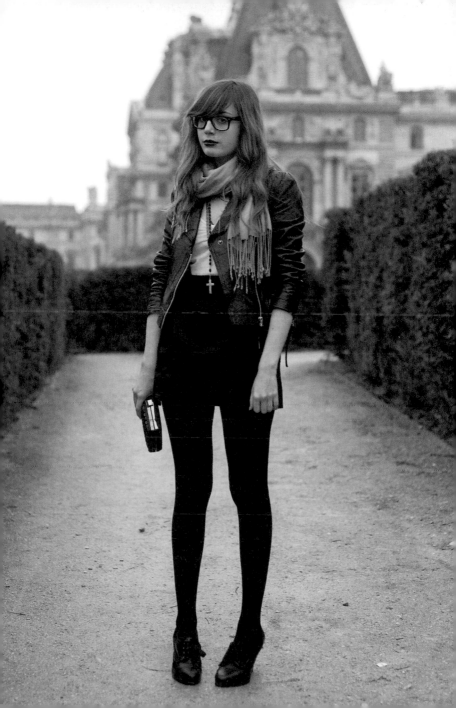

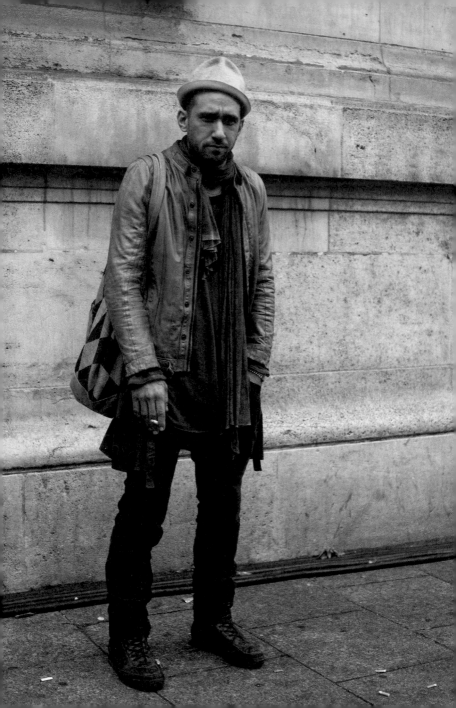

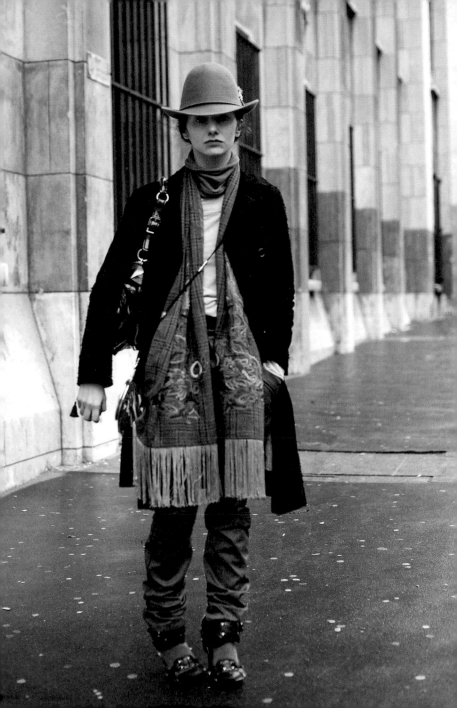

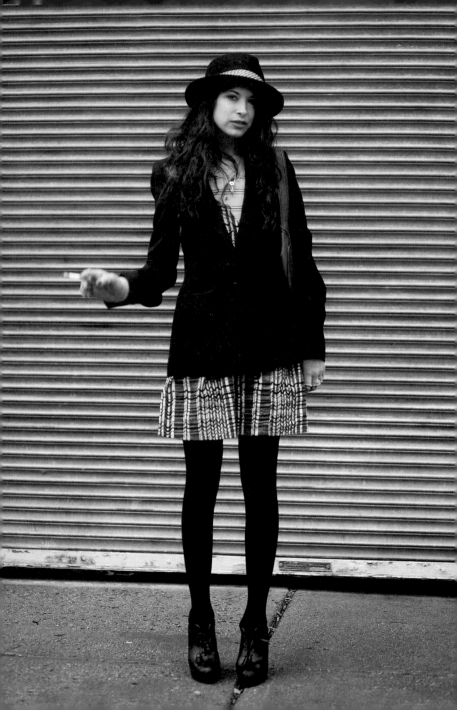

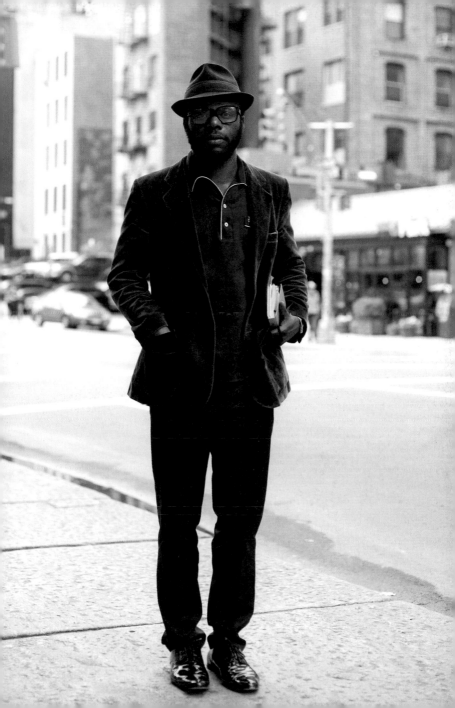

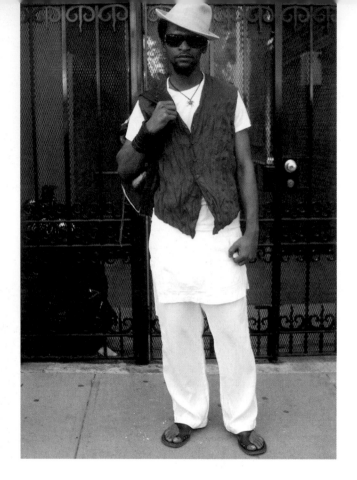

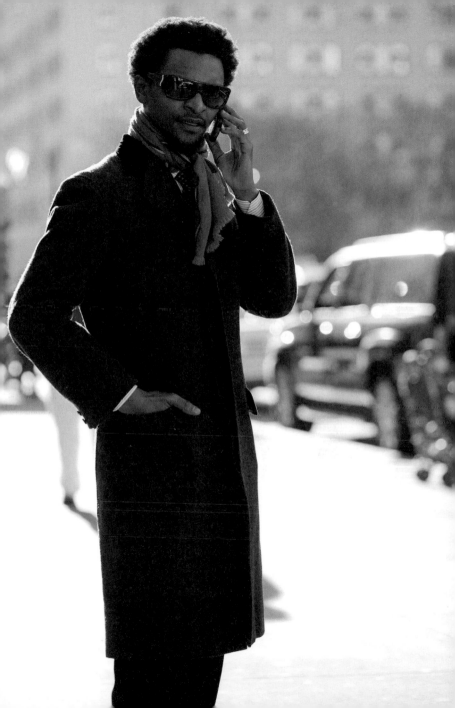

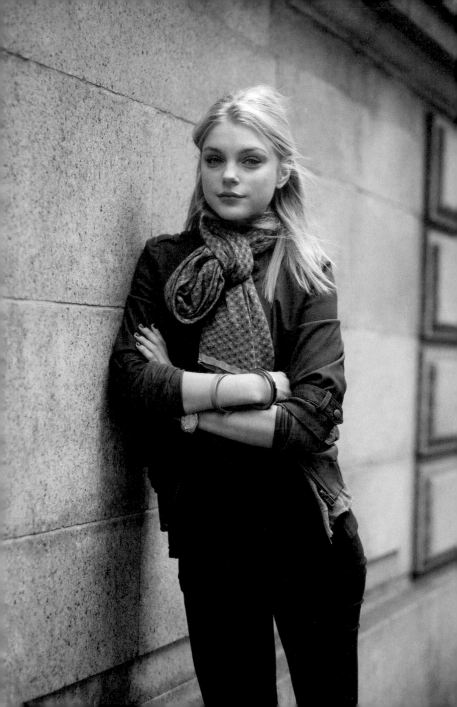

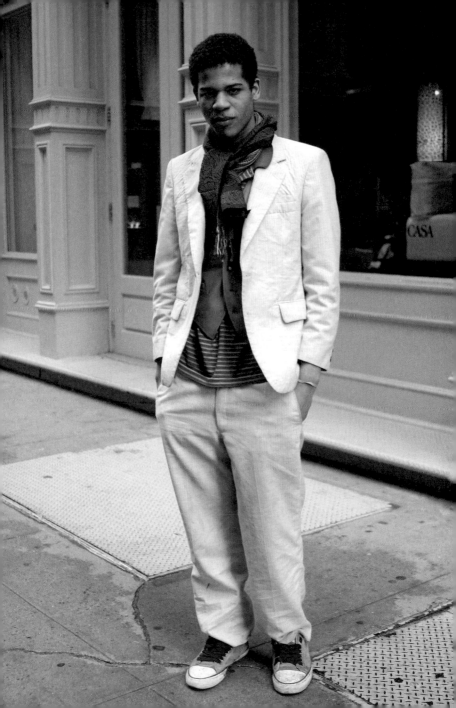

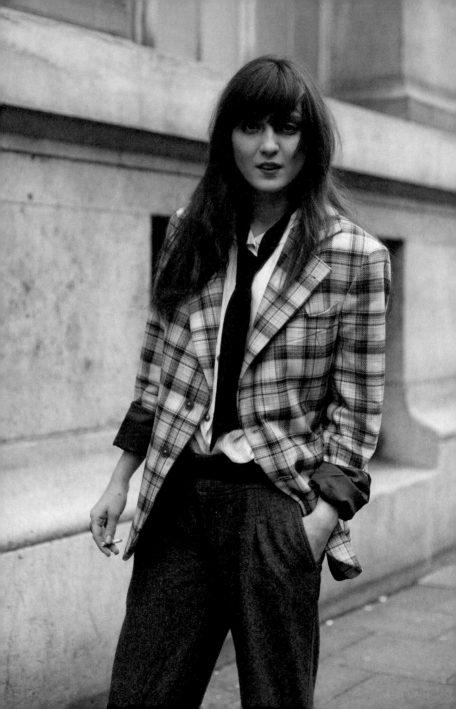

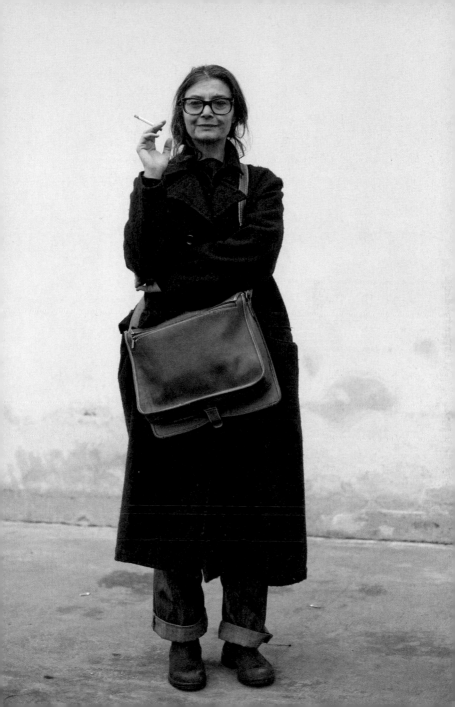

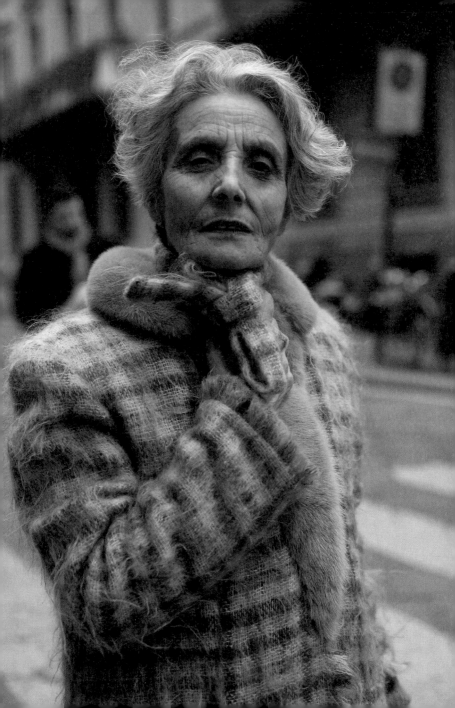

'Mi bruta', Milan

I saw this elegant woman on one of the most chic shopping streets in Milan. It didn't take me a moment to know I had to ask her if I could take her photo.

It is tricky as a young man to approach an older woman on the street for any reason, especially if you don't speak the same language. First you have to try to calm their suspicions, and then you must try to communicate your request. Luckily, I don't look too scary, so I approached this young lady and pointed to the camera and then to her, making the international sign for 'take a picture'. Of course, she thought I wanted her to take a picture of me – that happens often. Once she realized that she was the intended subject she protested: *'No, mi bruta.'* I knew enough Italian to understand that she felt she wasn't pretty enough to be photographed. I wasn't sure of the Italian word for 'beautiful', so I did what every American would do – I just added an 'o' to the end of the word. *'No, molto beautifulo!, molto elegante!'*

Well, this went back and forth for a several moments. I could see that if I kept this up for much longer I was in danger of her thinking I was hitting on her. Finally, I gave up, smiled and began to walk away. After a few steps I heard a simple 'Excuse,' and she motioned for me to take the photo.

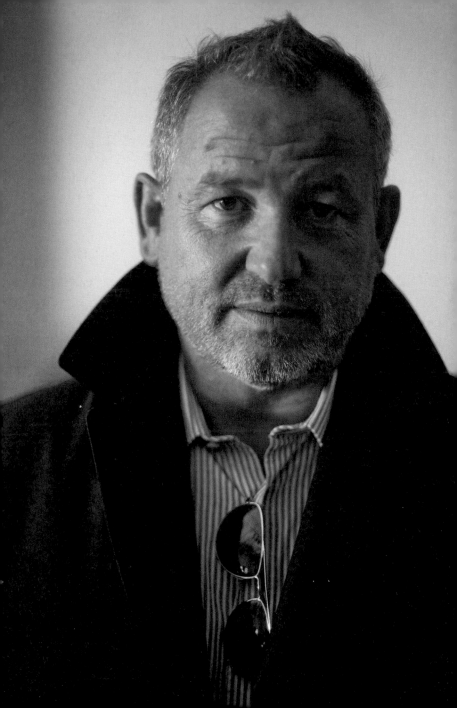

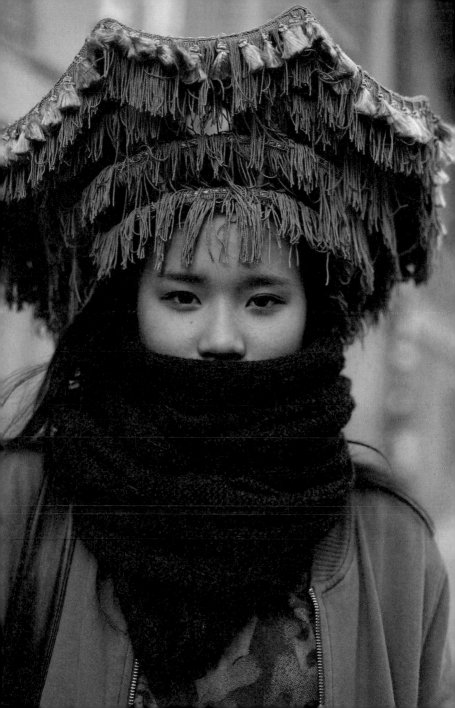

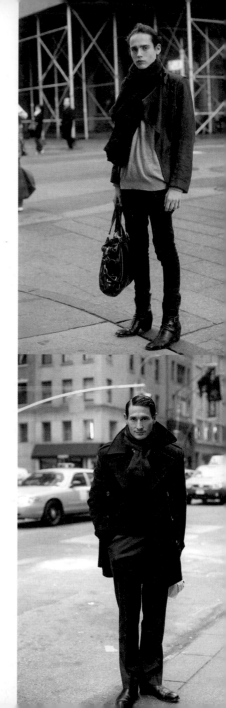

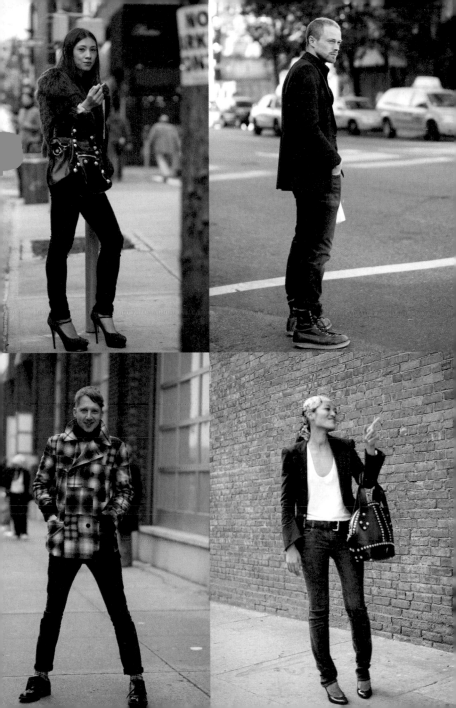

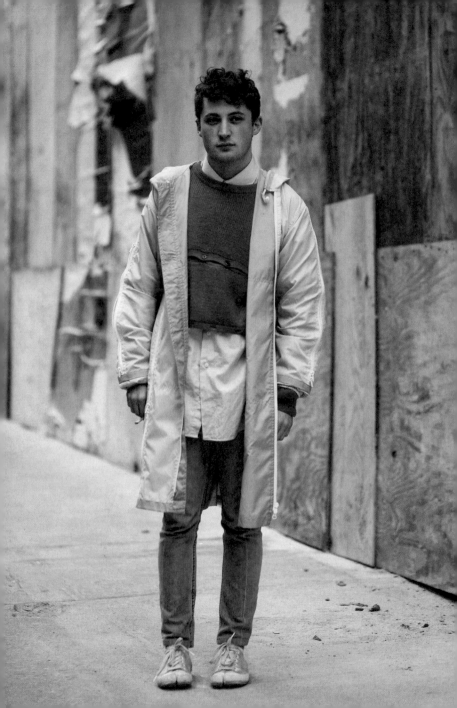

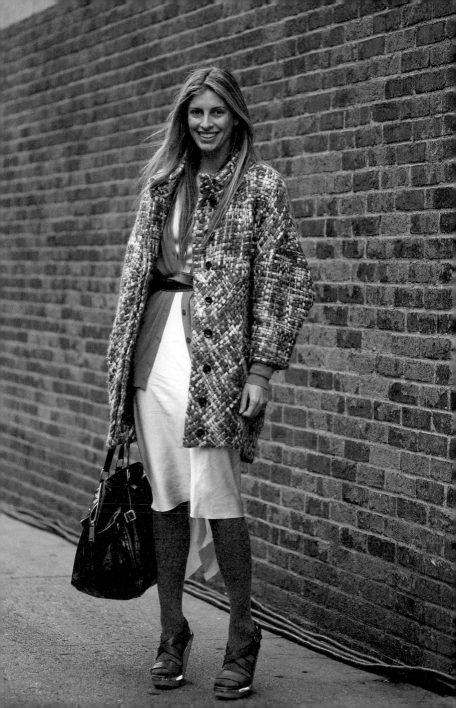

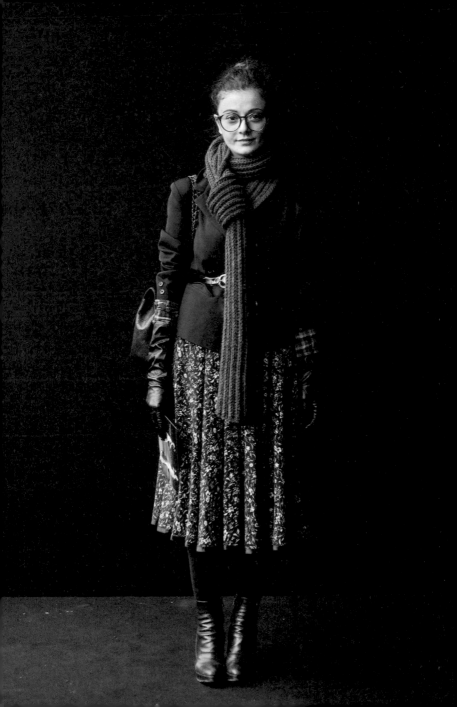

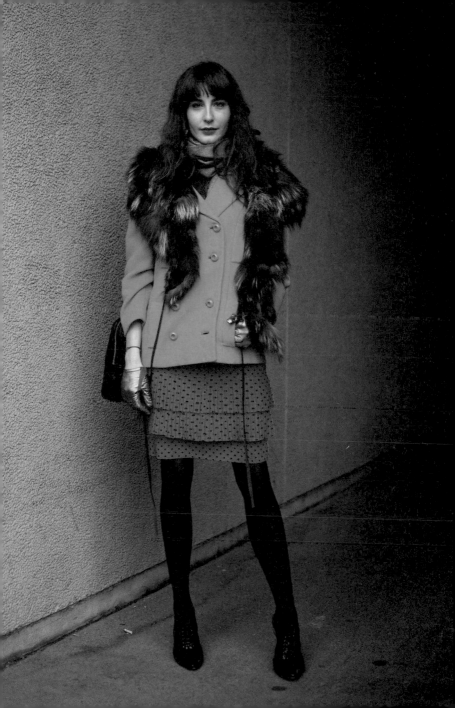

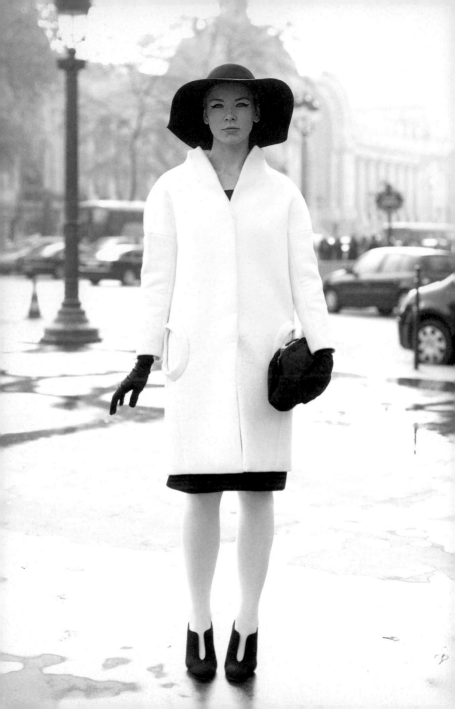

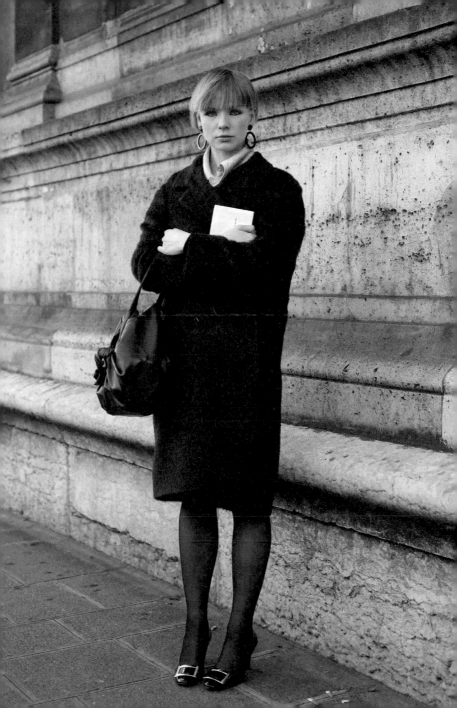

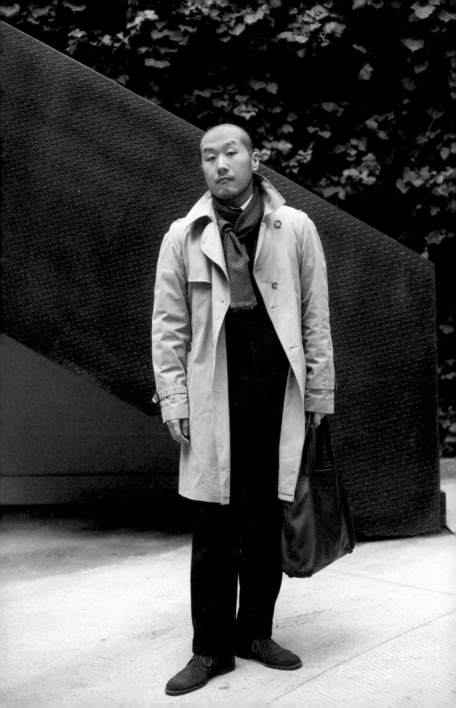

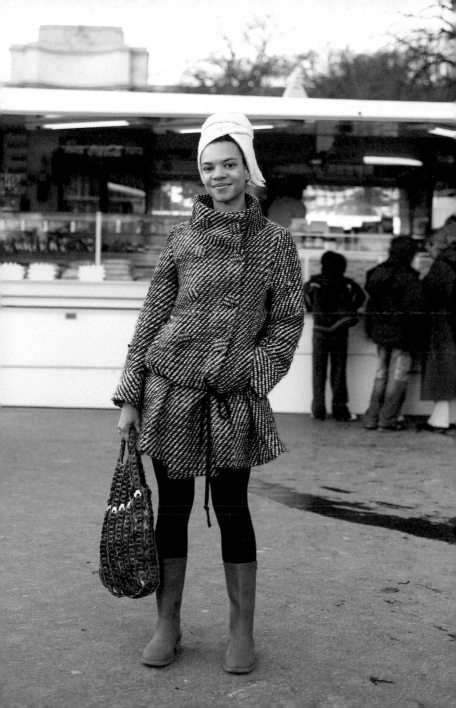

Je ne sais quoi, Paris

French girls have such an effortless way of making everything they wear seem exotic and sexy. I agree that part of it is an innate cultural way of looking at fashion, but what cannot be underestimated is the languid physicality of French women. They can say as much, if not more, about themselves with a simple hand gesture or seductive tilt of the head than just about any nationality of woman known to man. These two styles would look cool/nerdy chic on an American or Swede, but on a mademoiselle they still ooze sexiness.

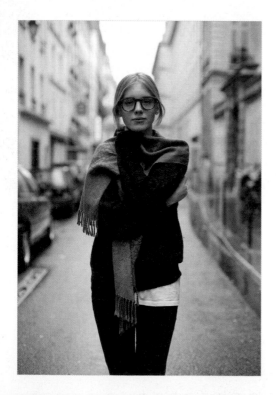

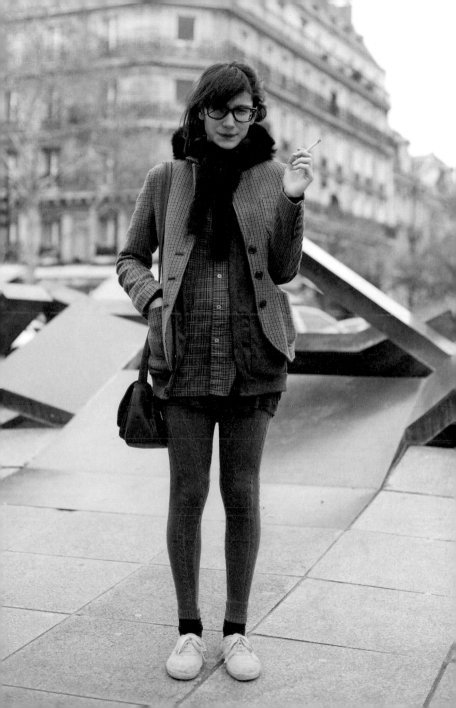

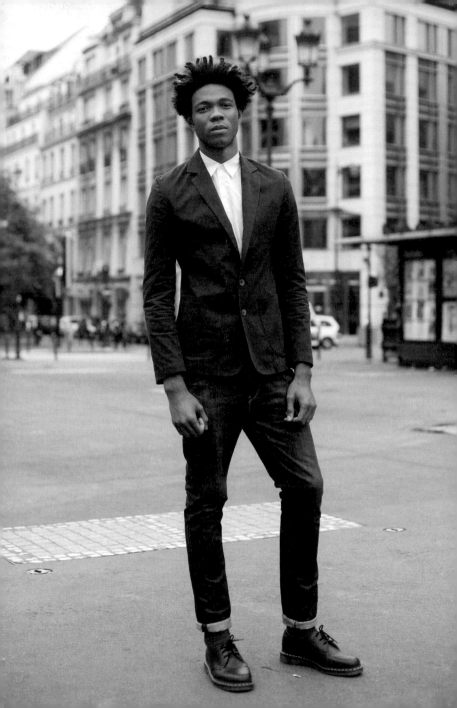

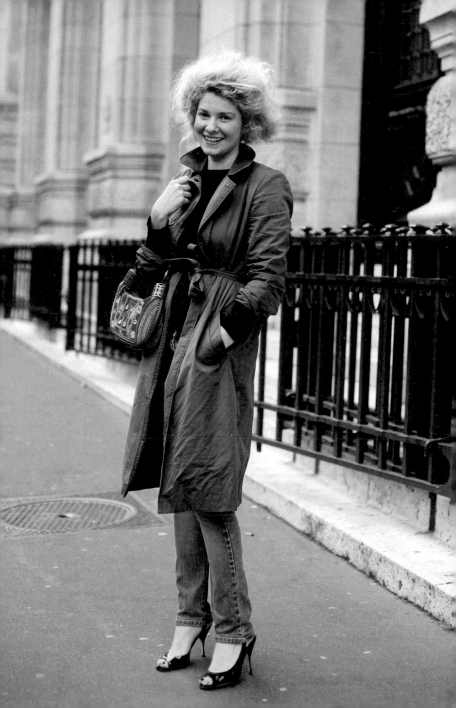

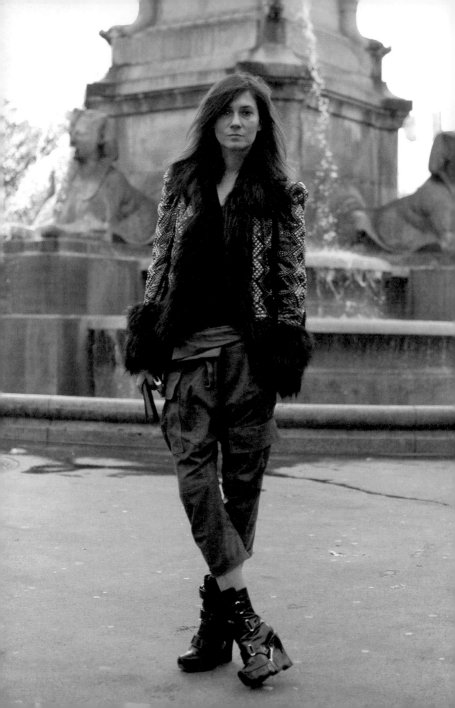

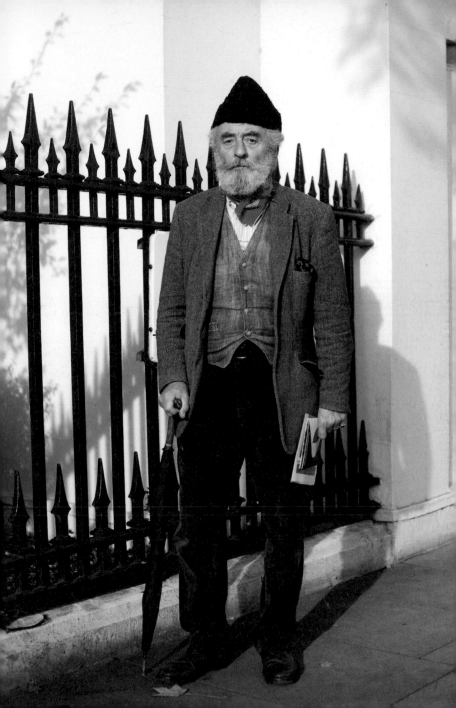

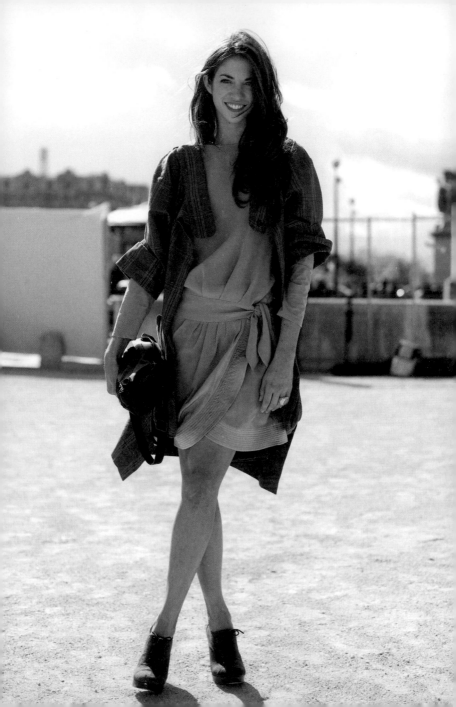

Signs of Life, Paris

I was chatting with Susan after I took this picture and mentioned that I thought her hair was just beautiful – her best feature.

She thanked me and said that she had once lost her hair because of cancer. She now purposefully keeps it long because she feels it is such a gift to have it back and, for her, it's a sign of life.

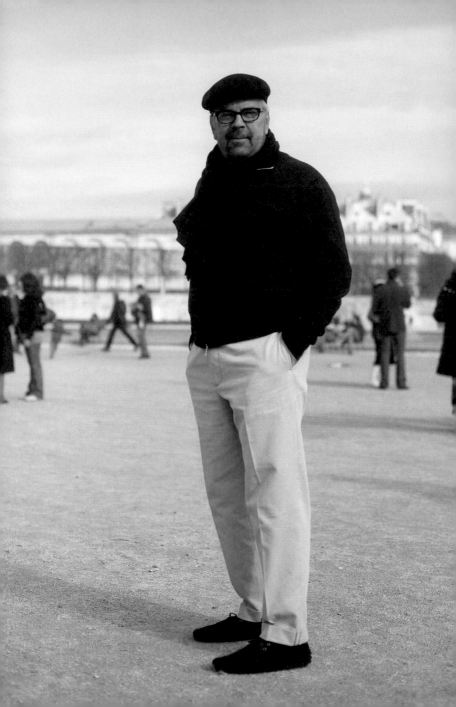

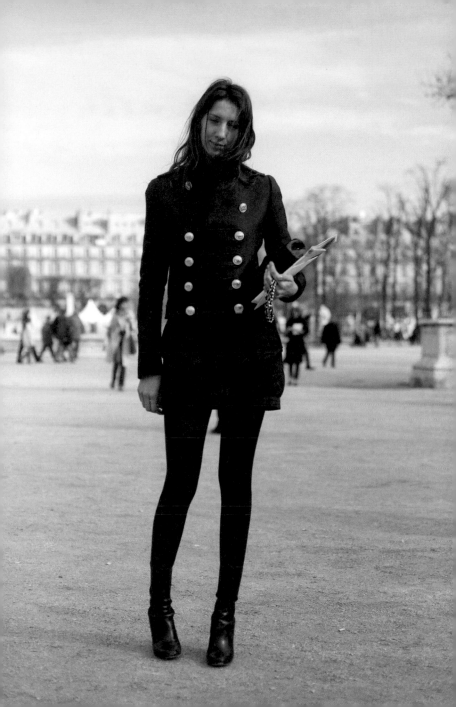

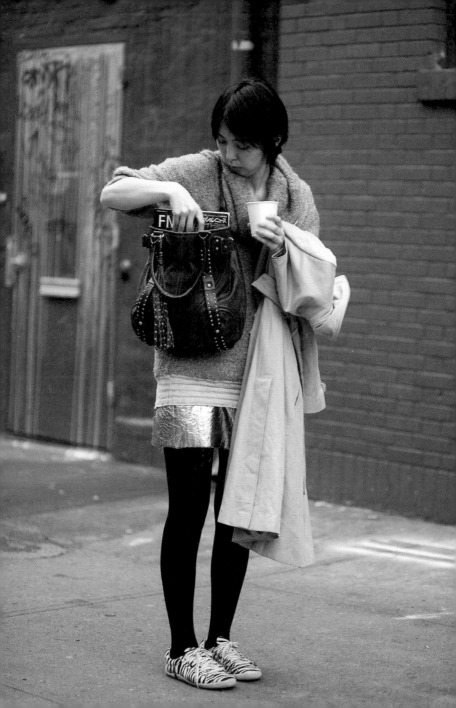

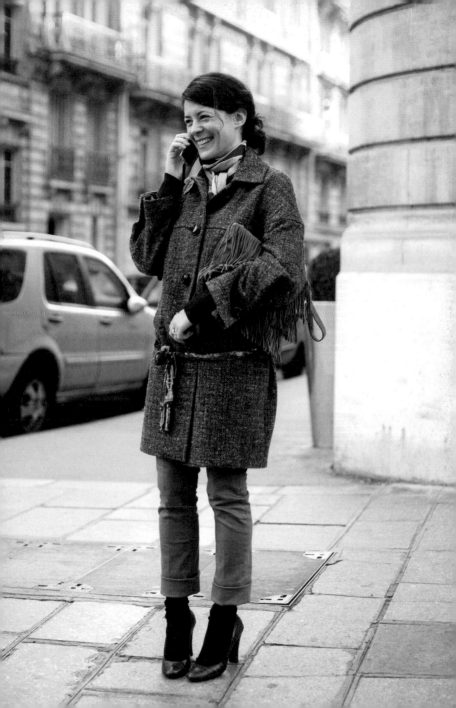

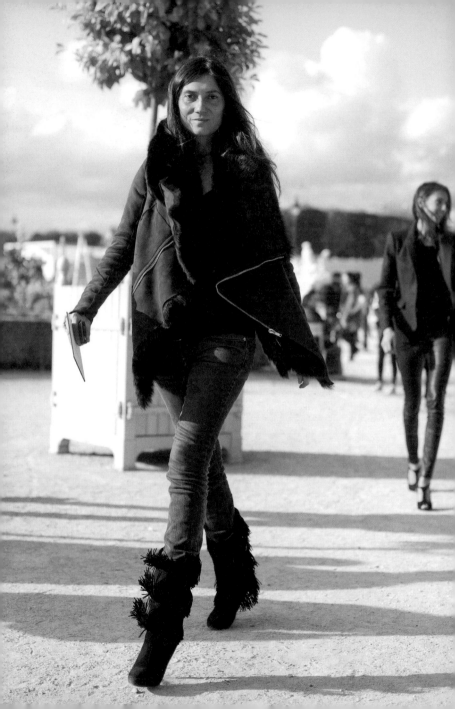

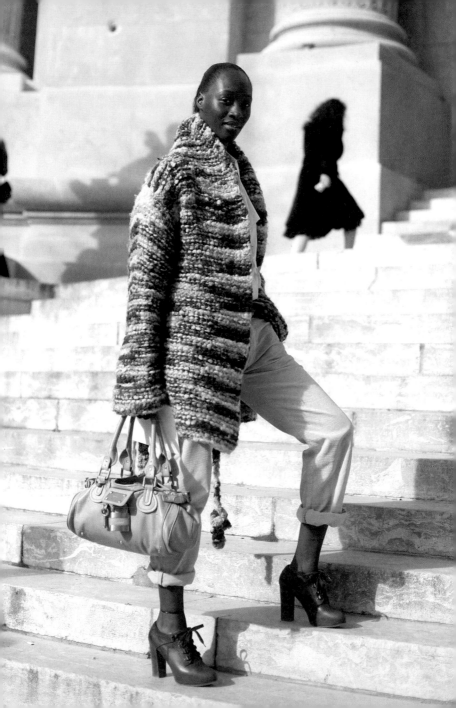

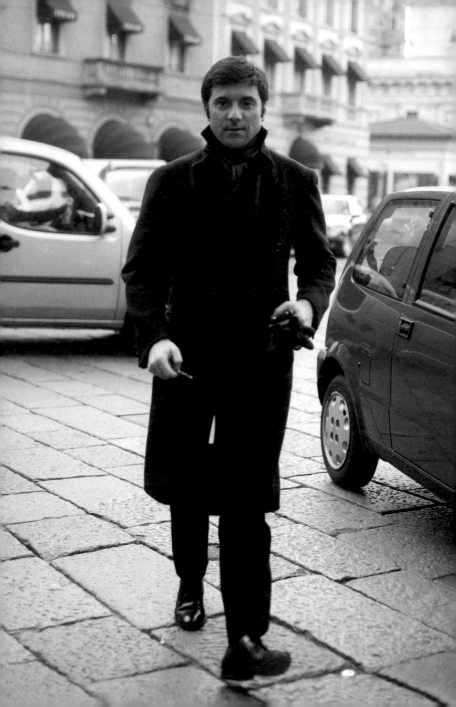

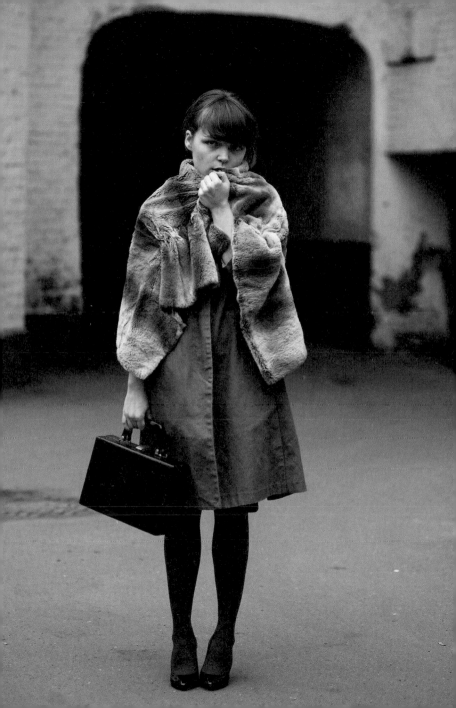

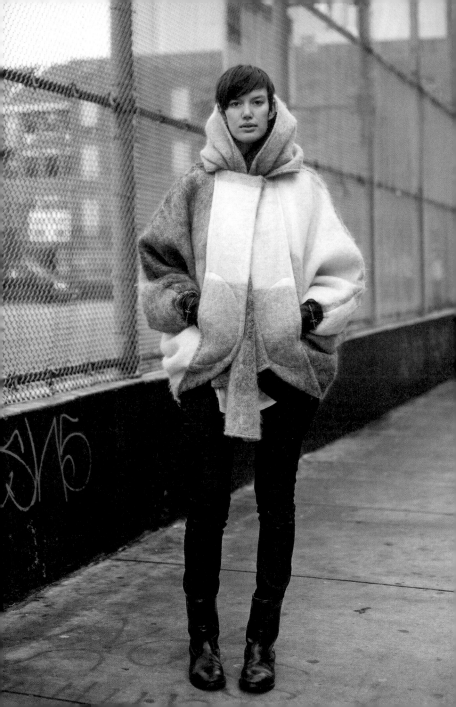

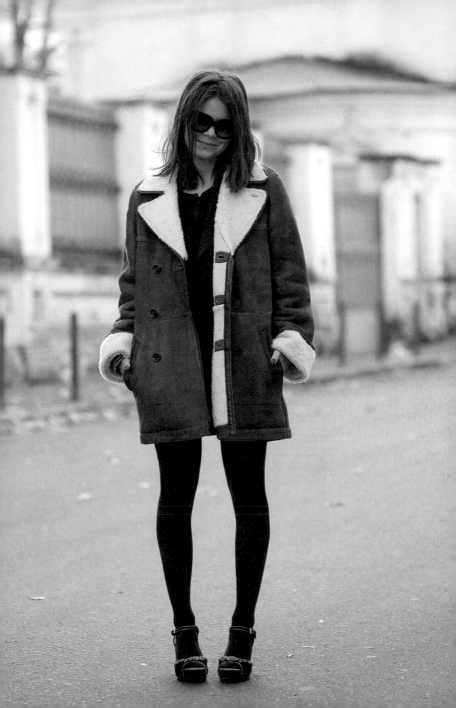

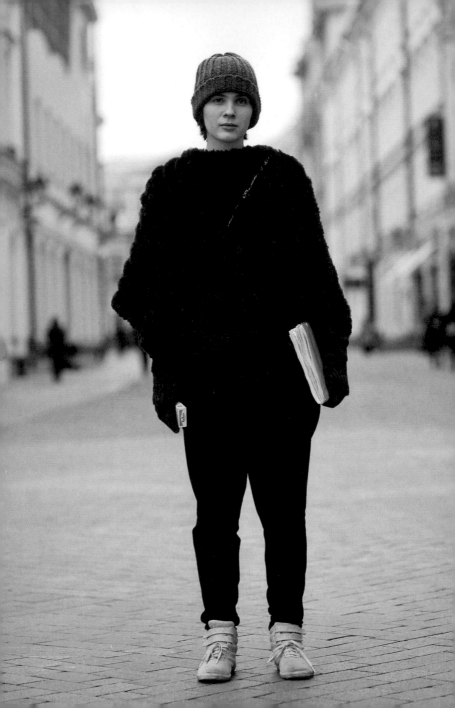

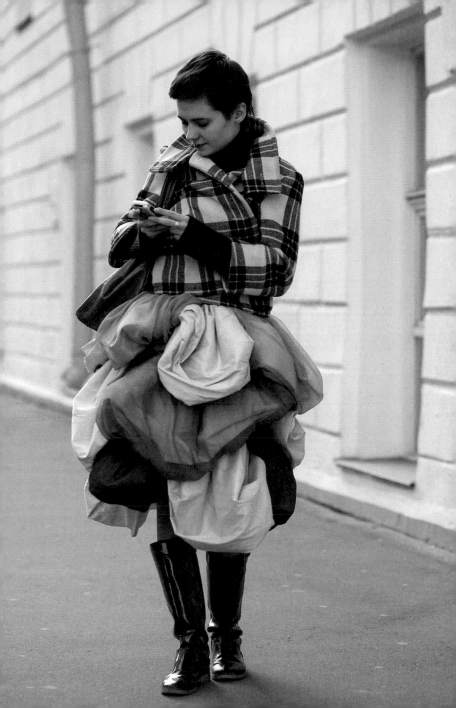

My daughter. I didn't
tell her to pose like that.
Sometimes you're just born
with a special something.

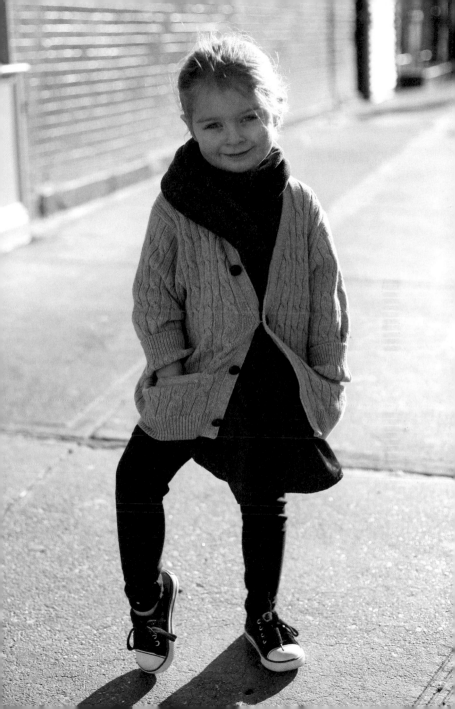

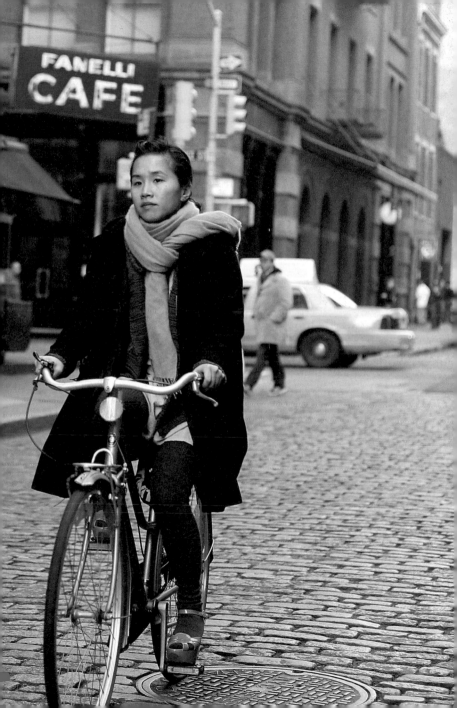

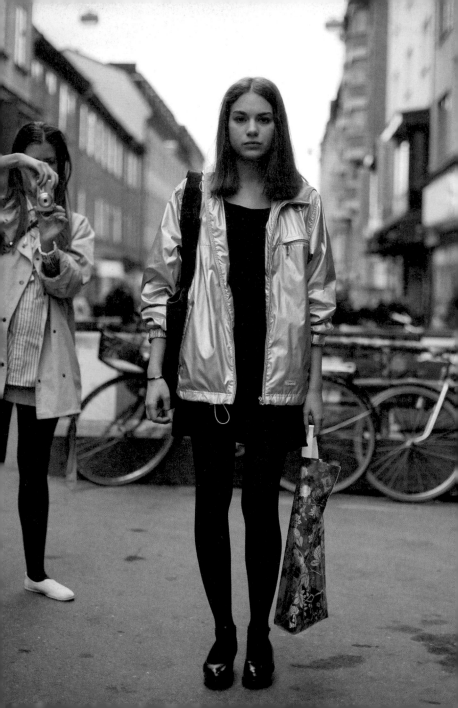

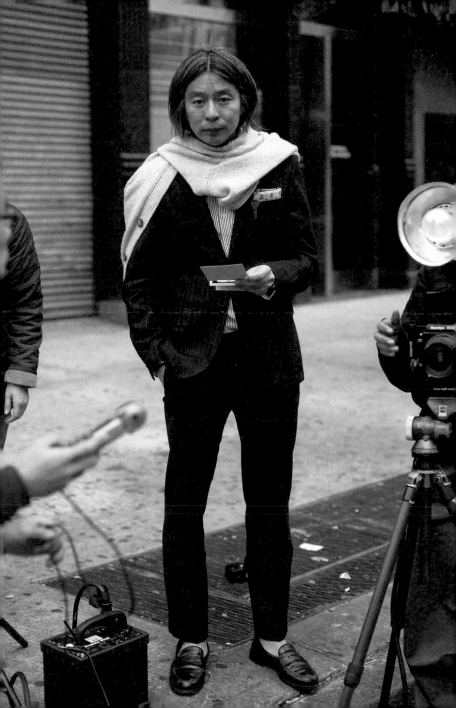

Couture Clash,
New York

A cop out would have been to keep this whole look super-luxe by pairing this beautiful cashmere coat with some type of equally luxe cashmere knit or silk blouse. However, Gloria never takes the easy way out and instead mixes (or clashes) it with a $20 American Apparel neon yellow nylon anorak. That, to me, is the real essence of modern New York style.

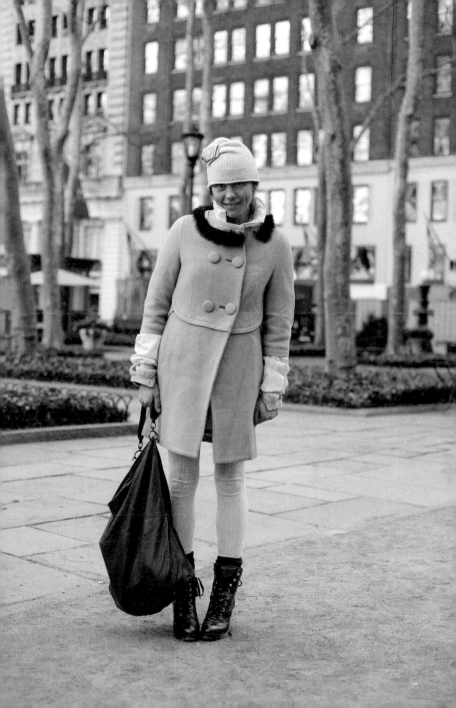

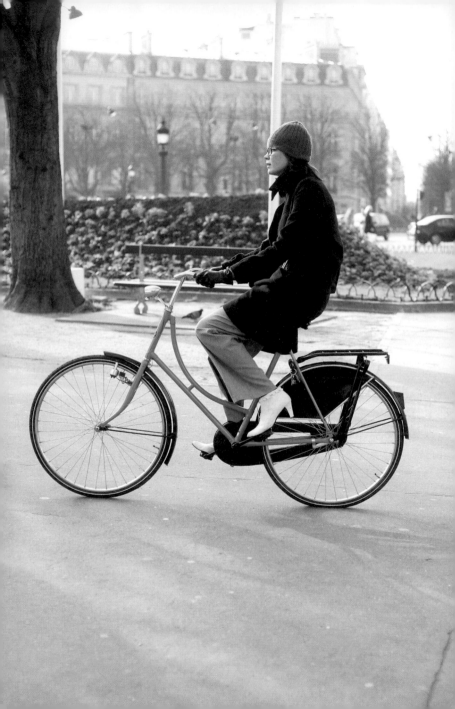

Avenue Montaigne, Paris

I was talking on the phone when I saw her coming up and about to ride past. I love how chic she looks with the boots and this beautiful coat. I really only had a split second to get the shot – this is one of the few times I got the focus dead right first time. I think people really like the bike shots because there's this implied sportiness to being dressed up and bicycling that you just don't see that much any more. It's so romantic to think people are jumping on their bikes dressed like this every day.

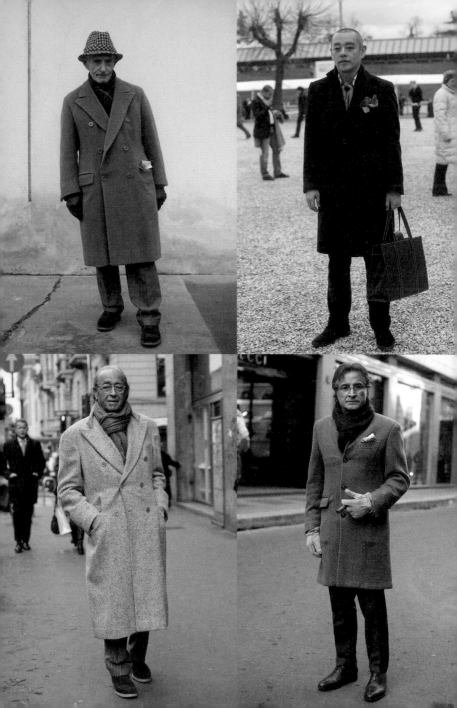

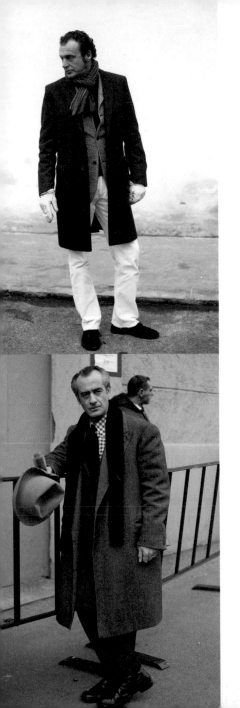

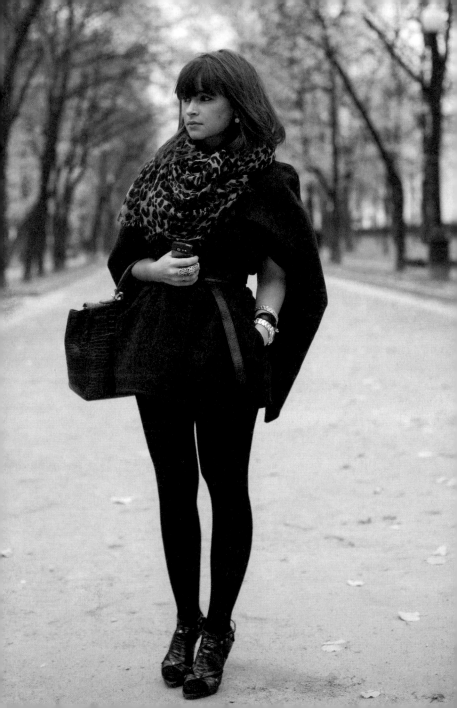

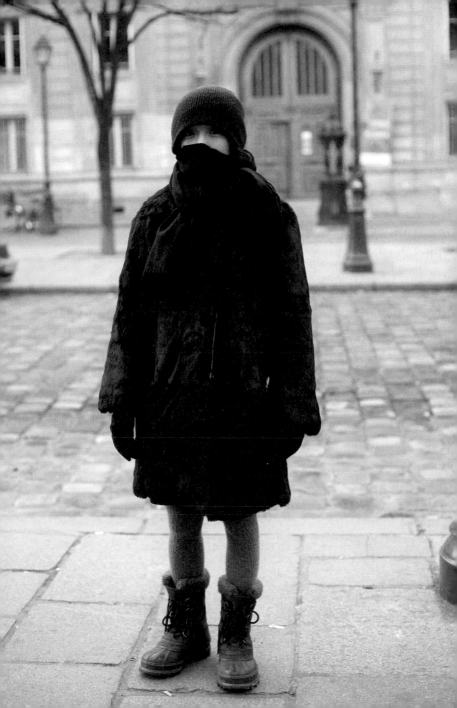

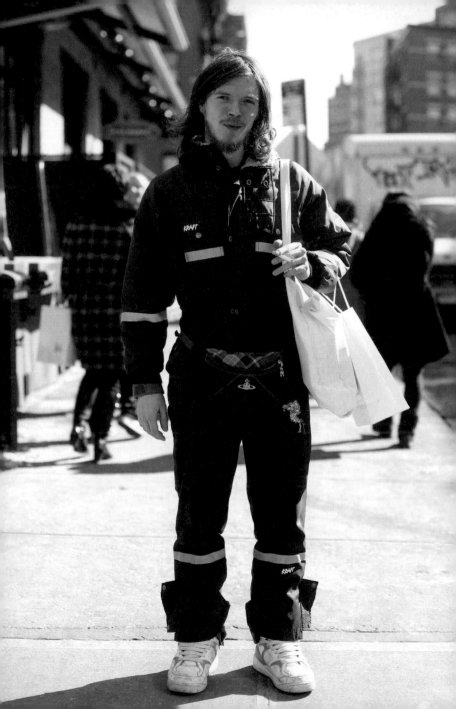

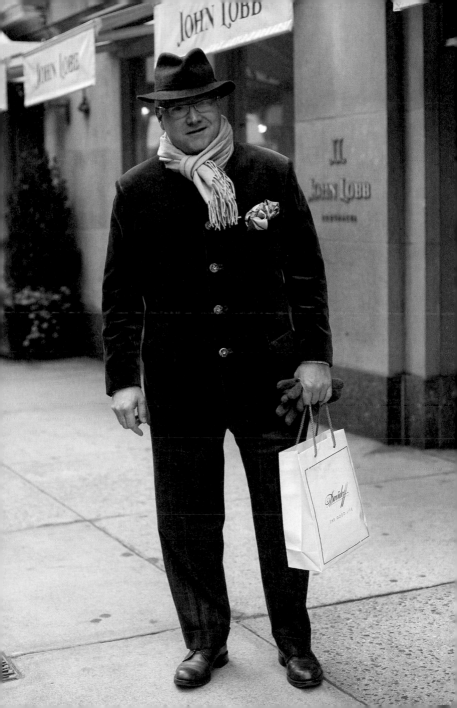

Party boys, Paris

When I am walking through Paris or Milan I always keep my eyes wide open, because it seems that a great shot can happen around every corner.

I remember that for this photo I had a little time between shows and I figured I would take the long way to the next location.

I was in a nowhere area of the Left Bank on a tiny street, and as I passed an even smaller intersecting alley I noticed two curious shapes about 100 yards down the way. Usually, the first thing I notice is the general shape or proportion of people, and maybe colour combinations. It took a moment for my eyes and mind to resolve the image (I don't have great natural vision) as I passed the alley. Since most people are dressed in such a typical manner, if I see something unusual (even in the distance) that takes me a moment to visually register, then my curiosity gets piqued. In this case my inquisitiveness was rewarded by two hipsters who had a unique, updated Romantics/Teddy Boy vibe.

Sometimes people say that I shoot too many 'fashion world' people – these guys, as it turns out, are well-known party boys in the London fashion scene. However, when I first saw them they were just vague, interesting silhouettes in the distance, and only later did I learn that they were known figures in the fashion world.

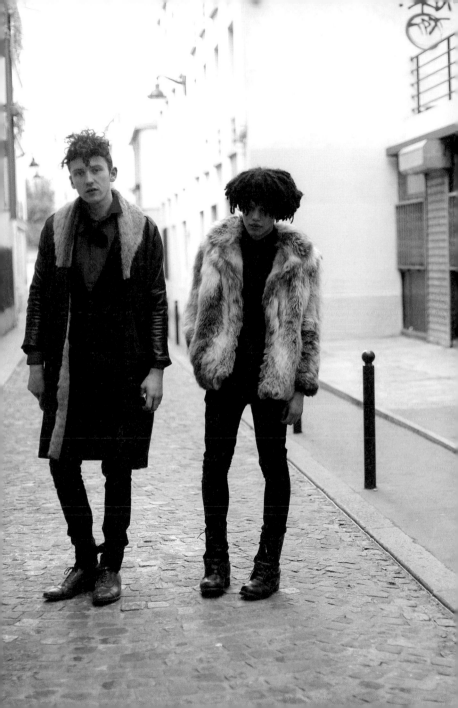

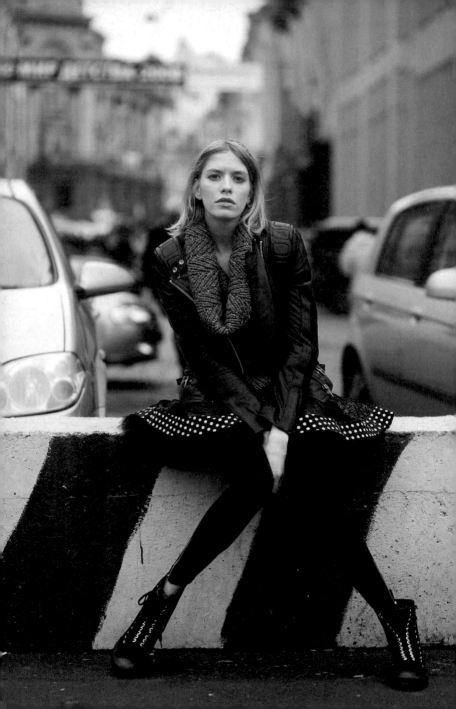

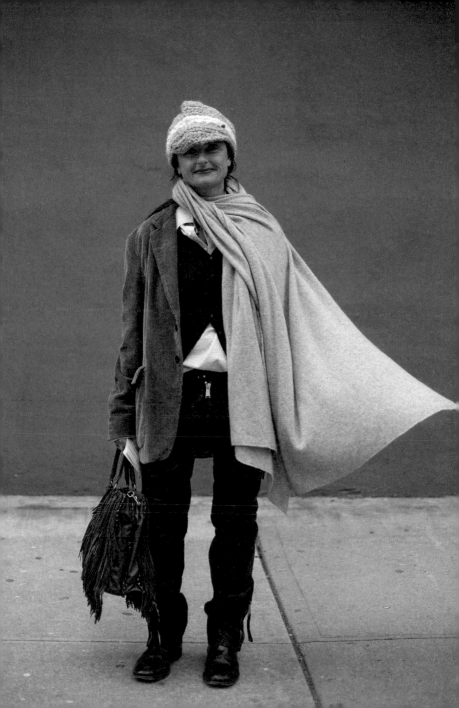

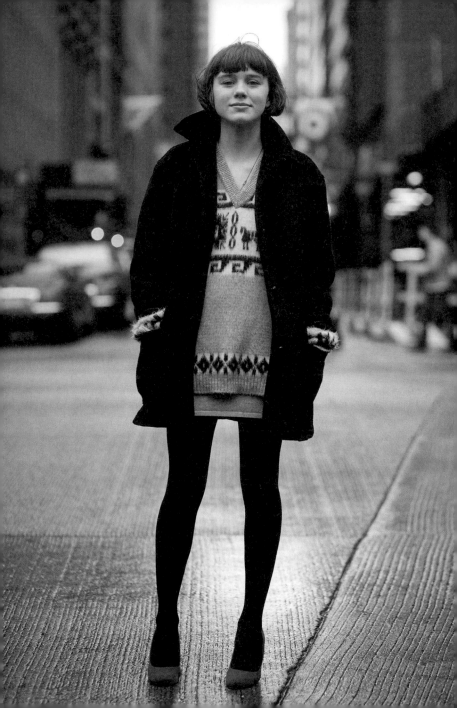

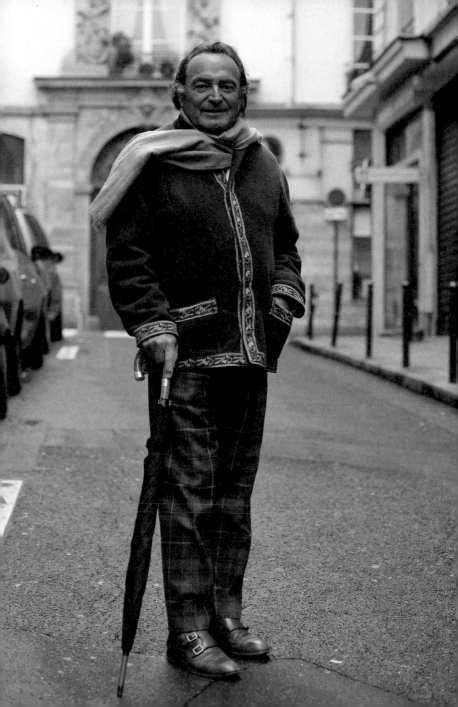

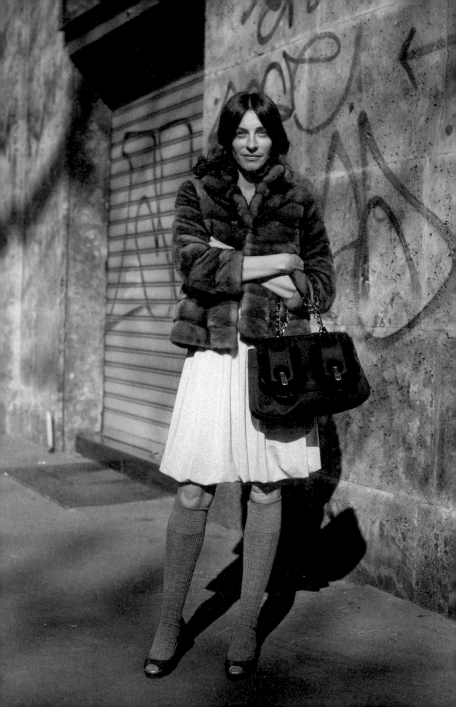

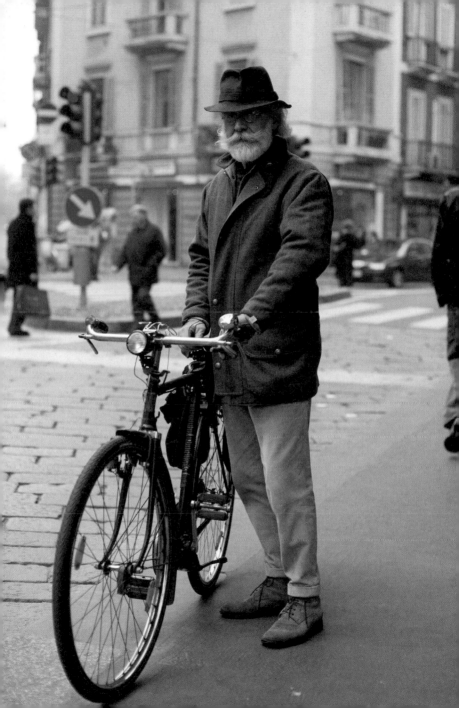

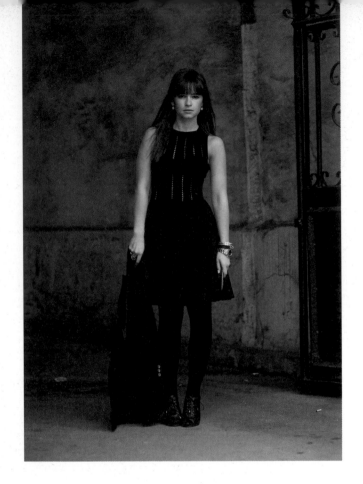

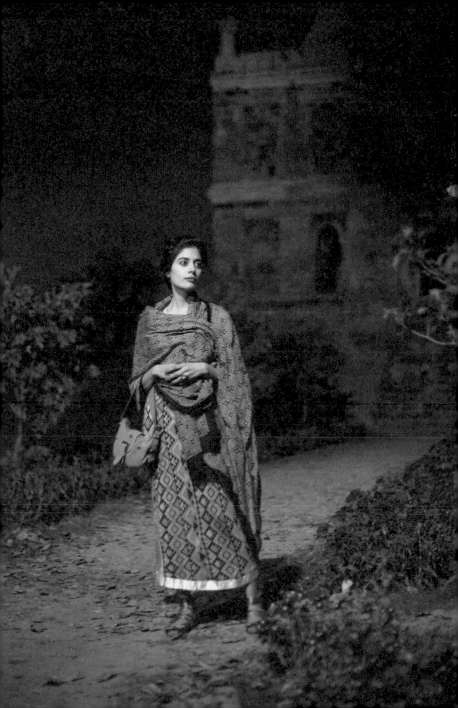

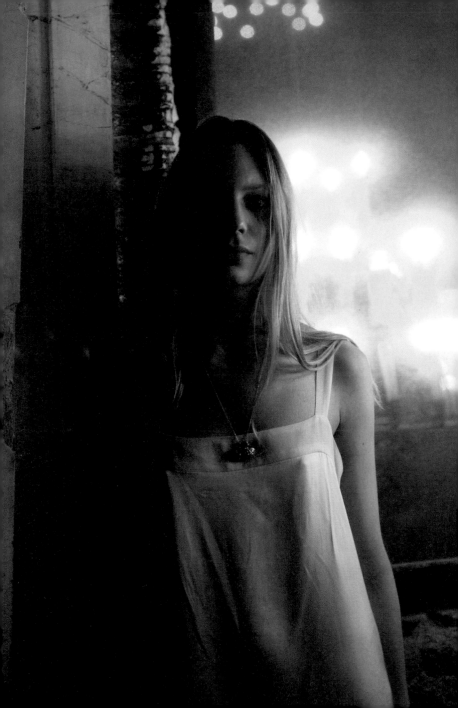

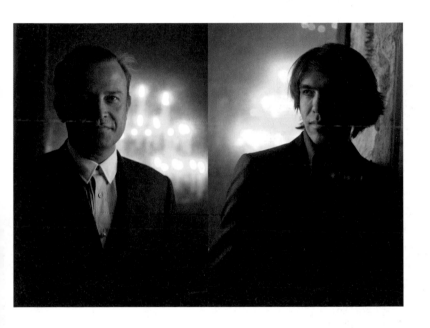

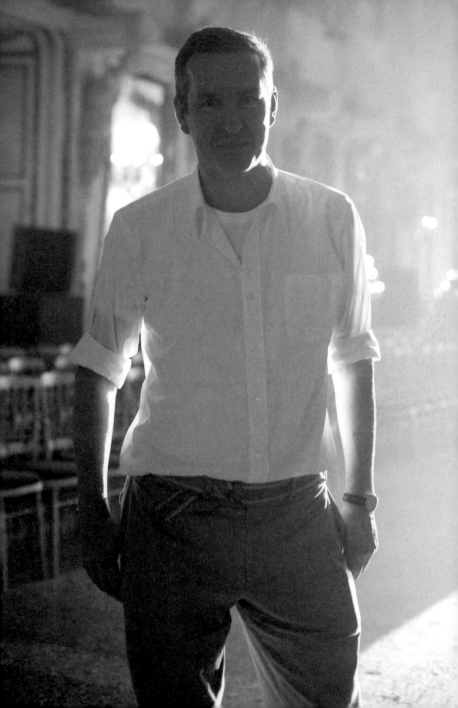

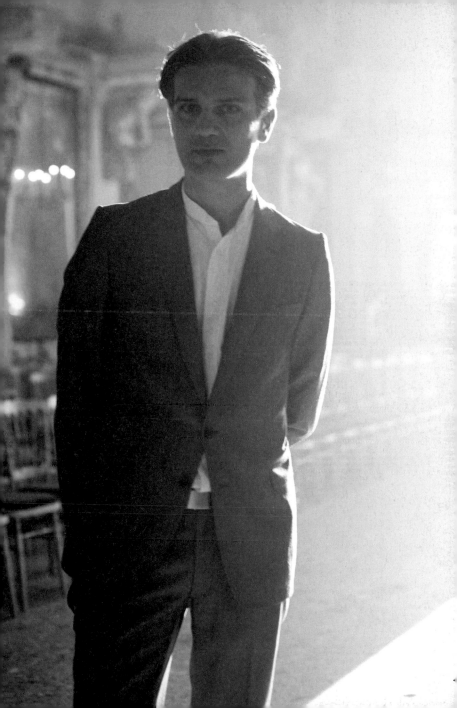

Index